NOBUYOSHI ARAKI

NOBUYOSHI ARAKI

SHIJYO TOKYO – MARKETPLACE OF EMOTIONS

*E*DITION *S*TEMMLE

Edited by Zdenek Felix

Texts by Zdenek Felix and Ulf Erdmann Ziegler

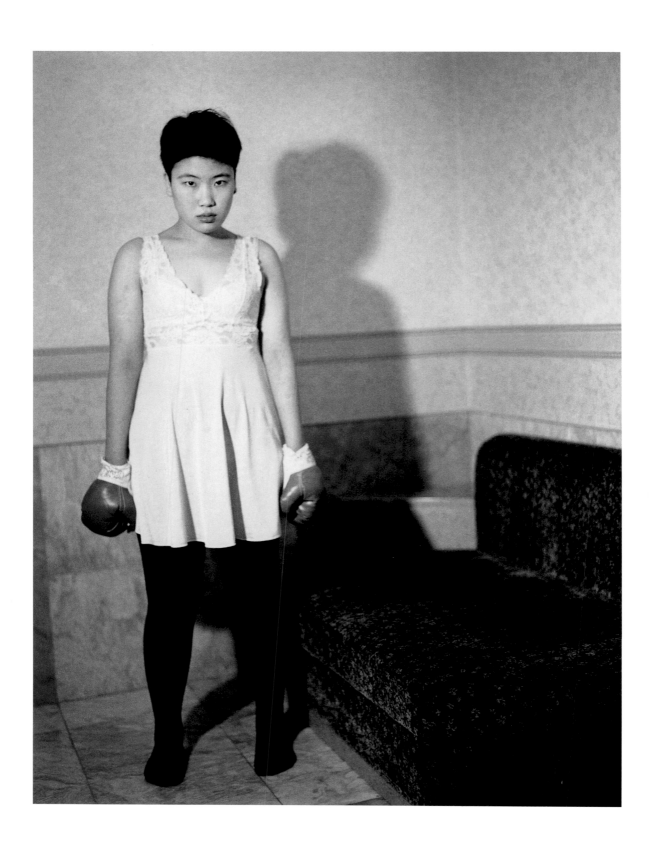

CONTENTS

Zdenek Felix

THE UNIVERSE IN THE PHOTOS
OF NOBUYOSHI ARAKI

6 The most striking feature of Nobuyoshi Araki's photographs is the Japanese artist's unmistakably obsessive appropriation of his motifs. In his painstakingly staged images of bodies in bondage or his precisely composed flower still lifes, in his more spontaneous "snapshots" of Tokyo night-life or the melancholy scenes from his own garden, the traces of his obsessive urge to communicate with the world of visual phenomena, which he literally extracts and preserves with his camera, are evident everywhere. The more than 100 books of photography published by Araki to date bear remarkable witness to his all-consuming desire for images. Araki employs a combination method in most of his publications and in his exhibitions and slide shows as well, presenting photos that relate to differing themes in groups or series and in overlapping slides. Virtually impossible for the individual viewer to fathom at once, the Japanese artist's universe behaves much like a system in entropy: It appears that disorder does not diminish within the whole and that chaos expands as the number of images grows larger.

The longer one studies Araki's work, however, the more obvious it becomes that this seeming chaos of themes and motifs conceals a structuring force of precise selection. Although coincidence may well play a part in his art, the majority of Araki's photos draw their strength from his astonishing powers of observation, which enable him to expose an unexpected facet in nearly every motif. Araki is constantly on the move, wandering through his native Tokyo in search the moments that provide him with new material for his investigations into the spheres of life that have permanently captured his fascination, into themes that he continually approaches anew: the city of Tokyo, sexuality and death. In making such a list, of course, one runs the risk of failing to do justice to the complexity of Araki's work, of placing it too near the realm of documentary photography. The Japanese photographer is hardly a documentarist, however, although it is true that every photograph with a recognizable theme is in its own way a document of its time. Essential to Araki's view of photography is the question of the extent to which a photo can serve as a metaphor for specific feelings, desires and moods and thus take form as a psychological statement, a penetrating, highly individual image. Many of Araki's photographs have such qualities, not because they violate supposed or genuine taboos but because they are non-mediated responses based upon subjective experience, upon an experience of the familiar. In this respect, they share certain underlying affinities with the photographs of such contemporaries as Noritoshi Hirakawa, Sakiko Nomura, Nan Goldin, Cindy Sherman, Robert Frank and Larry Clark. Araki's work with the American artist Nan Goldin, which resulted in the book *Tokyo Love* (1994), shows that astounding parallels in the con-

stitution of contemporary photographic images can emerge between two different artist personalities.

On the other hand, certain aspects of Araki's work clearly reveal the specific character of his origins, althought this has little to do with what is generally subsumed within the concept of "Japanese culture." Instead, it relates to the special system of metaphor that plays a major role in Araki's work. His publication entitled *In Ruins,* which appeared as the eleventh volume of *The Works of Nobuyoshi Araki* in 1996, contains a series of photographs centered primarily around the themes of beauty, growth and bloom but also concerned with decline and mortality in nature. An air of morbidity envelopes all of the animals, plants and dried fruits. A cat is shown lying in a cardboard box. Whether it is dead or alive is impossible to say. The skeleton of a reptile, a feather torn from the body of a bird, the core of a half-dried melon — each serves as a *memento mori.* We see abandoned, partially rusted garden furniture on a terrace surrounded by an invading horde gorillas, prehistoric animals and gigantic black flies — all made of rubber — a picture full of disturbing beauty and signs of impending doom at the same time. In Araki's art — and this applies to his photos on sexual subjects as well — the theme of death is a constant presence.

Araki explained his intimate conceptual concern with the idea of death in great detail in his conversation with Nan Goldin. Asked why he thinks that the smell of death is attached to photography, he answered: "When you hold on to something that moves, that is a kind of death. The camera, the photographic image have always called forth the idea of death. And I think about death when I photograph, as you can see in the pictures. That may be an oriental, Buddhist concept. For me, taking a photo is an act in which my 'ego' is brought out by the object. Photography has always been associated with death. Reality is colorful, yet early photography always took the color out of reality and made it black-and-white. Color is life; black-and-white is death. There was a ghost hidden in the invention of photography."

Araki's statement serves as a fitting motto for this publication. Under the title *Tokyo — Shijyo,* freely translated as *Tokyo — Marketplace of Emotions,* the book gathers together 100 color and 100 black-and-white photographs, each from a different series, in a single volume, arranged in a sequence of contrasting pairs. The fascinating, brilliant color of the "Flower Series" stands in strange contrast to the dark mood of the black-and-white series, which Araki entitled "Death Reality." This part of *Tokyo — Shijyo* presents the remains of an old movie made by Araki with a simple camera in the 1970s. Stored improperly for many years, the film itself shows severe damage in some places. It is streaky and bears traces of smoke or soot, as if it had been subjected to violent treatment — a sign of mortality and death in Araki's eyes.

The Flower-Series is virtually bathed in opulent color. Unlike Araki's earlier photographs of this type, in which dead geckos served as moribund reminders, the callas, orchids and daisies in these photos unfold their magnificence undisturbed. Their connotation as symbols of life derives in part from the fact that plant sexual organs have traditionally evoked anthropomorphic associations. Supported by a long tradition of Japanese painting, in which plants and shrubs have played a significant role in a number of different respects, Araki exploits the suggestive power of Cibachrome photography to create images with multiple meanings in a spectrum that encompasses expressions of pure beauty, erotic obsessions and metaphors of emptiness and death. Regardless of their specific themes, all of Araki's photographs can be approached within this context.

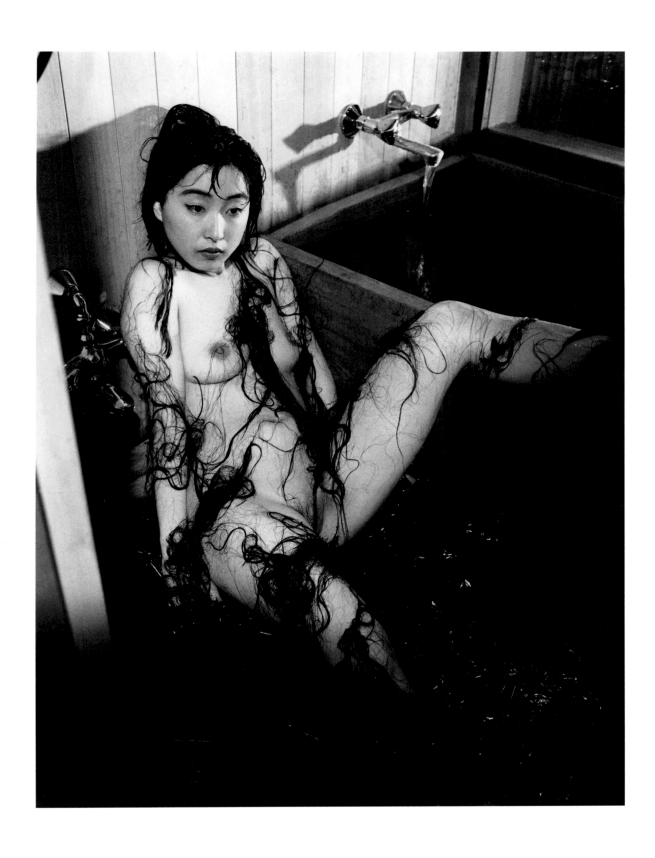

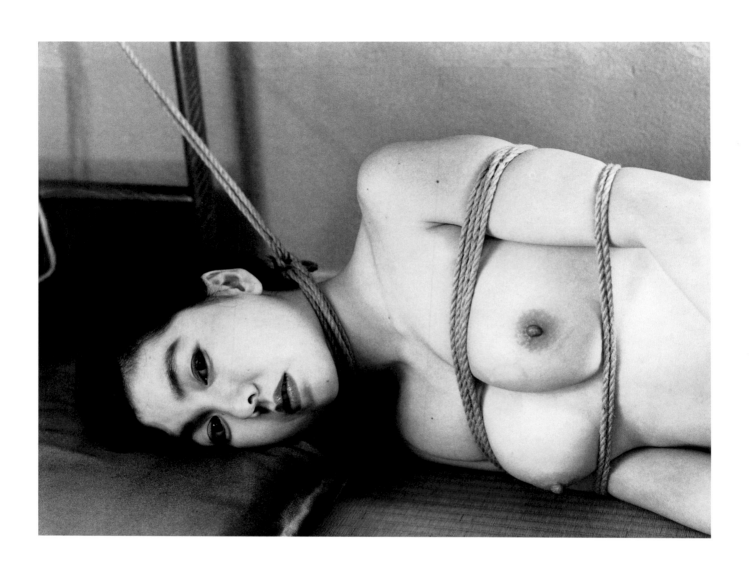

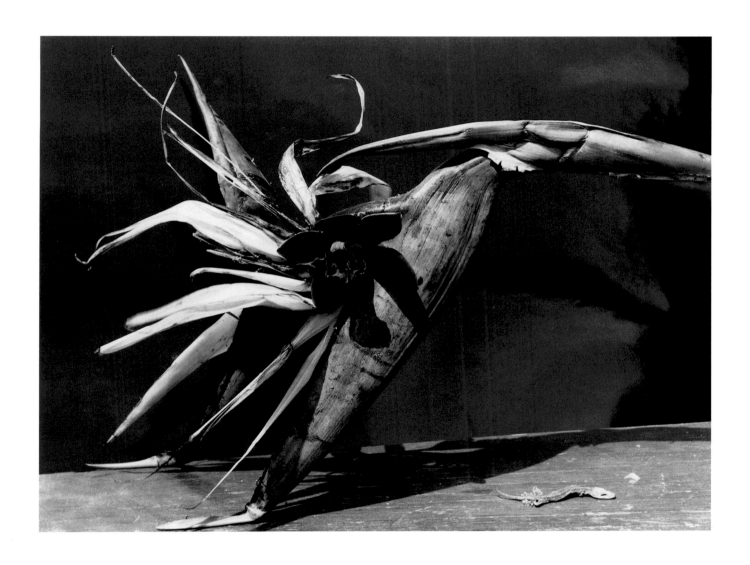

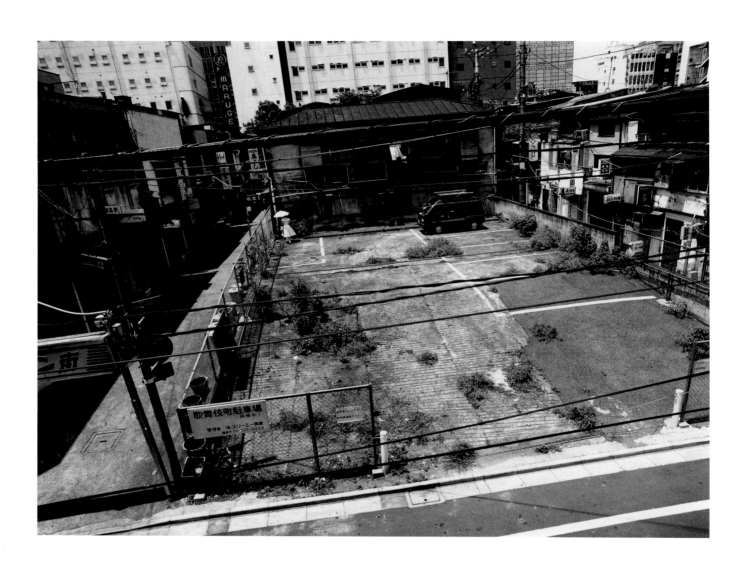

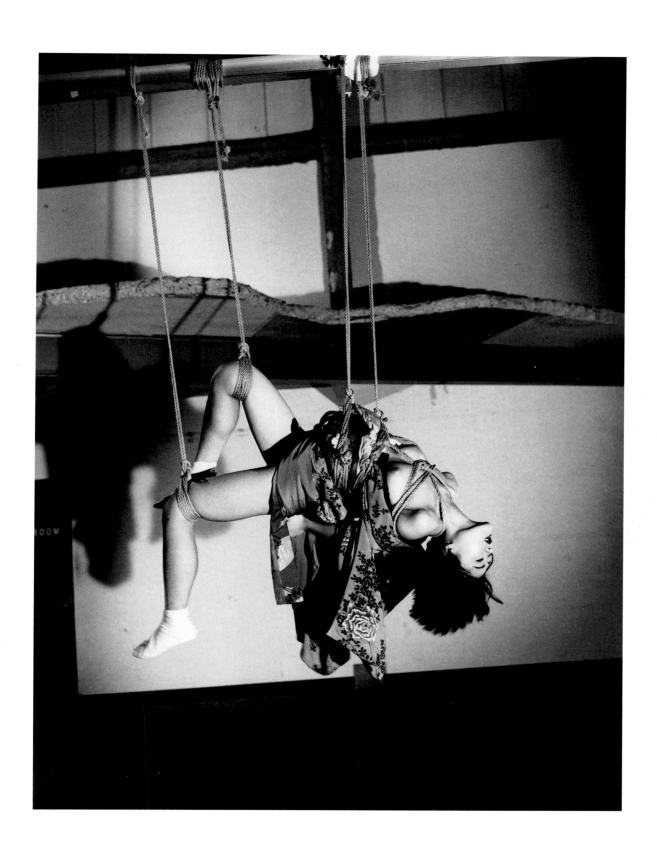

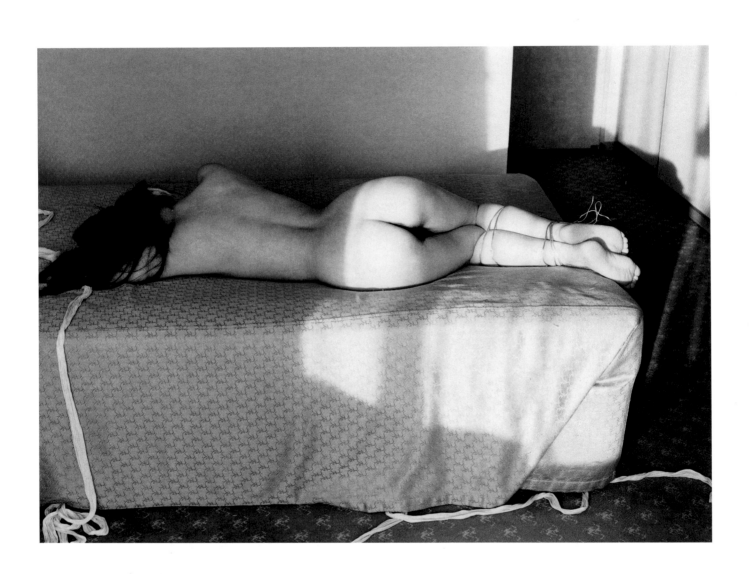

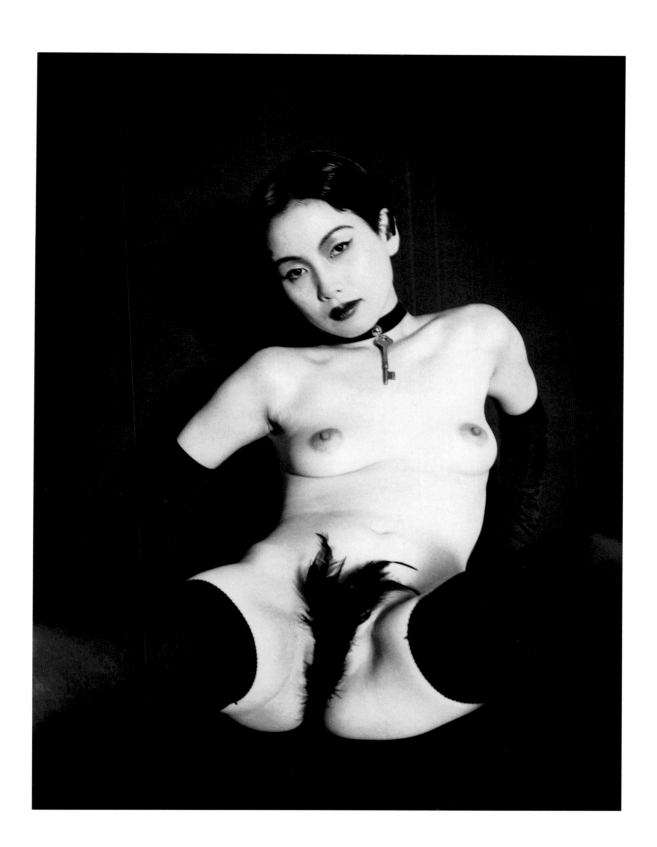

Ulf Erdmann Ziegler

A COMPLEX CHARACTER.
NOBUYOSHI ARAKI'S PHOTOGRAPHY

A model of the other. Of the many photographers currently unsettling the art scenes of the western world, Nobuyoshi Araki is perhaps the most bizarre figure of all. His subjects are difficult to grasp for western viewers, who find them baffling or disturbing, or in many cases both at once. That is not to say that Japanese pictorial motifs are incomprehensible *per se* – for that is not true at all. Japanese art, from Hokusai's woodcuts to the elegant sculptures of the *Gutai* group, offers westerners clues to Japanese culture – more so than the cinema, where film subtitles ordinarily lag far behind the obvious richness of the original language. But Araki's photographs are not keys to an understanding of Japanese culture. In fact, one might prefer to rule out the possibility that they could be "typical" of what moves Japanese people, and Japanese women in particular.

Araki brings back the idea that everything truly Japanese automatically excludes us from participation. In western eyes, Japan has been the very model of the other, although it remains unclear to what extent the reverse is also true. Araki's art should actually fall within this category of the *other,* for we know that the photographer rarely leaves Tokyo, that he did not attend a western university and that he speaks only Japanese. Yet his work achieves precisely the opposite effect. We gain the insistent impression that these pictures are addressed "to us" – not in the sense that they are images or reflections of western culture – like the parodies of western art and cinema found in the travesties of the Japanese photographer Morimura – but because they operate according to rules developed within western "modernist" discourse.

Born in Tokyo in 1940, Nobuyoshi Araki was 32 when he left the advertising agency for which he had been employed as a stills photographer.[1] For the next two decades his work remained virtually unknown in the West. Of the 75 books and brochure editions of his photographs produced in Japan during those years, not a single one was available in Europe. His first solo exhibition outside Japan was shown in Graz in 1992 and subsequently appeared at ten other venues in Austria, Germany, Holland, Scotland, Scandinavia and Switzerland during the following three years – an extraordinary success story for an artist who had previously been a no-name at European galleries and museums.

But he was not the typical artist – painstaking, introverted, regional – unjustly overlooked by the hectic exhibition scene. Nobuyoshi Araki had long since become a media star in Japan, a figure constantly surrounded by an entourage, like Michael Jackson, a hard-drinking, boyish-tough character, like Damien Hirst, an elegant maverick, like Jean-Luc Godard, and an artist noted for specific eroticisms, like Helmut Newton, albeit for very different ones.

[1] In the words of Carol Lutfy, "By day he photographed refrigerators and toasters; by night he sneaked women into the company's photo studios and pursued his interest in nude photos." Carol Lutfy, "A Japanese Mapplethorpe," in *International Herald Tribune,* July 30th, 1994. In one catalogue we read that he had made his living from fashion photography, which might be true as well. See Gijs van Tuyl, "Fotografie auf Leben und Tod," in *Tokyo Novelle* (Wolfsburg: Kunstmuseum Wolfsburg, 1995; catalogue in German and English).

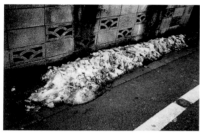

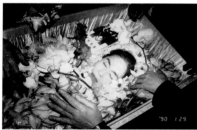

© Nobuyoshi Araki, *Akt-Tokyo 1971–1991*.
Graz: Camera Austria, 1992

2 Reinhard Matz, writing in *die tageszeitung*, was the first to express wonder with regard to the motifs and dates. His observation: "On January 28th Araki photographed a dirty patch of snow at the side of a street. Its shape is astonishingly similar to that of a covered corpse." See Reinhard Matz, "Um jeden Preis mitteilen," in *die tageszeitung*, September 14th, 1993. Matz assumes that the dates recorded by the camera on the negatives are not manipulated. However, Araki's announcement to the public would be the same in any case: the sexual gaze as a perpetuation of pain.

Having sifted through the myriad rumors and the sensational stories associated with the name Araki, one is drawn to such comparisons. As difficult as it is to comprehend Nobuyoshi Araki the artist, the goal of tracing the origins of his art and determining its real objective is no less elusive. That it is loaded with explicit sexual imagery and heavy-handed sexual metaphors is a given. Yet Araki's explicitness is not "hot" in the sense exploited by the sex industry, and his metaphors forge links to many other, similarly sensual images – cityscapes and interiors that are often devoid of people and have a metaphorical intensity of their own. We also know that Araki draws from a huge store of photographs that is expanded continuously – photos that bear neither dates (the few exceptions are discussed below) nor titles – and ultimately revolves around a small core of frequently recurring images. The majority of his pictures can easily be classified within a small range of subjects. Repetition – not as a structural principle but as kind of ecstatic obsession – is a part of Araki's program.

In one sense, Araki's photos, exhibited in great numbers and in plain display, can be taken in with a single glance. They exude a solemn morbidity, they tell of a great journey within a small space, they play urban and corporeal experience off against each other, even interchanging them, suggestively, on occasion. If we examine the photographs individually – a difficult undertaking in view of their sheer quantity and the similarities of the motifs – we find that the city scenes were captured much more hastily than the pictures of semi-nude or nude women with their hands or their entire bodies bound with thick ropes. The city images are like flowers picked along the wayside: here a glance into a desolate alleyway, there a wide shot showing water and a high-rise; and the sky, again and again, lead-gray or paperlike, filled with cheery cumulus clouds or hung like a threatening curtain that seems on the verge of being torn apart.

There is nothing random about Araki's photographs of women. His models are carefully chosen. They are young, and there is often something extreme about them. The lustfulness of their smiles has a touch of debility, or their glances are cross-eyed, or they remind us of type-cast figures from western and Asian B movies. Some of them represent the Japanese ideal of feminine innocence: expressionless devotion, a perfect hairdo, small, firm breasts. A few are not so young at all, seem somewhat deranged, less spoiled than tormented by luxury.

Another aspect of Araki's considered approach is his selection of shooting locations. Empty streets are relatively rare; we sometimes see hotel rooms, luxurious hotel bathrooms or constantly changing interiors that must belong to apartments somewhere. Some of his photos are done in the studio against a gently modulating non-representational background.

A third aspect is the photographer's use of elaborate detail in dress and props. The latter group includes an entire arsenal of plastic animal models, a signal from nature in the figure of the amorphous. The juxtaposition of the theatrical and the ridiculous appears deliberate. As a result, many of the photos seem plain at first glance but develop a certain eccentric charm in the collage with other images when the gaze returns to them.

Although the biographical trail of Araki's oeuvre has since been lost again, it was still clearly recognizable at the 1992 Graz exhibition entitled *Akt-Tokyo 1971–1991*. The catalogue contains a photo of Nobuyoshi and Yoko Araki as a sad-looking wedding couple in 1971. The few pictures of Yoko are intermingled in the following pages with glaring flash photos of women in Tokyo sex clubs from the mid-eighties, some of them even later. Finally, Yoko is seen standing at the side of a freshly made bed in a hospital room. She is smiling. Only a few days later – January 29th, 1990 – we see her lying in a casket beneath mounds of flowers.

The pictures are dated electronically. An elongated, blackened patch of remaining snow, photographed the day after Yoko's death, becomes a dreadful allegory of mortality. The flash photograph of a naked woman lying on a hotel bed was taken on the day after her funeral. The woman's face is not shown; her legs are spread apart. With her left hand she clutches her completely shaved pubic region, two fingers hooked inside her vagina, the ring-finger extended to her anus, which is positioned precisely in the center of the picture.[2]

This violation of taboo can probably be traced to the work of the Surrealist artist Hans Bellmer, who did a series of pictures featuring proudly presented labia with his girlfriend, the writer Unica Zürn, in 1958. Strangely enough, Bellmer and Zürn produced another motif that reappears in Araki's work, although in considerably more artistic form: the female body in bondage. Bellmer's photos are not portraits but

17

rather studies of bodies bound randomly with packaging tape, from which uncovered areas of flesh bulge as tortured matter – "long folds and impure lips, notched," as Bellmer noted, "previously unseen breasts multiplied, in unspeakable places."[3] Whereas Bellmer fragments the body to create a wild proliferation of flesh, Araki judges his subject on the basis of its exceptional role. Bellmer shows no faces; Araki always reveals complete figures in bondage and emphasizes above all the undisturbed contentment in the faces of a variety of very different women. In many of his bondage scenes, the vulva, if it is shown at all, is adorned with a flower, an obvious juxta-position of lust and ritual.[4]

Bondage scenes. The most astonishing of Araki's motifs, from a western point of view at least, are those scenes of women in bondage – women crouching on reed-covered floors, tied by the hands to the crook of a tree branch or suspended from a ceiling like mobiles of human flesh in sophisticated networks of knotted cords. Dis-played as if for the benefit of guests invited to a bizarre soirée or for a public willing to pay admission for a fleeting moment of sensation, the suspended figures are more obviously what the other women in bondage are, though less obviously, as well: artifice – adept and willing objects of highly skilled masters of ceremonies who exag-gerate rather than illustrate sexual fantasies. Placed within interiors (as in the many photos in which the bondage appears relatively uncomplicated), the bound women strike us as part of an intimate ritual in which the man both places the woman in bondage and liberates her from it. There may indeed be intimacy between the photographer and the woman in bondage, but the imagined constellation of two people alone with each other is fictitious.[5]

One of these staged scenes portrays the – apparent – victim of a ritual rape. This vertical format photo[6] shows a young woman, bound and gagged, in the midst of bushes. Her arms are presumably tied to a tree behind her back. Her schoolgirl's dress has been folded up to her abdomen. Her legs are bound in a bent position and tied like packages in such a way that they are forced to spread. Her plain white panties have been slit open with scissors at the genitals, and the scissors lie, opened, in front of her left foot.

The scene is overstated in every imaginable way. One needn't be an expert in the history of Japanese culture to recognize that no traumatic event has actually taken place here. Araki diminishes dramatic tension in two ways. First, he embellishes the fantasy to the extent that it is exposed as a reference to pornographic pictures (the slit panties, the open scissors). In addition, the women, depending upon the particular scene, succeed through pantomime in achieving a deliberately sought balance between play and non-play. The iconic overstatement is intensified as the scene is emptied of all anecdotal elements.[7]

And this brings us to the core of the dynamics of obscenity, which George Bataille, in his *Histoire de l'Œil,* describes as an anti-religious excess that culminates in insanity. In his analysis of Bataille's work, Roland Barthes isolated the pictorial im-ages of the narrative and discovered that they coexist as in a relationship of mutual substitution (the eye, the sun, the bowl of milk, the testicle, the egg).[8] Rhetorically speaking, the relationship of substitution is known as metonymy; metonymy is related to structure and is entirely compatible with repetition. It may be that the motifs are finite, but in a conceptual sense they are not.

The idea of the dynamics of obscenity is incomprehensible if taken as a sug-gestion that we should picture society along the lines of "Araki – this is the orient!" That is not the point at all.

The real issue involves an obsessive process of forging links, and in photogra-phy, unlike literature, the question arises why women wish to participate as perform-ers in it. As far as bondage itself is concerned – quite apart from the photographic image – it isn't all that puzzling a phenomenon, if one calls to mind tattooed men and pierced women. Why would one choose to turn one's body – instead of shaping it into a symbol of intellectual, psychic, democratic energies – into an object of mythological imagery. A significant aspect of the tradition of tattooing involves men's desire to conserve the image of their subjugation during military service or in prison as an experience of pain and unfulfilled desire: a living threat posed to a citizen-society that has no use for these oppressed spirits. In the West, women have joined in this voiceless-decorative rebellion. The experience of Japanese women who submit to bondage must be quite similar.

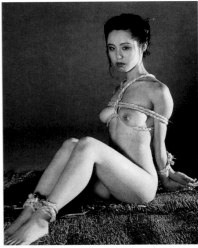

© Nobuyoshi Araki, *Akt-Tokyo 1971 – 1991.*
Graz: Camera Austria, 1992

[3] Hans Bellmer, *Photographien* (Munich: Schirmer/Mosel, 1983).

[4] These are often tiny, sparkling objects. This is important, because a vagina penetrated by an amorphous object signifies the link to fetishism. The frequent emphasis on the idea that Araki offers women in bondage showing clearly visible genitals is misleading: The suggestion of such an "offer" originates with the authors who wish to see things this way.

[5] Jan-Philipp Sendker has described a studio shooting. The model, a 29-year-old woman, was an unmarried saleswoman from the northern Japanese city of Sapporo. She responded to an add in the sado-masochist magazine *Spider* and flew to Tokyo. Helpers in the studio included a stylist, three assistants and the bondage expert; in other words, there were at least seven people on the set, including the photographer and the German reporter. See "Wenn die Lust Fesseln trägt," in *stern,* August 21st, 1997.

[6] Untitled, in *Tokyo Novelle* (Wolfsburg: Kunst-museum Wolfsburg, 1995).

[7] As Thomas E. Schmidt observes: "The women's facial expressions are relaxed, almost dreamy; the impression one has is more suggestive of an auto-erotic act. One might say that the images of bonds are the most extreme form of the definition of an intimate enclosed space." See "Der Kobold in der Manga-Stadt," in *Frankfurter Rundschau,* May 31st, 1997.

[8] Roland Barthes, "La Métaphore de L'Œil," in *Essais critiques* (Paris: Edition du Seuil, 1964).

18

Yet bondage – even when it causes pain – has one advantage over tattooing. It leaves no evidence on the body. The tattoo's counterpart – as a lasting image – is Araki's published photograph. The photographic work of art may indeed hold a greater attraction for women than the monstrous theatrical experience of being tied up expertly by a master of the art of bondage. Every woman who plays a part of Araki's œuvre becomes a substitute for Yoko and is at the same time totally interchangeable with any other image beneath the skies of Tokyo.

Practically no artistic statement can withstand normative questioning. Is it right to do what Araki does? The author of an essay in the catalogue accompanying the temporary exhibition in Vienna expresses the suspicion that western enthusiasm for Araki promotes the restoration of a "notion of the artist which long seemed to be on the way to extinction ..." in support of an "obviously misogynistic practice." An examination of the argumentation reveals, however, that considerable reshaping of the history of western art is necessary in order to find in it the precursor of a Japanese satyr: "The modernist celebration of the liberated (male) individual is thus based on acts of symbolic violence and subordination."[9] However, Manet's *Olympia,* for example, is not meant to suggest that ogling naked women is a privilege that is beyond criticism; what it does tell us is that a society which – for certain reasons – carries its money by the handful to whores and mistresses must be able to look straight into the eyes of these increasingly self-assured women. Back then, in the salons, taking this look was a painful experience.

Satirical reportage. Nobuyoshi Araki's career is also connected to prostitution and its interpretation. This became quite evident last year when a German publisher acquired the rights to a work published in Japan in 1991 under the title *Tokyo Lucky Hole.*[10] Had it appeared in the West ten years earlier, the book would have ruined the photographer's reputation immediately. The German author Elfriede Jelinek succinctly characterized the puzzling phenomenon of the artist's position as "... the call for the article, this loudest but not always laudable cry of the artist ...".[11] The work is a bulky compendium of stories from a journal entitled *Photo Age,* founded by Akira Suei in 1981. The magazine's focus was an incredible boom in the sex-entertainment industry that captured the fancy of many Japanese until their legislature put an end to it in 1985.[12]

Suei and Araki exposed the rugged gaiety of high-speed pleasure in photo-documentaries and staged scenes made to look like photo-documentaries. In Kabuki-cho, a particularly lively red-light district in the Shinjuku quarter, Araki photographed street, bar and sex scenes in highly dramatized detail. We become witnesses to a bizarre scene, devoid of inhibition, in which lusty, still fresh-looking women appear to await the photographer with radiant smiles – nor do their customers mind having the hallway door left open for the photographer's flash while they engage in sex. Araki also took photo still lifes with sobering views of small rooms and compartments, gazed into refrigerators and registered the joyless stickers bearing the whores' portraits.

This amusement business specialized in the immediate realization of a customer's every fantasy. A man is led into a child's room, for example, where he gets a bib hung around his neck and his penis powdered before the predictable part of the program commences. Finally, a ribbon is tied around his flaccid penis – the photographer still on the scene. Another specialty consisted in the separation of desires from the proven techniques of sexual service: the invention of the hands-on peep show, for example; the vagina as a shrine; and more bizarre yet, a system of compartments with holes through which customers could stick their penises and have their lust satisfied by women on the other side of the partition, whose pictures – ostensibly theirs, at least – were hung on the compartment wall.

Araki's photo-documentaries appear very strange in retrospect, because the photographer views the mercilessly regressive male fantasies from the vantage point of the women's world, although he does so only for the sake of his own highly amused involvement. AIDS had not yet arrived in Japan, drugs were nowhere to be seen and pimps appear to have played no role at all. The whole scene has the look of a children's playroom during a pillow fight. The alienation effect, deliberate and forced, turns into satire. Despite their satirical hue, however, these documentaries are fundamentally affirmative.

The focus here is upon a subculture of a society seemingly assured of perpetual prosperity. Araki and Suei use its image to run circles around government censorship.

© Nobuyoshi Araki, *Tokyo Lucky Hole.* Cologne: Benedikt Taschen Verlag, 1997

[9] Christian Kravagna, "Bring on the Little Japanese Girls. Araki in the West," in *Nobuyoshi Araki, 26.9.–6.11.1997* (Vienna: Wiener Secession, 1997; catalogue).

[10] *Tokyo Lucky Hole* (Cologne: Benedikt Taschen Verlag, 1997). The book includes texts by Akihito Yasumi and Akira Suei. There are significant discrepancies between the German, English and French translations of their contributions, however. The publisher's press release at the time of publication read: "This is the first uncensored version of the book."

[11] Elfriede Jelinek, "Clearing the way. Some thoughts about the photographic art of Nobuyoshi Araki," in *Nobuyoshi Araki, 26.9.–6.11.1997* (Vienna: Wiener Secession, 1997; catalogue).

[12] See the essay by Akihito Yasumi in *Tokyo Lucky Hole* (Cologne: Benedikt Taschen Verlag, 1997). The "New Amusement Business Control and Improvement Act," passed on February 13th, 1985, was to have put a stop to escalation in the sex business, but, as Akihito presumes, may also have been designed "to protect the traditional sex industry."

19

They show the casting off of inhibitions as an integral part of the popular culture of their country, in which corporations are constituted like great feudal families and men must join their bosses and down their liquor after work.

In order to understand Araki's role as he moves back and forth between the art and amusement scenes, we must consider that he was not only a satirical reporter for *Photo Age* but a married man as well. Before, during and after the Shinjuku scenes, a diary of a marriage took shape: Yoko in a taxi and in the bathtub, Yoko looking pensive and Yoko reading, in a kimono and wearing an apron, here with an appealing pout, there in lascivious gaiety – a complex character.

Yoko, the third volume of the new, twenty-volume edition of Araki's works, contains a photo of her with her head thrown back wildly in an obvious gesture of total sexual abandon, whatever its source may be. This kind of motif has been recycled with increasing frequency in Araki's sea of images. The portrait of a woman in the throes of ecstasy is often complemented by the pedantically illuminated view of an open vulva. This motif is not taken from Araki's fund of Yoko pictures, however, but from his documentaries on prostitution.

The western world had its own counterpart to Yoko and Nobuyoshi Araki in the husband-and-wife duo of Ilona "Cicciolina" Staller and Jeff Koons. As a visual artist, Koons knew how to make effective use Cicciolina's status as an Italian porno-film star; her genitals were not exactly the classic well-kept secret. Koons showed himself – in silk-screen prints made from unmistakable photographic originals and in glass and plastic sculptures – in the act of having sex with his wife. The marriage failed and was followed by a legal dispute over the custody of their child.

A cat named Chiro is all that remains of the Arakis' life as husband and wife. But Nobuyoshi Araki has transferred the entire sentiment of their marriage, which survived until death parted them, into his photographic oeuvre. And that explains the peculiar mixture of promiscuity and faithfulness, shamelessness and melancholy. Araki's is the work of a widower who cannot stop mourning his wife's death, yet does everything in his power to forget her.

Araki/Goldin. Although there can be no doubt that the Kabukicho scene catered to a heterosexual clientele, the traditional rules of the business were suspended there. Ordinarily, it is accepted as given that men who pay for sex do not want to be photographed while engaging in it. Also at work here is a theatrical exaggeration of perverse constellations featuring pseudo-offices, children's playgrounds and jail cells, mirrors and magnifying glasses. We do not get the impression that men with genuine perversions are offered "anything and everything" they crave, but instead that anything and everything is made available – in theme-park style – because it is so amusing to do something different for a change. Deviance is more a function of money than of desire. The perversions seem more like charades than scenes of true suffering.

This leads to a different view of the matter of roles and props. As in the gay scene, where SS uniforms are readily and consistently recognizable as costume – half theater, half stimulus[13] – the rites of reciprocal exchange are also disguised as unequal in Araki's work. In fact, his women have the same lascivious air, mixed with pride in their being different, as young male hustlers. When more or less conventional middle-class women adopt this posture, even if only partially, it is hard to tell who is who: The boundary between "honorable" and "dishonorable" is no longer there. With respect to Araki's photographs, bondage is part of the disguise. While the women in bondage become links in the metonymic chain, the process of exchange is rendered almost totally inscrutable.

Thus it comes as no surprise that the American photographer Nan Goldin recognized in Araki her oriental counterpart, that she worked with him and helped to promote his success. Like Araki, Goldin also made her own immediate world the subject of her work. She witnessed the rapid growth of bohemian culture in New York during the 1980s – an excess of trash, which she romanticized in her colorful photographs, to include her own blackened eyes. Aside from her macho lovers, she focused her attention on her gay and transvestite friends, many of whom fell victim to AIDS. A sense of mourning in the face of unrecoverable loss links Goldin's work with Araki's, even though the aesthetics gained from the experience are not the same. Many of Goldin's transvestites and transsexuals could not survive outside of the milieu of shows, bars and commercial sex. Both Araki and Goldin leave the shifting back and forth between the milieu and an everyday hedonistic lifestyle unquestioned.

© Nobuyoshi Araki, *Yoko, The Works of Nobuyoshi Araki 3.* Tokyo: Heibonsha Limited, 1996

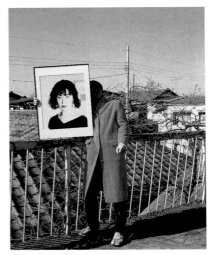

© Nobuyoshi Araki, *Akt-Tokyo 1971–1991.* Graz: Camera Austria, 1992

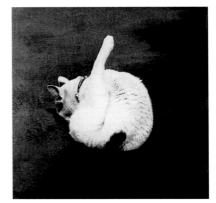

© Nobuyoshi Araki, *Akt-Tokyo 1971–1991.* Graz: Camera Austria, 1992

[13] Carol Lutfy has compared Araki to Robert Mapplethorpe: "Araki pushes the limits of what is legally acceptable, morally palatable and just plain bad taste." See Lutfy, *op. cit.*

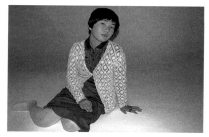

© Nobuyoshi Araki, *Tokyo Love, Nobuyoshi Araki, Nan Goldin.* Tokyo: Ohta Publishing Company, 1994

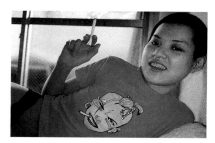

© Nan Goldin, *Tokyo Love, Nobuyoshi Araki, Nan Goldin.* Tokyo: Ohta Publishing Company, 1994

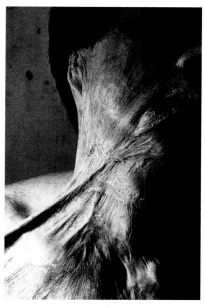

© Shomei Tomatsu, *Japanische Fotografie der 60er Jahre.* Heidelberg: Edition Braus, 1993

[14] Nagisa Oshima, "My Adolescence Began with Defeat," in *Cinema, Censorship, and the State* (Cambridge, Massachusetts/London: The MIT Press, 1992).

In 1994 Nan Goldin worked with Araki in Tokyo taking photos for a book that was later published under the title *Tokyo Love.* Goldin made the rounds of bars and apartments of people from the scene, focusing not so much upon their particular preferences but upon a characteristic defiance in their attitude towards the world: Take pleasure where you find it – no matter how high the stakes. Hectic life in tiny apartments filled to overflowing with peraphernalia appears as the ultimate model of a classless lifestyle far removed from the world of work. Araki saw, of course, what Goldin was doing, and he counteracted her urban-underground odyssey with work that is much more sharply defined than we might expect of him: photos of school girls in both formal and informal dress, posed standing, crouching or sitting in front of candy-colored studio backgrounds and photographed – each individually – with a flash and in color. Their awkward poses are the real theme of these pictures. Araki's meticulous but rude technique does not exactly emphasize their sunny sides.

It is astonishing to see that Goldin, whose poetics are oriented towards defeat and destruction, ultimately finds refuge in idyll. Next to Araki's, her work looks naive. Yet at the moment in which he is forced to take a position relative to the western photographer Araki does not expose the vitality of his concerns but instead emphasizes the recalcitrant nature of his view. He has little in common with the stereotyped image of the gallant.

The returning memory. Film director Nagisa Oshima refers to August 15th, 1945, the day the Emperor of Japan surrendered in a radio address, ending World War II, as "the day I learned that there was nothing of which one could say that it could never happen."[14]

Araki was five years old when his native Tokyo was almost totally destroyed by allied bombs. As a twenty-year-old college student of photography and film he witnessed the first great wave of grass-roots political resistance that overtook Japan in 1960 – well in advance of the first rebellions of Blacks in Alabama.

Nobuyoshi Araki, or so it would appear at first glance, is not greatly affected by this memory, which continues to haunt Japan to this day, not least of all because the question of war guilt has been left unsettled for decades. Yet we do find subtle signs of a concern with the memory in Araki's work. Some of the electronic dates on his negatives have been set to the 6th or the 9th of August, the dates of the nuclear attacks on Hiroshima and Nagasaki; others bear the date August 15th – the day of Japan's surrender.

The theme appears once again in Araki's recent work. It includes images from a film made by Araki many years ago but stored improperly during the intervening years. Little is left of the motifs themselves, just enough to reveal that the film is not a cinema production but a collection of scenes of everyday life and holiday celebrations. The modes of dress and models of cars recognizable in the stills suggest that the film must have been made about 1970. The perforations are meant to allude to their movie origins – in fact, however, they are the product of a photographic intervention, since the perforations do not appear on the left and right but instead frame the pictures on the top and bottom. Thus Araki has deliberately appropriated his own photos – much in the same way that Richard Prince takes details from advertising.

While some of the images are almost totally black and others are merely spotted, most of them have an apocalyptic look: Acid, fire and ice sweep through the streets, bashing holes in faces and bodies. It is impossible to avoid thinking of Shomei Tomatsu's pictures from his series "11:02 Nagasaki," studies of burned skin and grotesquely deformed objects (1966). A recently published Araki book containing hundreds of film stills bears the title *Lost Reality. Remembrance of Things Past.*

Araki has never really been a straight photographer. His techniques include the manual manipulation of photographs – collaging, etching and watercoloring. These photos undermine the suggestion of documentary photography (the edition of Araki's works is full of such playful tricks). Yet all of his motifs are substitutes for one another. All of them have their place as links in the metonymic chain: sky, Chiro, women in bondage, street, vulva. Even the brightly colored blossoms on view here belong to it as well. As we view the flowers and film stills in combination, we realize that the devastated stills put a damper on the substitution game. They stand apart from the metonymy. What we see here is amazingly aggressive work on the image of Tokyo.

21

No stylist. In an informal interview, Nan Goldin asked Araki about his sources and his ambitions. The photographer's answers reveal that he associates photography with a specific pattern of production and distribution. Of Cindy Sherman he says: "I like Cindy Sherman's things – they are not all that far from photography," an astonishing statement in view of the fact that Sherman exhibits only pictures composed of photographic materials. Araki suggests that "photos should be taken quickly and published. The medium is not the kind in which one has to think everything through and work it out perfectly." Thus photography stands for momentary experience that is shared with the public immediately. Apparently, the mechanics of looking and the productive power of the camera count for more than the outcome: "I like photography, and that's why I also like all photographers, even when they are bad or don't appeal to me."[15]

We realize, to our surprise, that Nobuyoshi Araki does not actually follow the recently established approach to the marketing of photographs. He neither dates his prints nor limits them in number; and he allows photographs of different sizes to be offered at the same price. Whereas Europeans and Americans expect the photographer, as an artist, to be involved in every detail of darkroom work, framing and, if possible, even the hanging of photographs, Araki is content with a rough idea. He supplies entire exhibitions on order.

This does not mean that Araki is unfamiliar with the most significant positions in international photography. During the sixties, while still employed by Dentsu, a major advertising agency, he saw photographs by many of the most influential western photographers. His feeling for articulate façades is reminiscent of Eugène Atget. He learned to pay tribute to commercial *tristesse* from Walker Evans. He shares Ed van der Elsken's urban melancholy. From William Klein Araki borrowed techniques of scattering people in urban space and capturing the psychological configurations that emerge.

It goes without saying that Araki is familiar with Japanese *auteurs* photography of the sixties, whichs brusquely abandonned reportage in favor of a subjective approach: the insistence upon the ritual of visual probing, close-up, often on the threshold of pain. From 1974 to 1976 Araki was involved in a photo workshop with several of these authors – including Eikoh Hosoe and (the above-mentioned) Shomei Tomatsu, both noteworthy figures in Japanese photography. Araki was its youngest member.

Given Araki's extensive knowledge and connections, we are astonished to see how little heed he has paid to established styles. Unlike William Klein in the West and Eikoh Hosoe in the East, Araki is not a stylist at all. He applies his photographic experiences to his subjects as if they were techniques. What he has adopted from his immediate predecessors is the overlapping of fact and fiction. And in order to ensure that everyone notices, he furnishes his scenes with artificial flies and dinosaurs or live and dried lizards.

Although Araki is indeed no stylist, he serves nevertheless as the flag-bearer for a very specific aesthetic code. And this quite naturally fits the cliché associated with the western image of Japan: the idea that Japan invents nothing but still does everything better than anyone else. And in this sense it is only logical for the photographer to neglect the West and glorify Tokyo. He has cultivated a Japanese slang full of expressions regarded by blushing translators as "untranslatable."[16] And he also fits in well with the western cliché of the Japanese, constantly clicking a camera shutter. Like so many other confusing signals received before his time and from his own surroundings, Nobuyoshi Araki also nourishes the suspicion that the Japanese are difficult to comprehend – and most of all that they might no longer completely understand themselves.

22

[15] The following remark of Araki's is in keeping with this view: "There is at least one great photo book in every household: the family photo album." See Lutfy, *op. cit.*

[16] Nan Goldin writes: "It's said that no one can really translate Araki because he speaks in puns and jokes. Most Japanese women are too shy to translate his endless sexual allusions, so when the women in his entourage blushed furiously, I'd say, 'Is he talking about his penis again?'" See Nan Goldin, "Naked City. Interview with Nobuyoshi Araki," in *Nobuyoshi Araki, Diane Arbus, Nan Goldin* (Munich: Sammlung Goetz, 1997; exhibition catalogue).

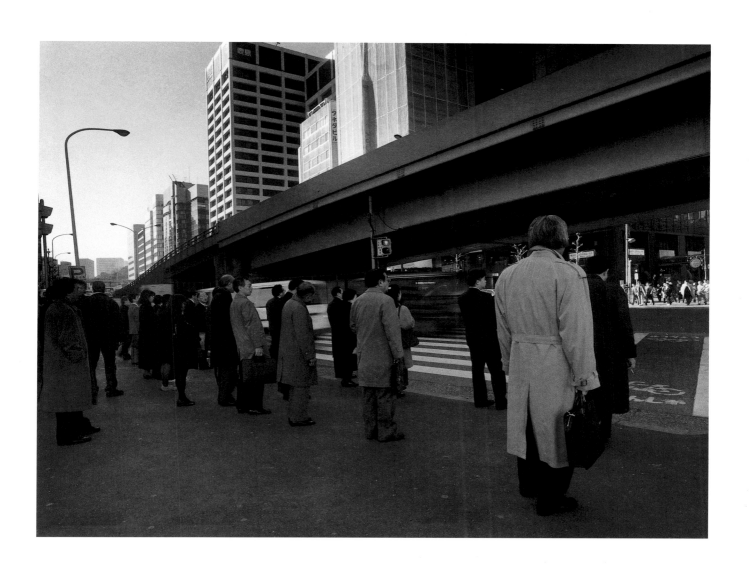

TOKYO – MARKT DER GEFÜHLE

東京死情

Tokyo – Shijyo

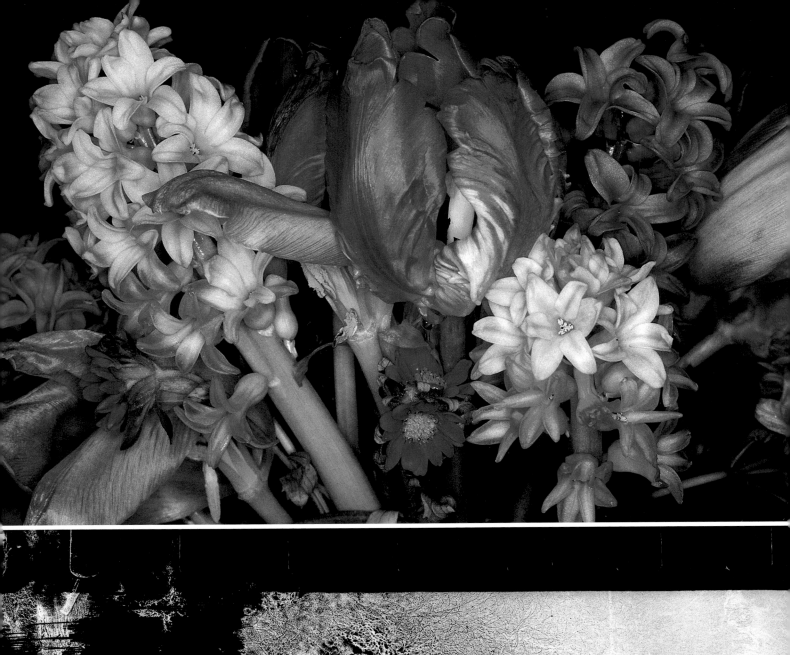

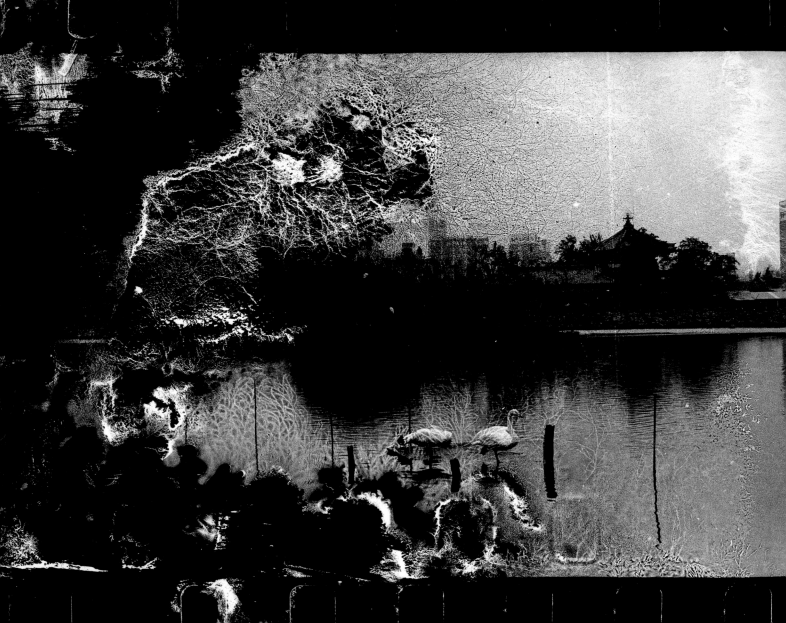

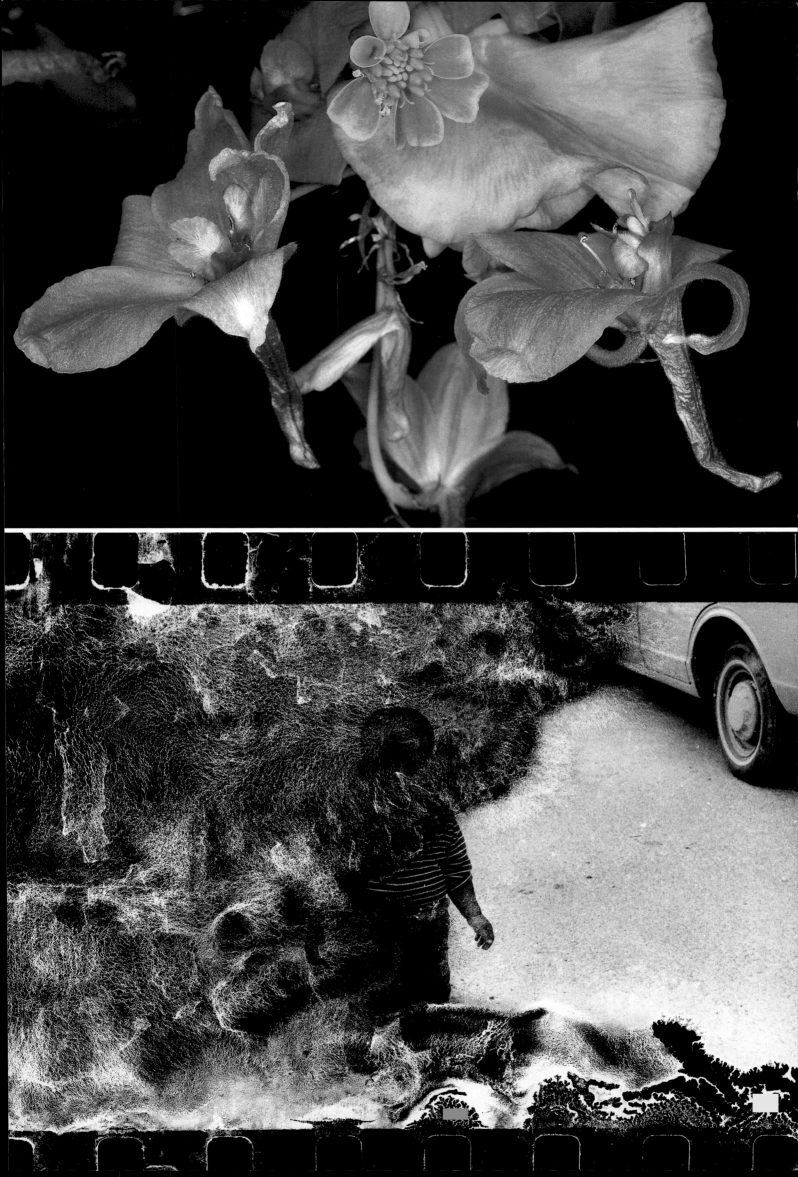

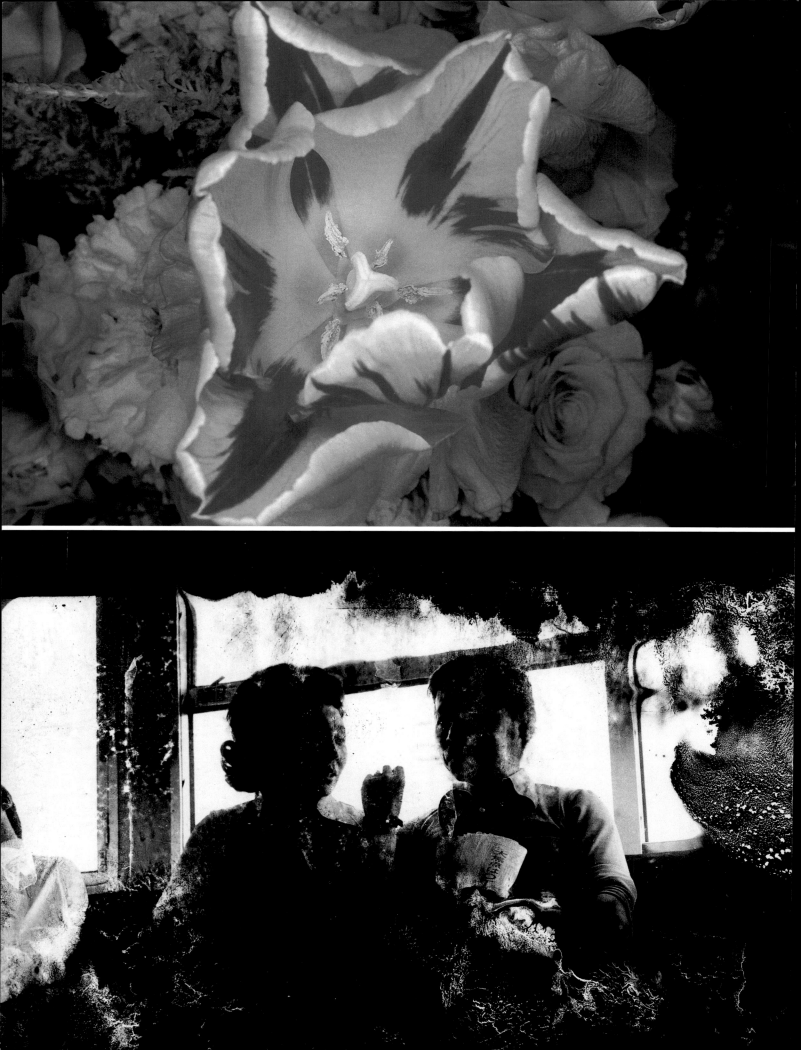

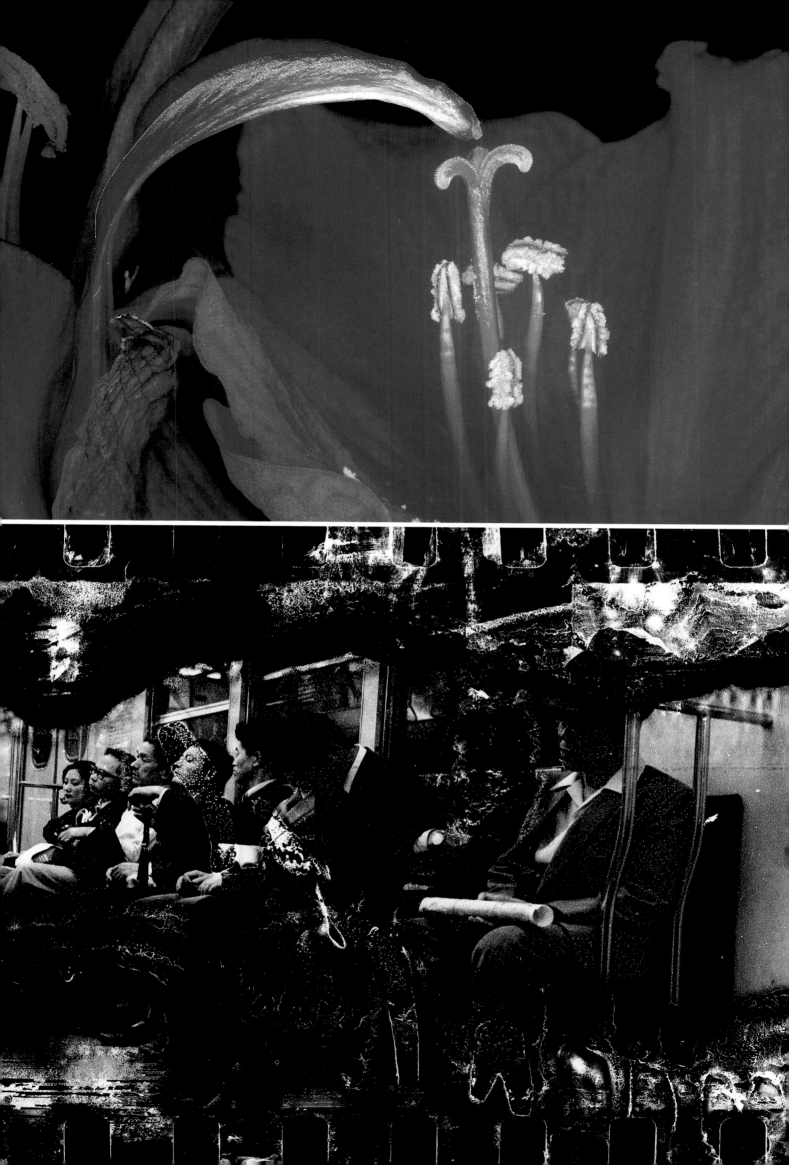

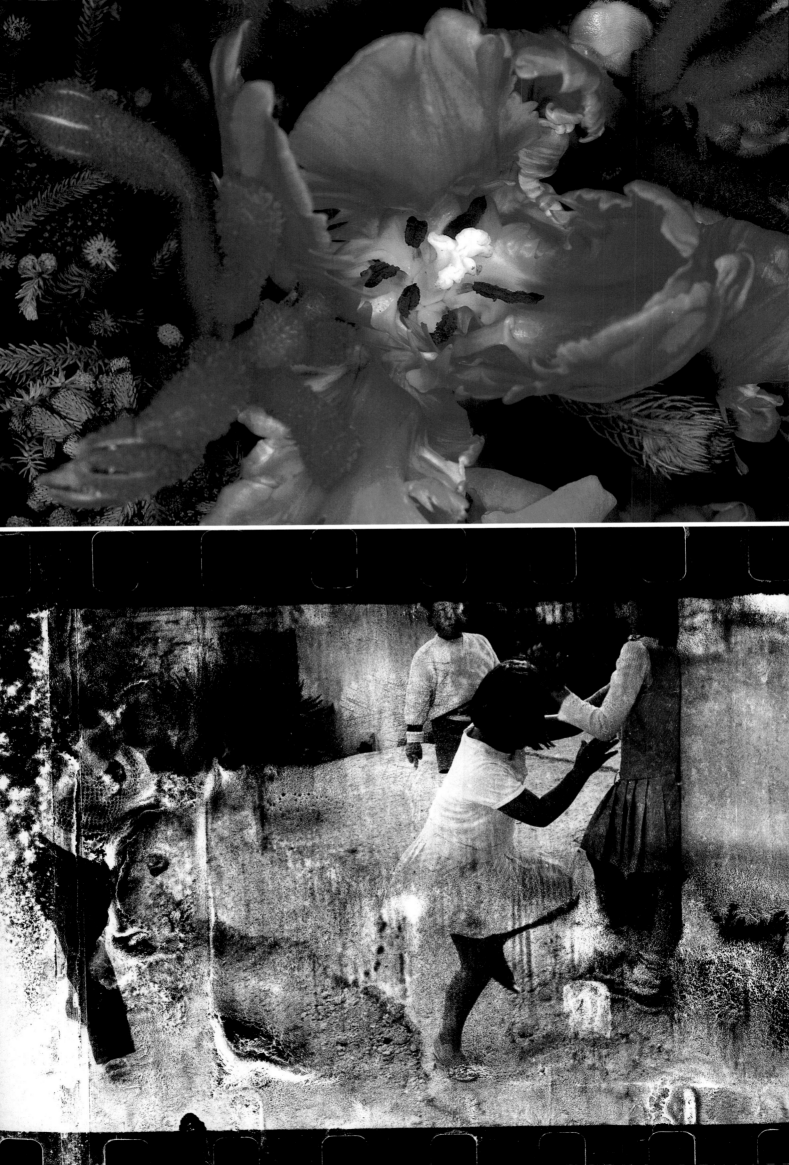

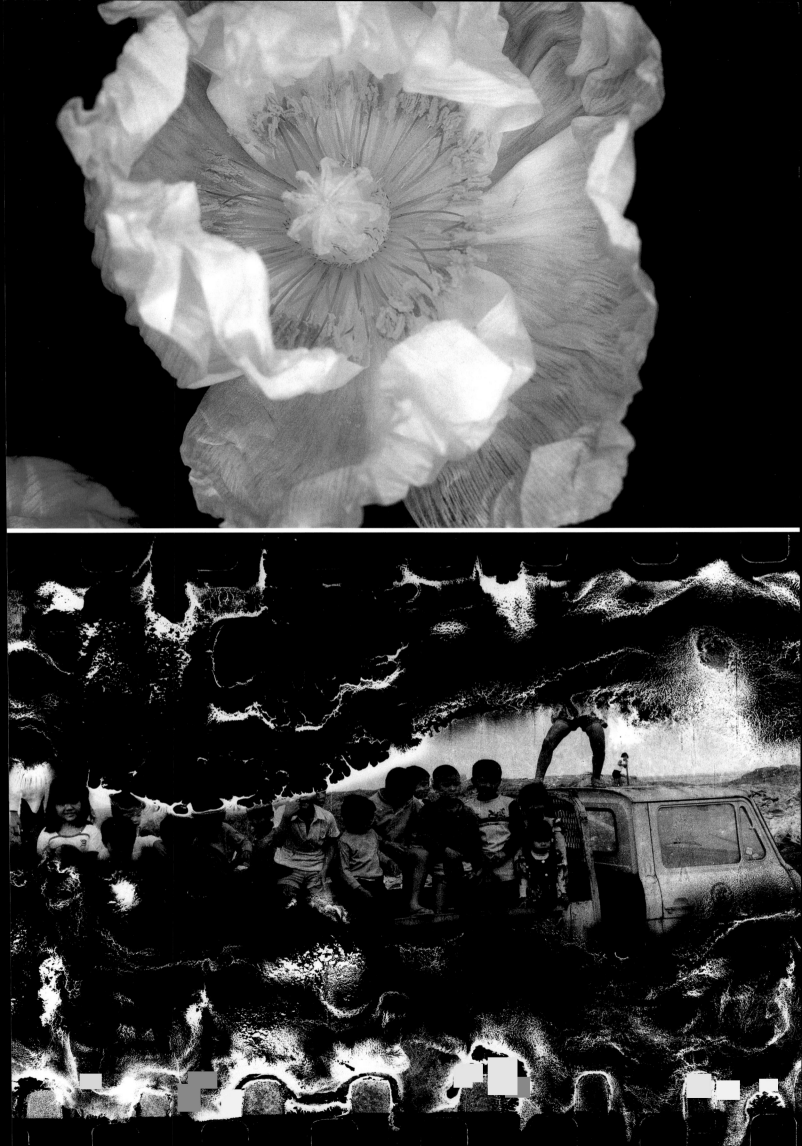

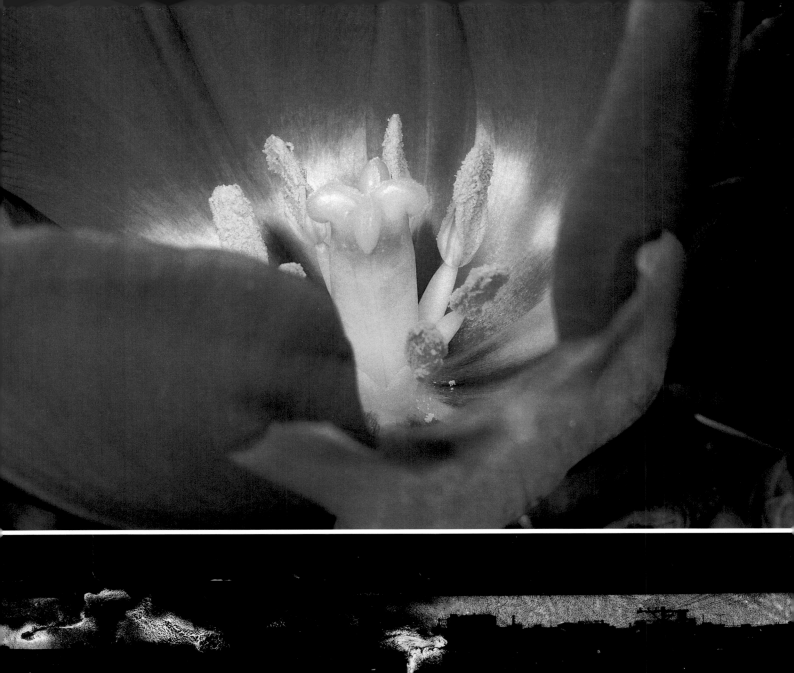
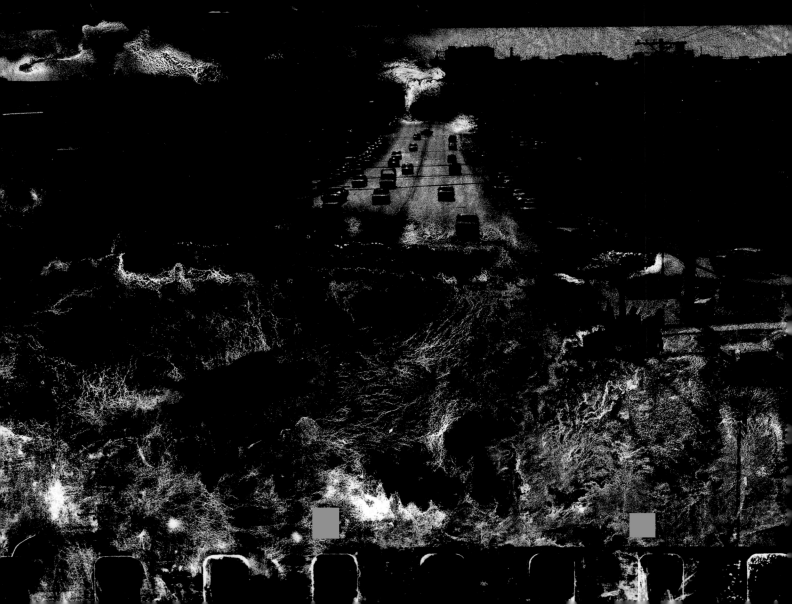

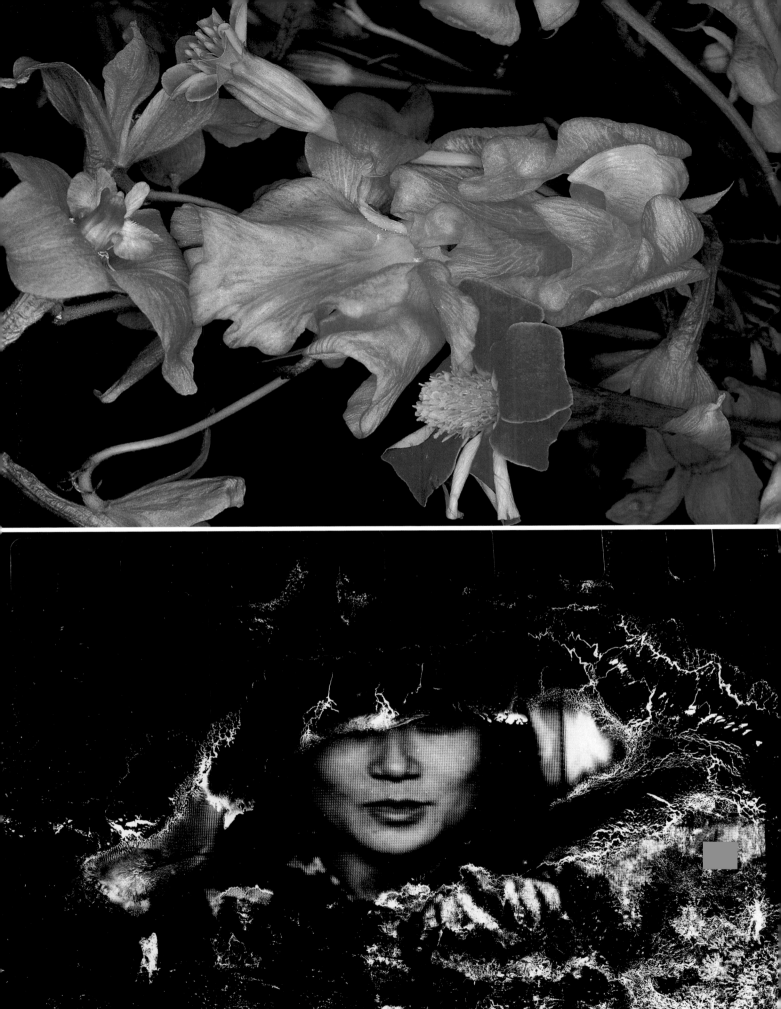

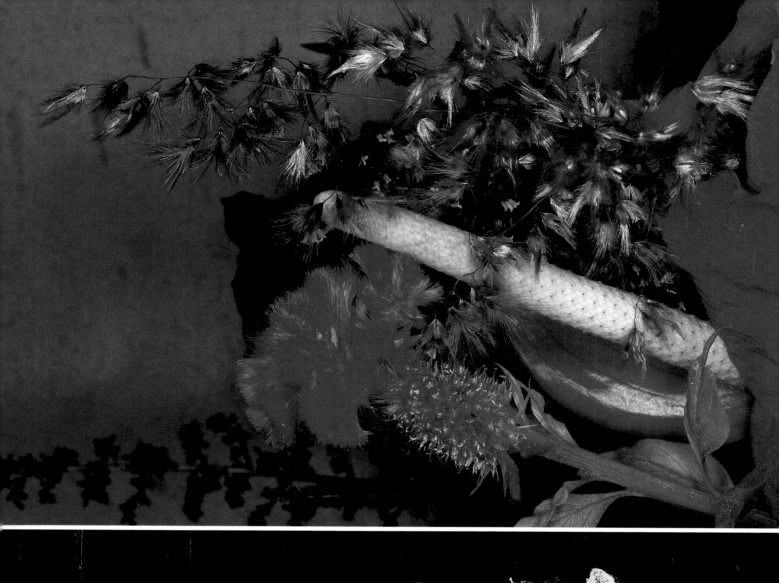
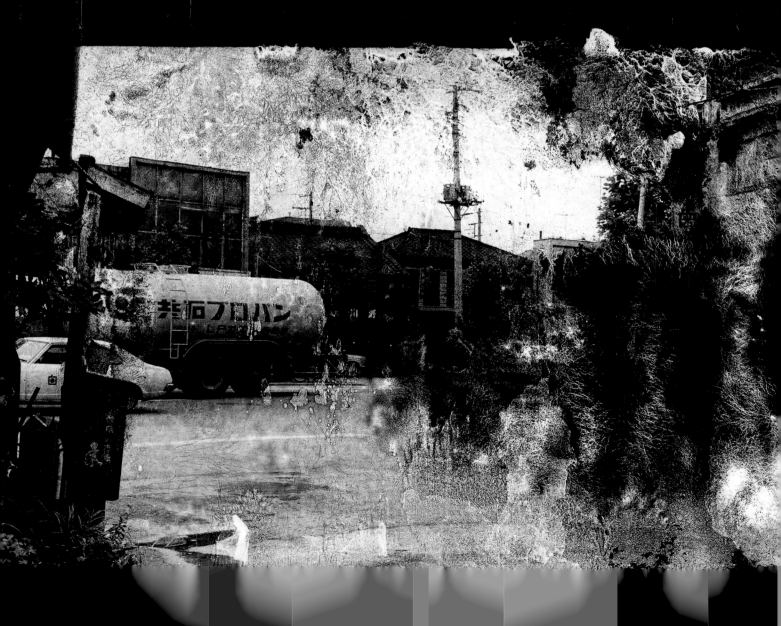

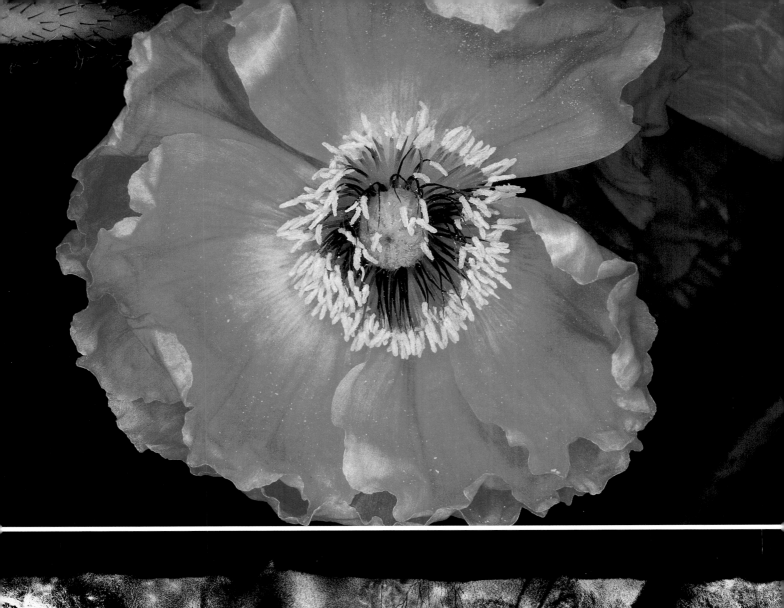
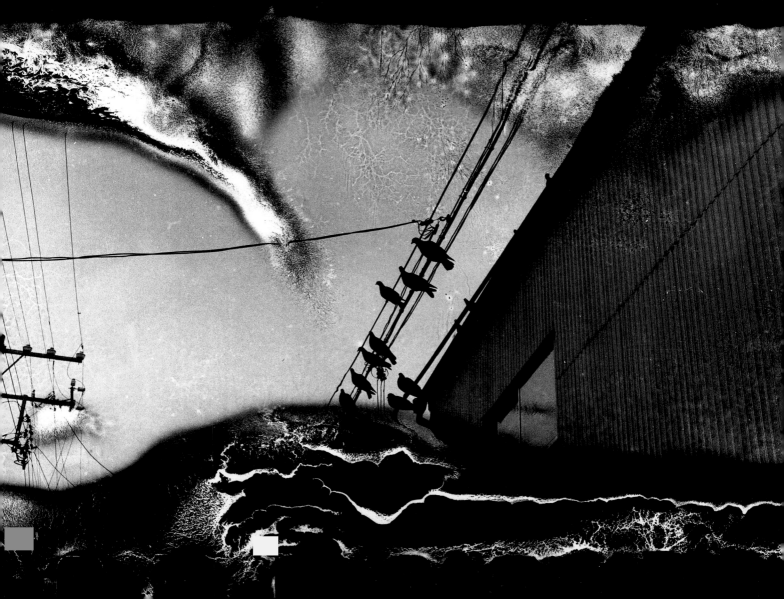

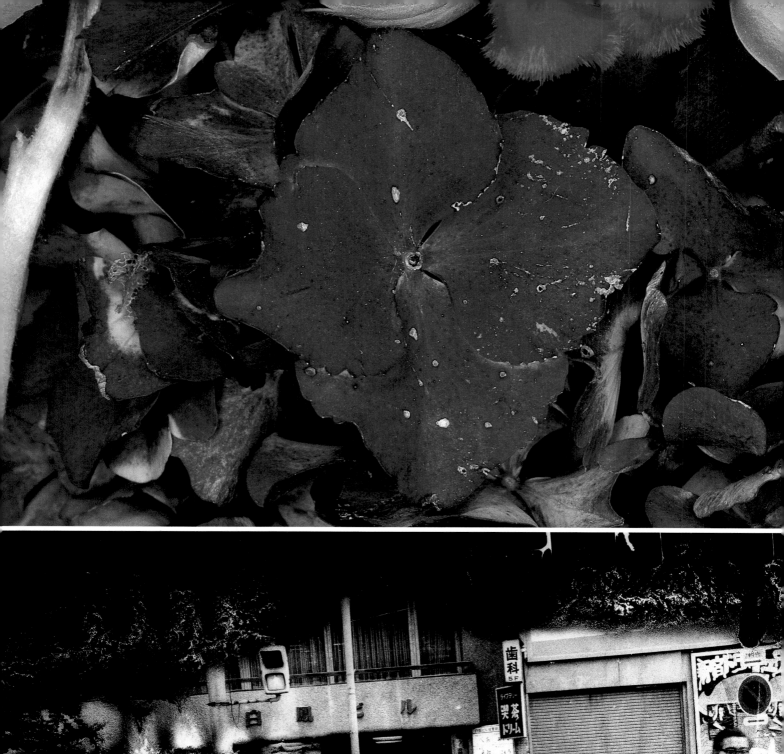
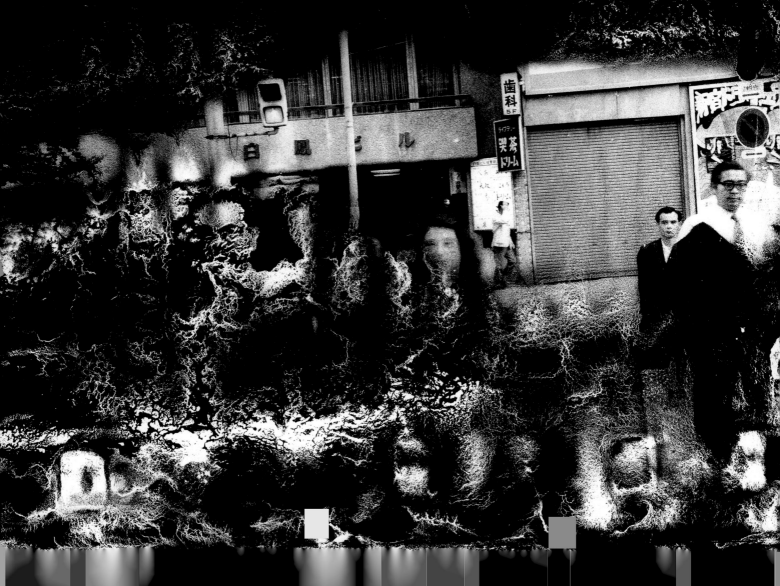

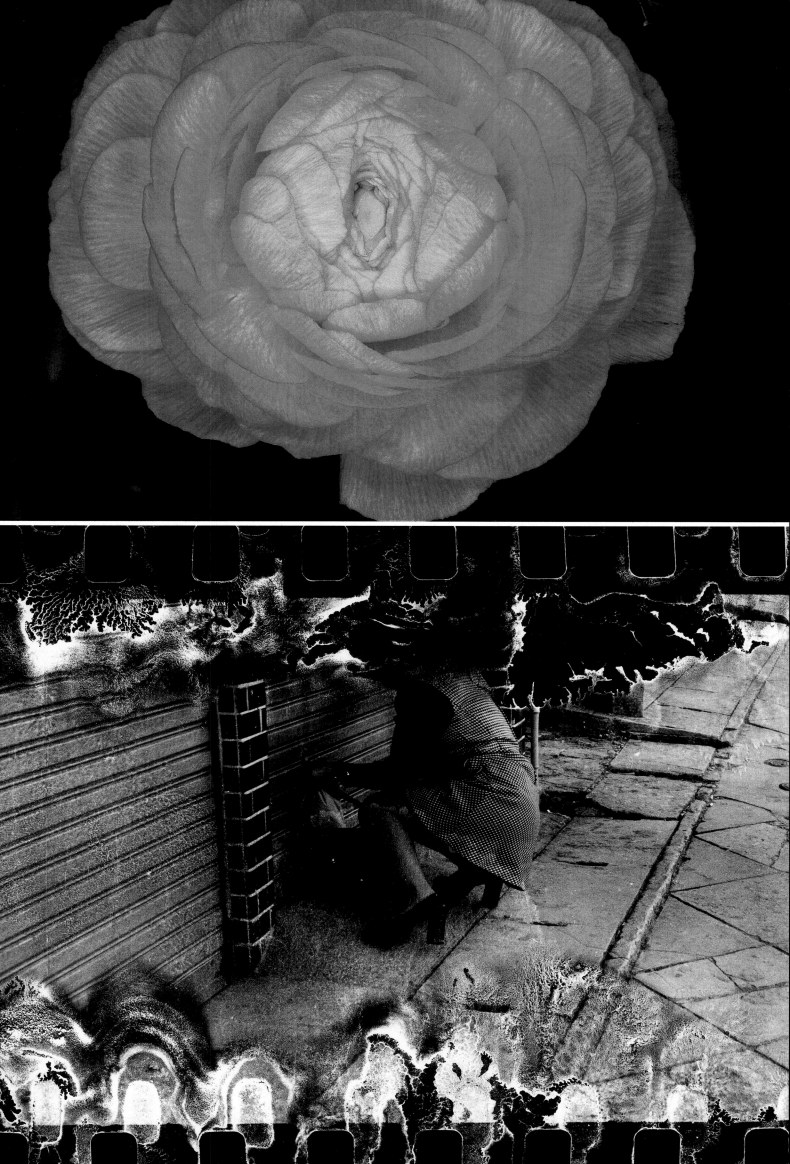

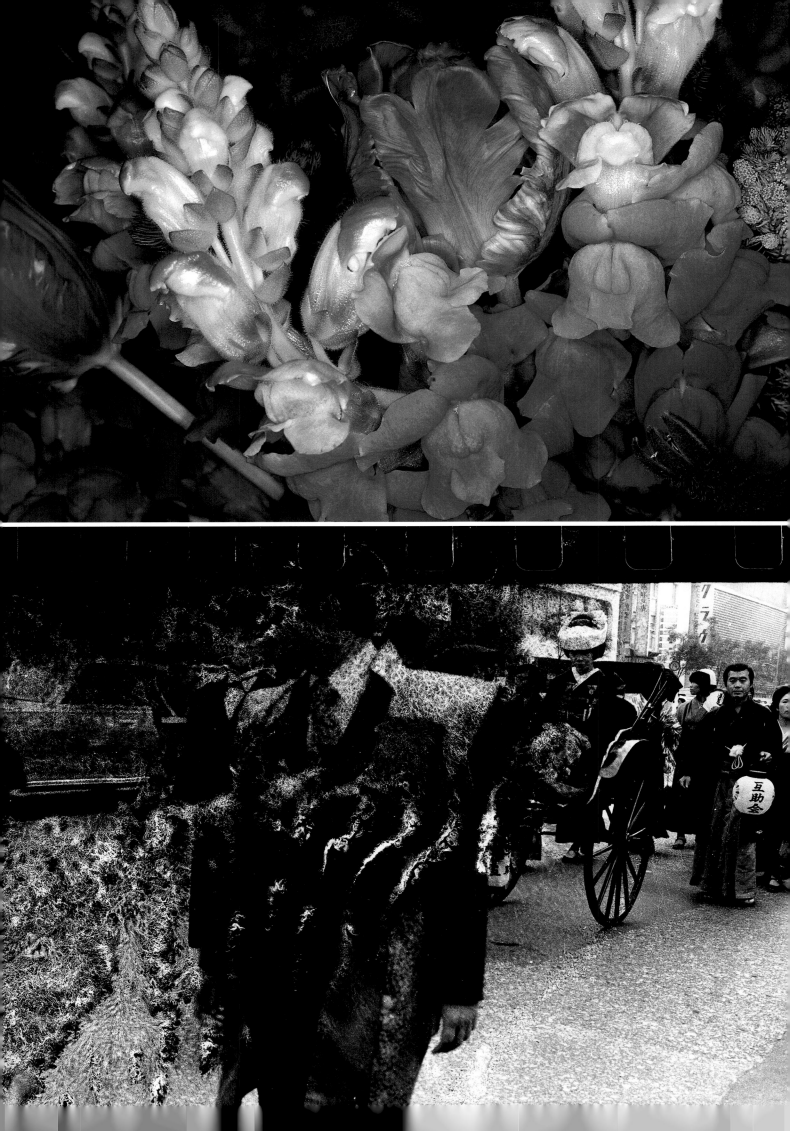

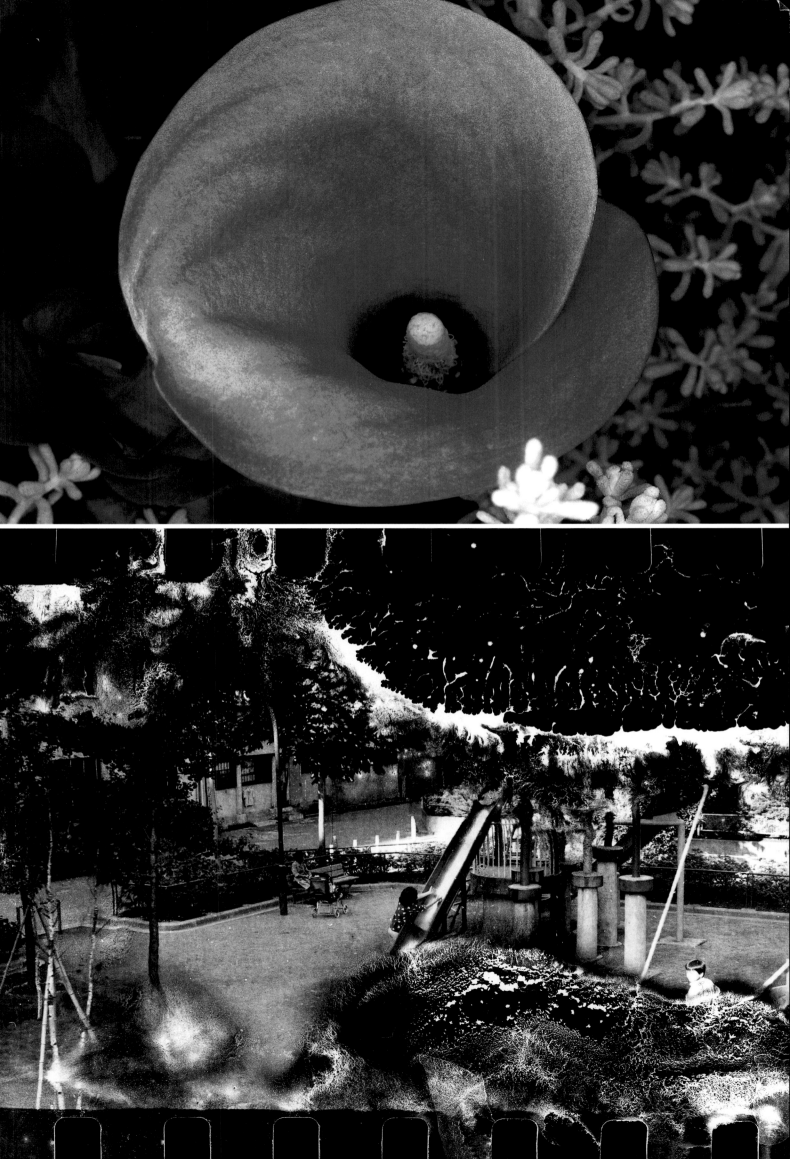

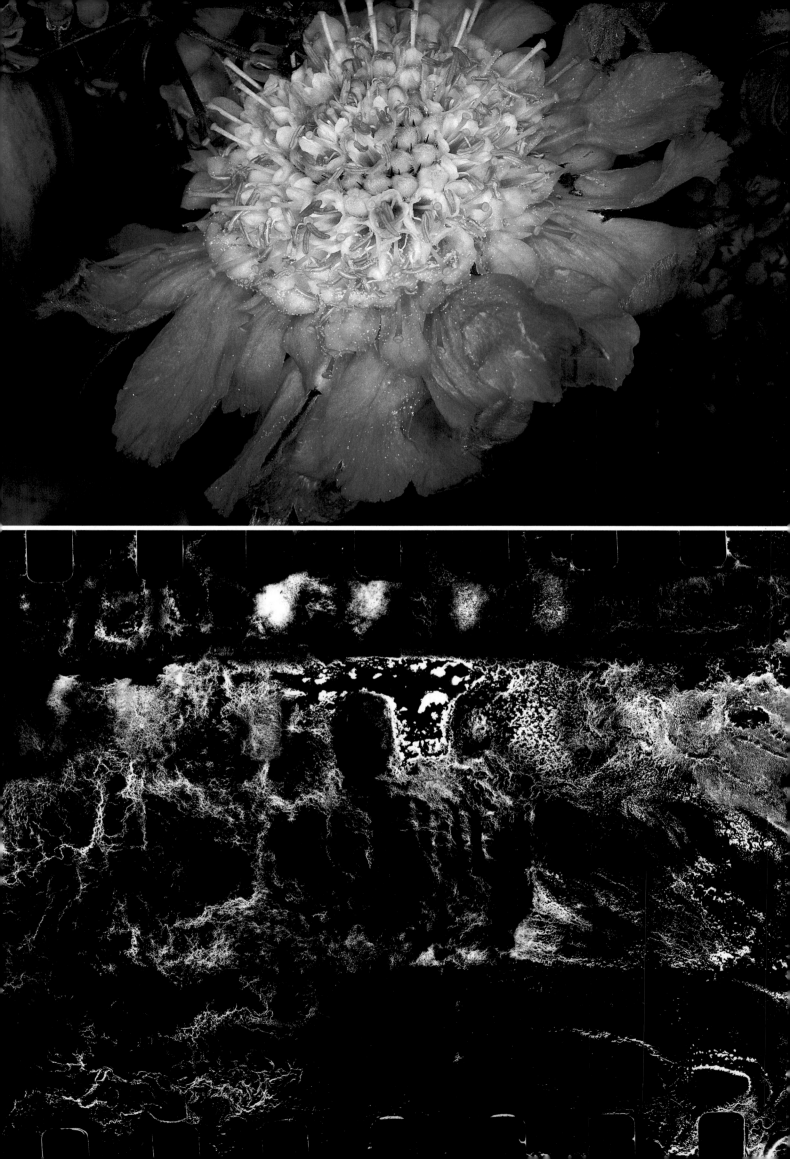

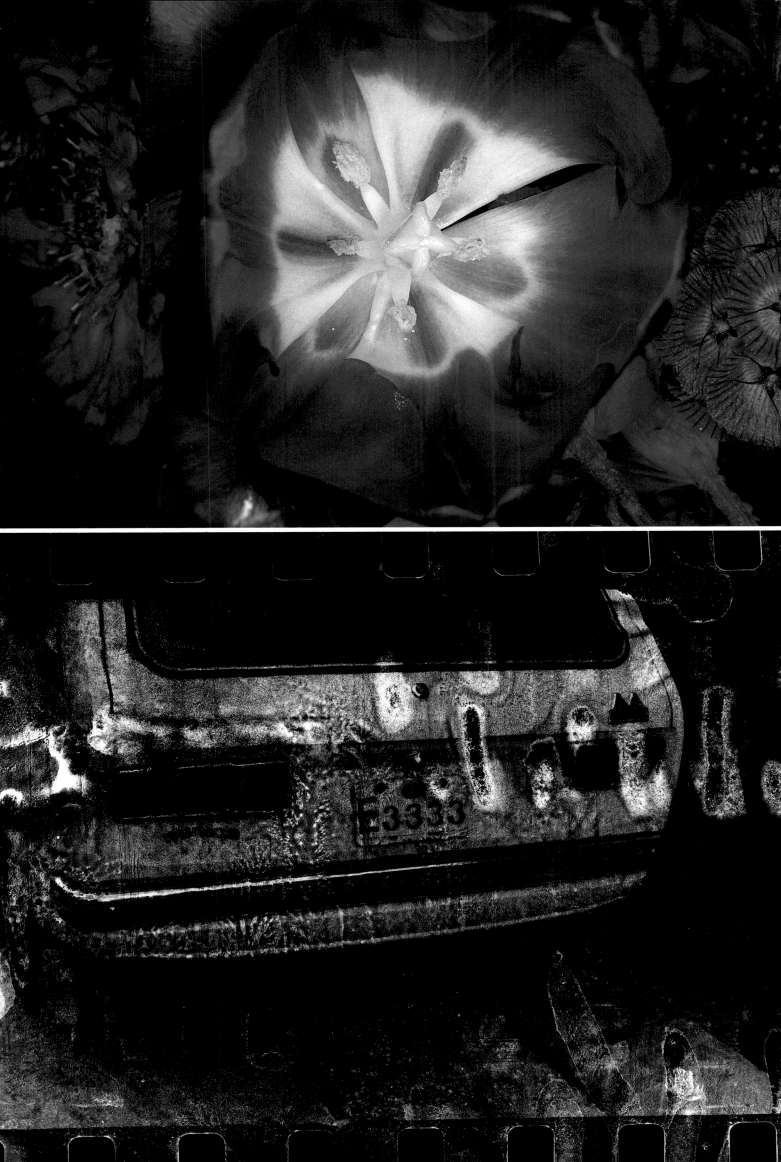

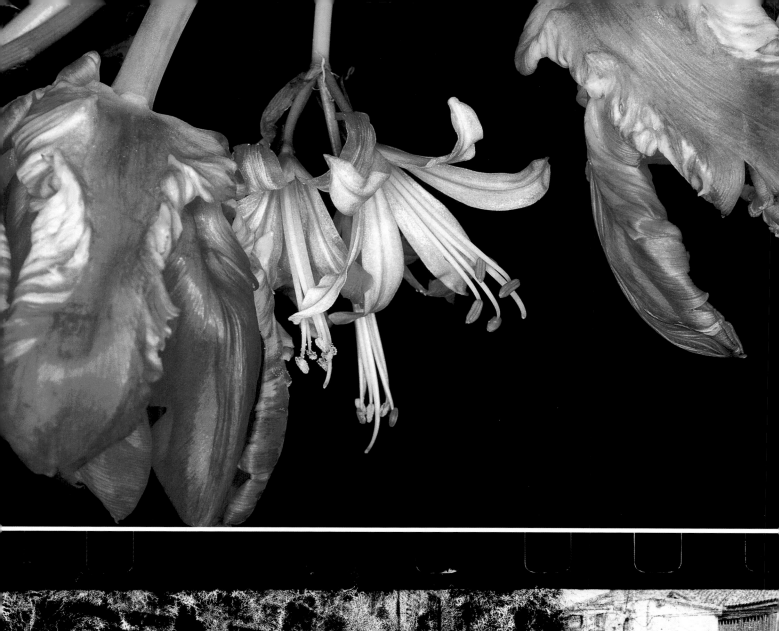
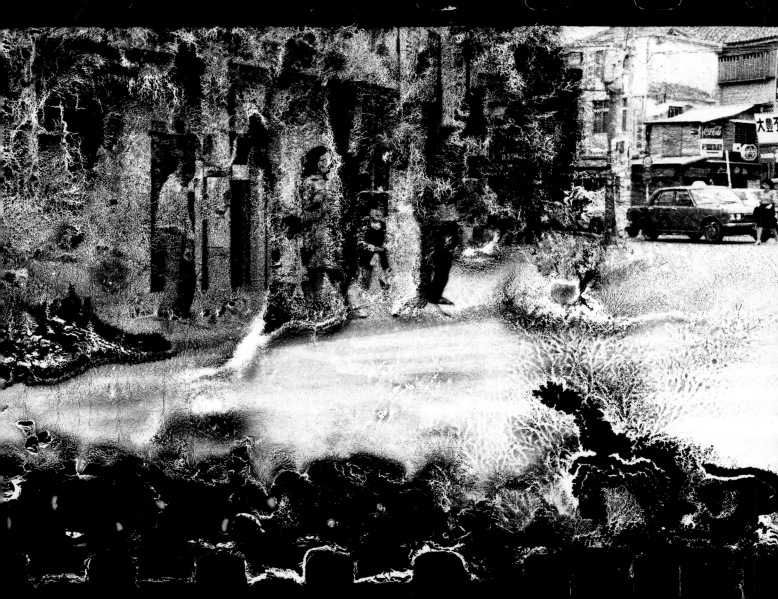

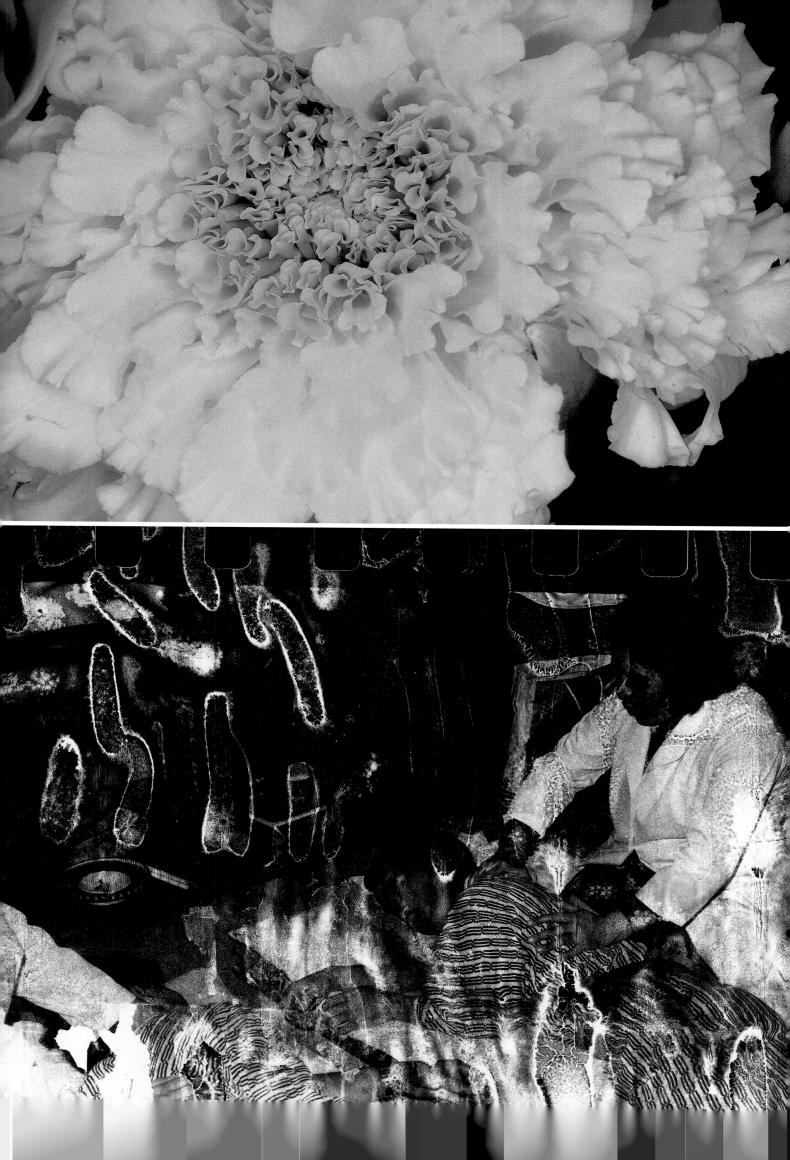

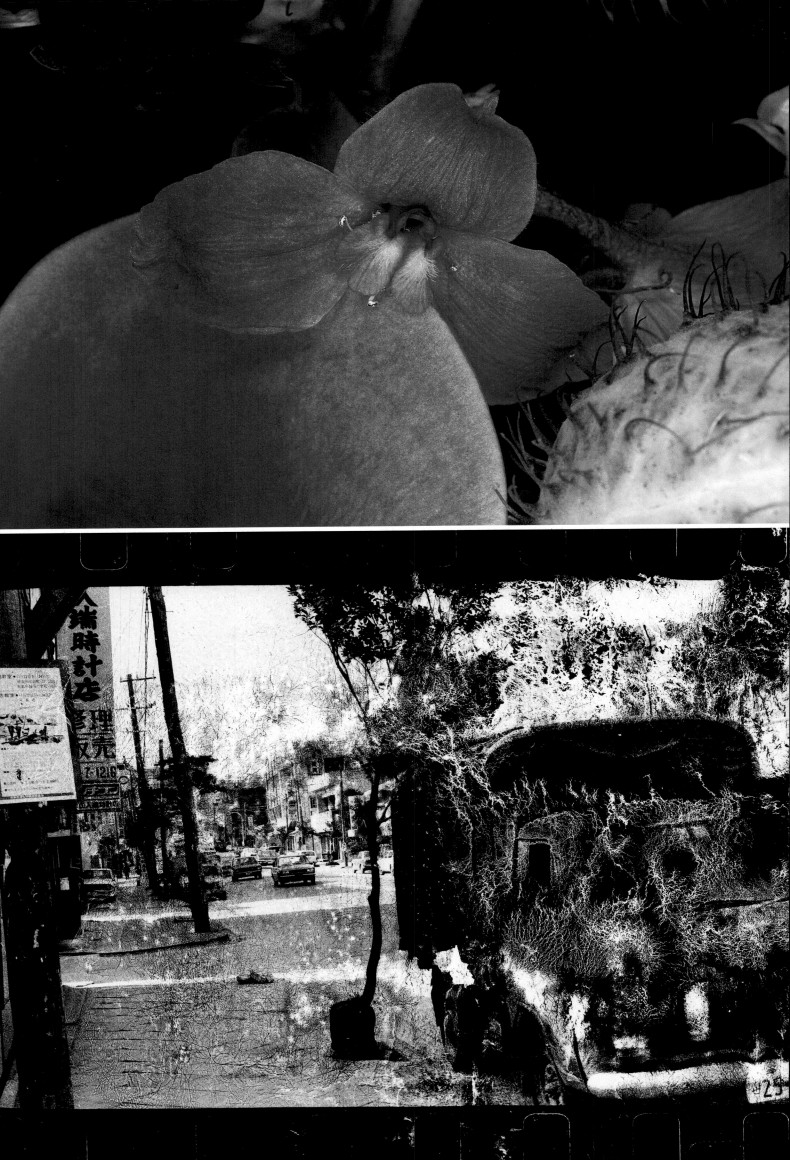

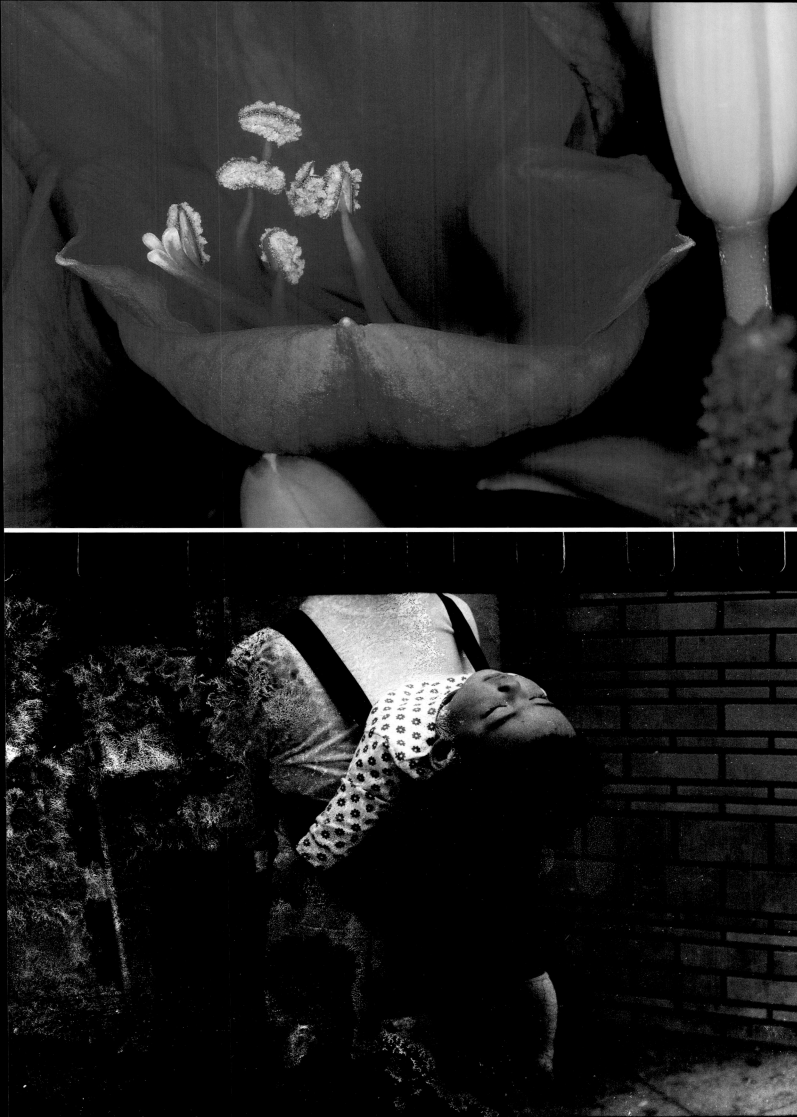

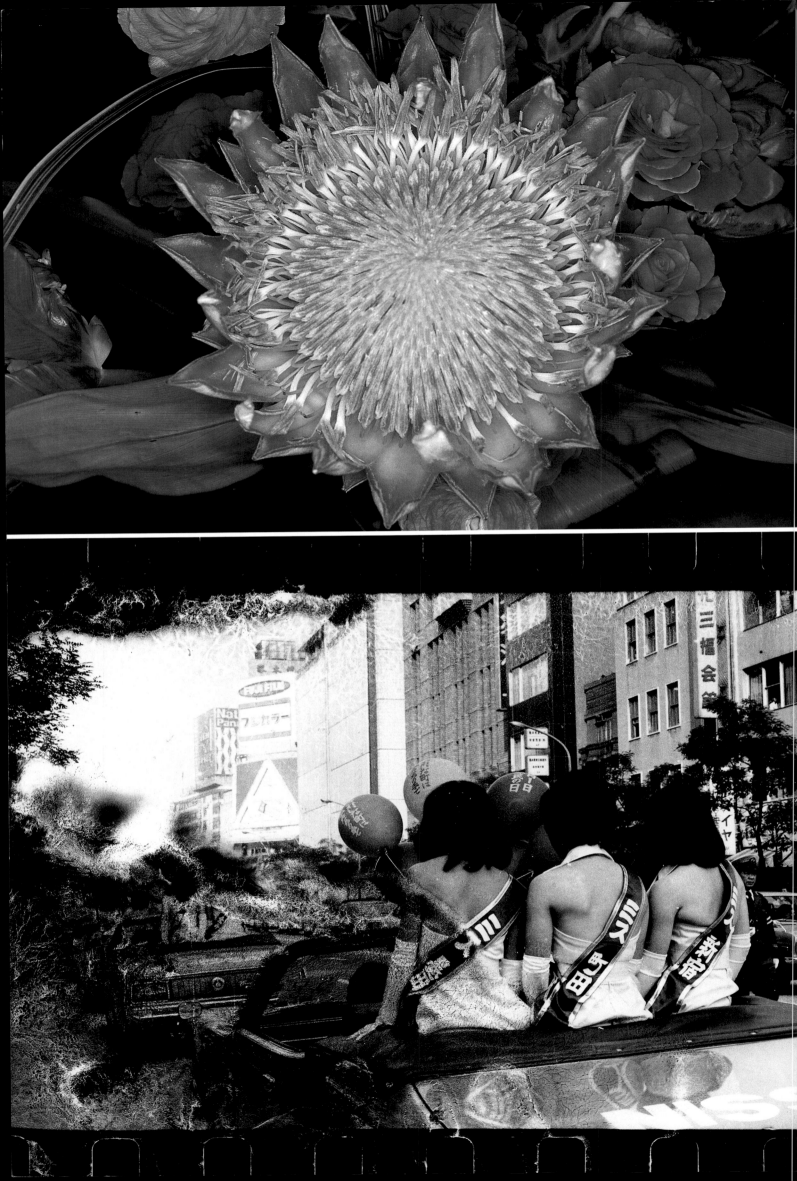

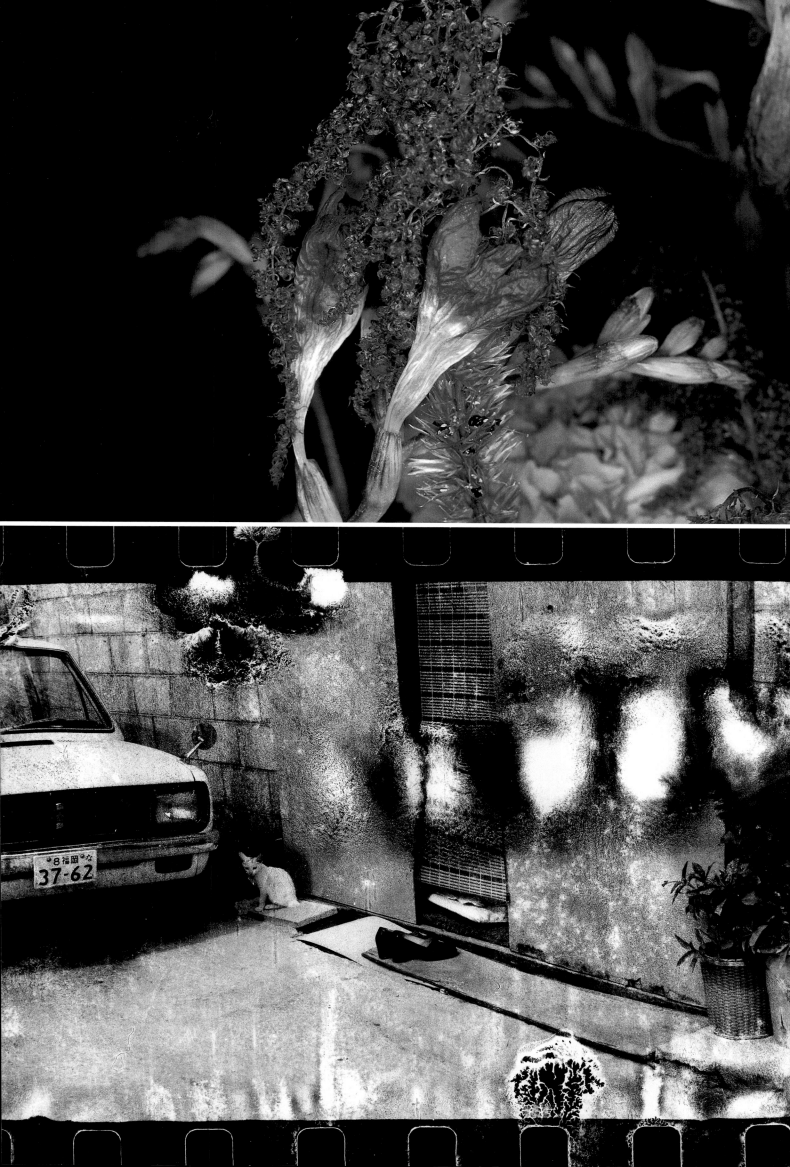

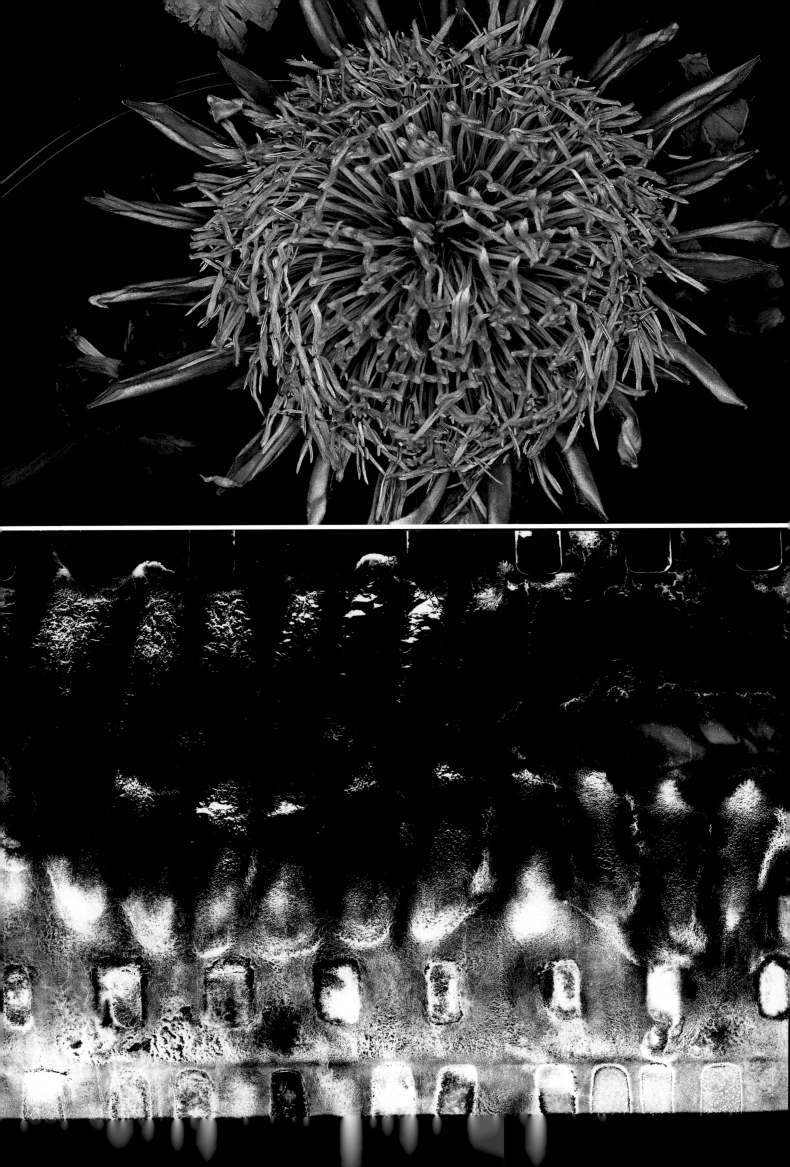

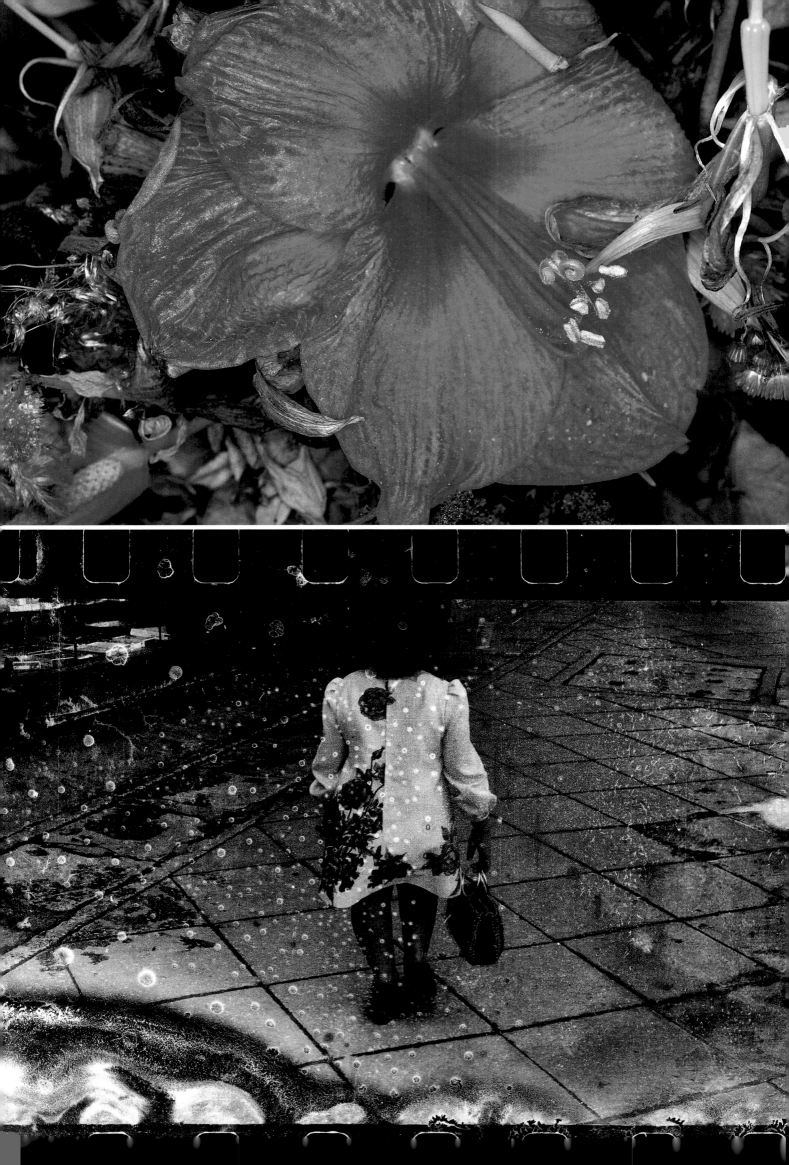

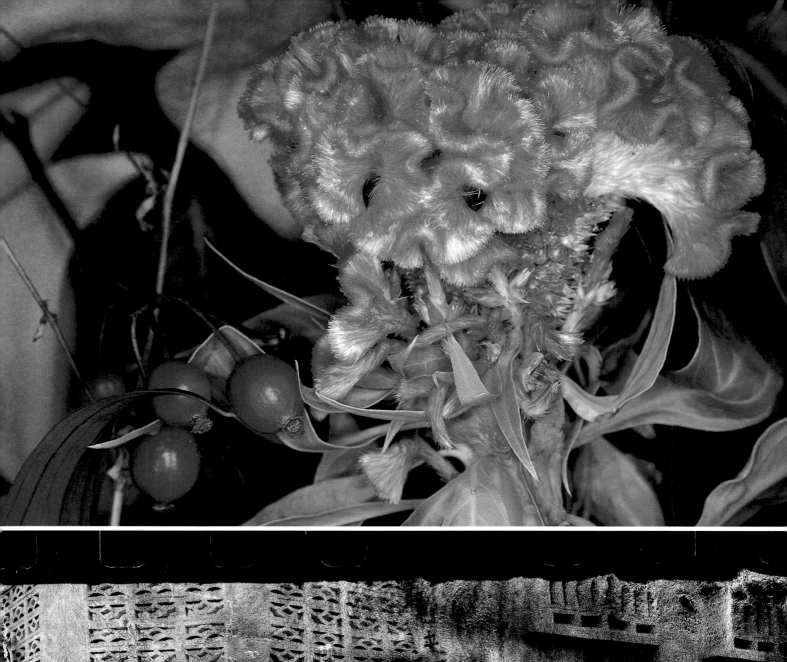

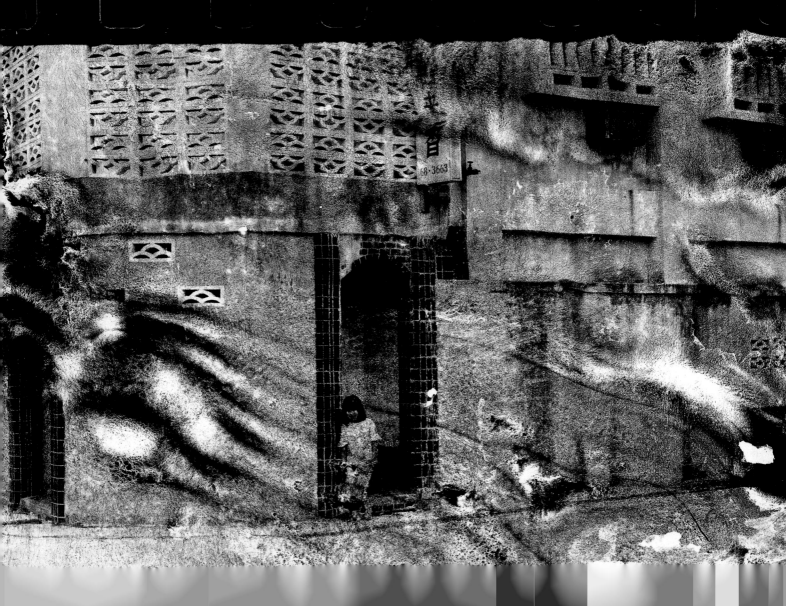

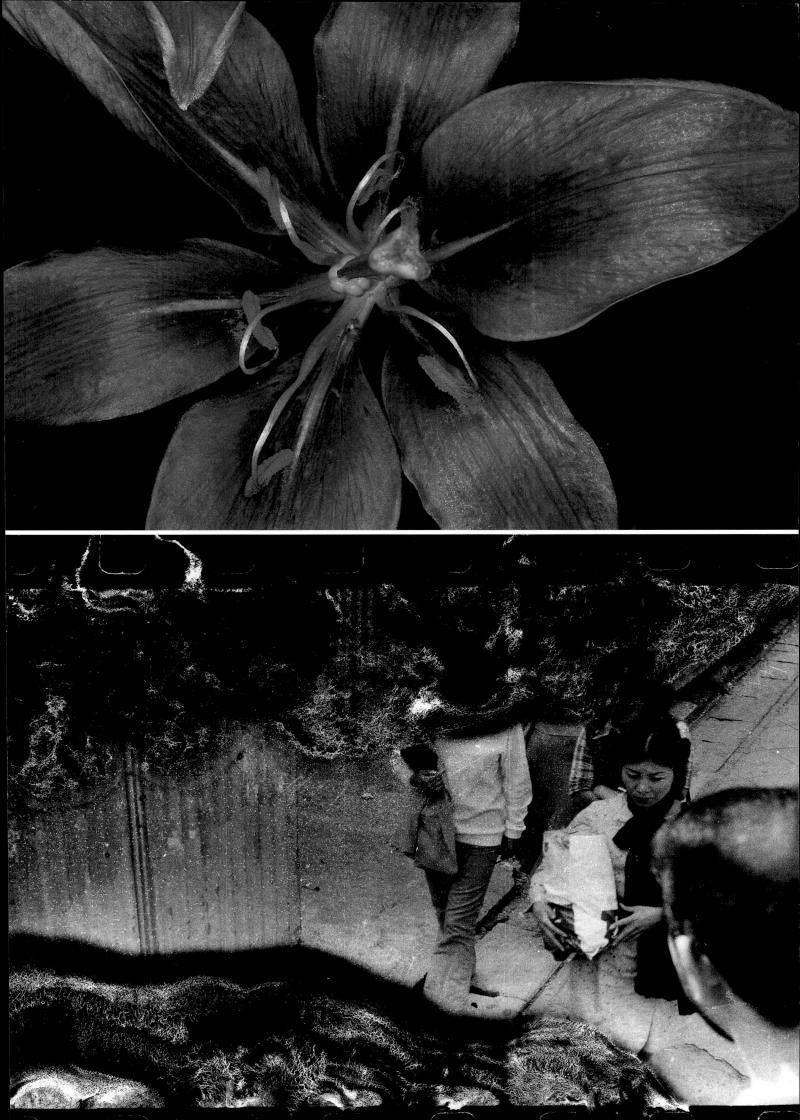

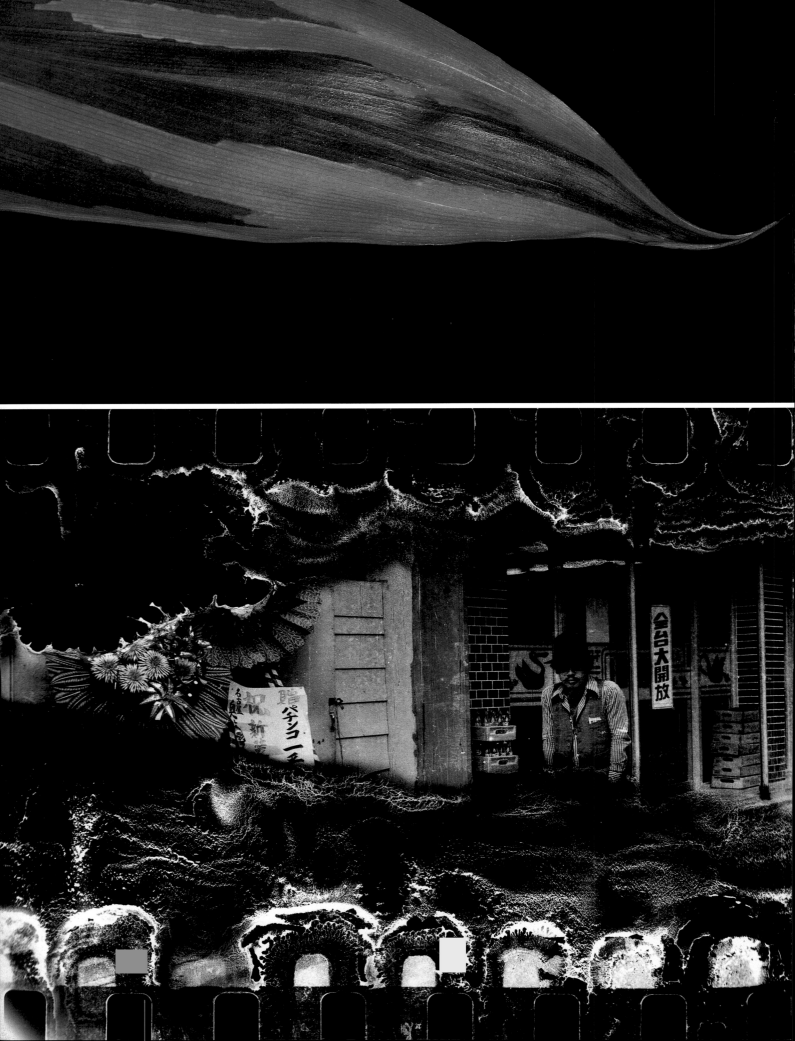

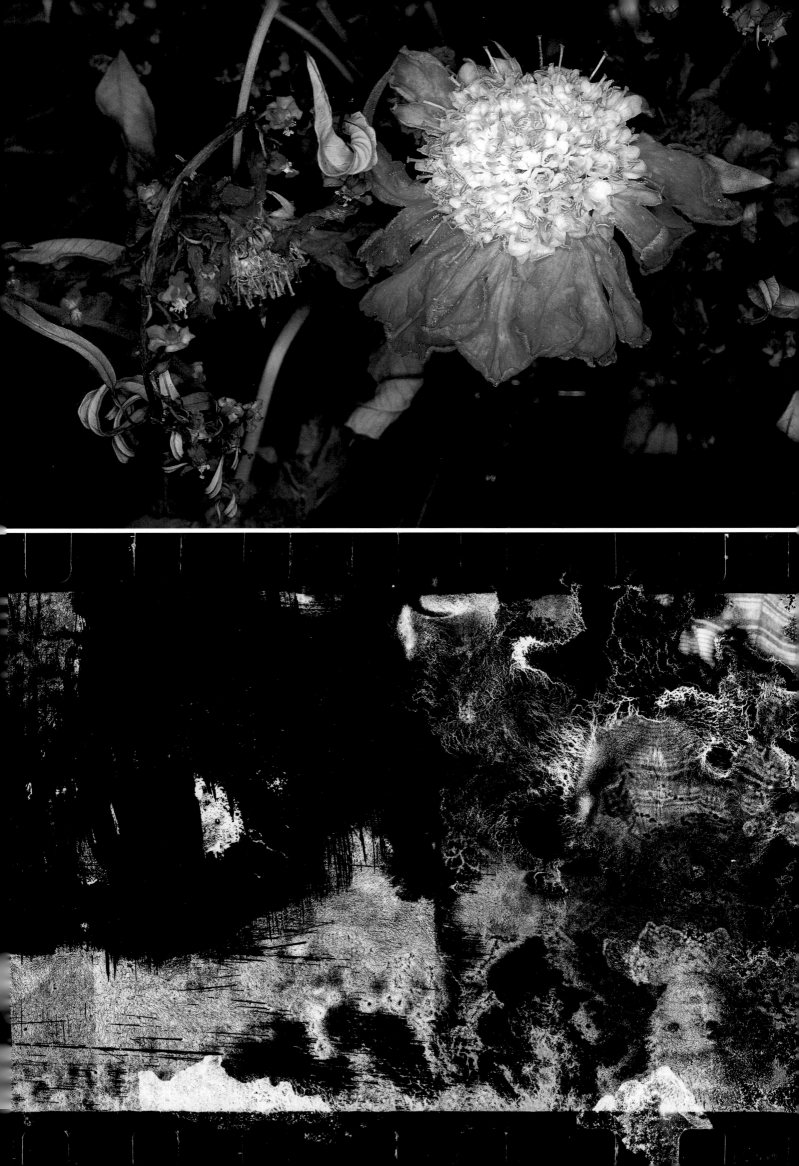

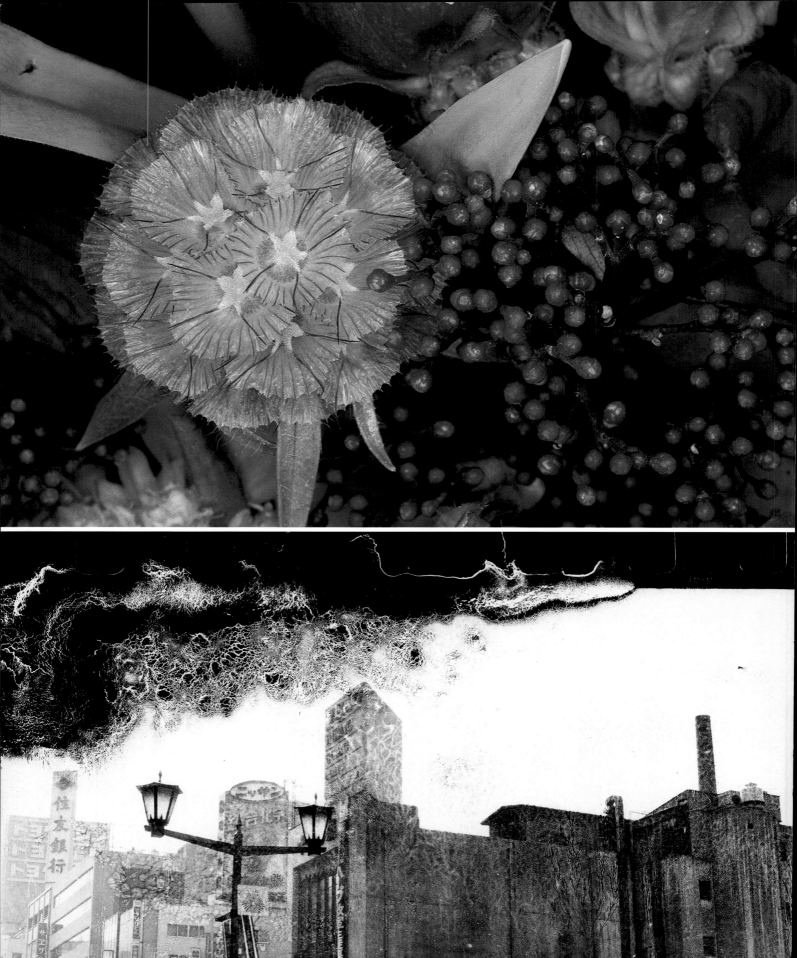

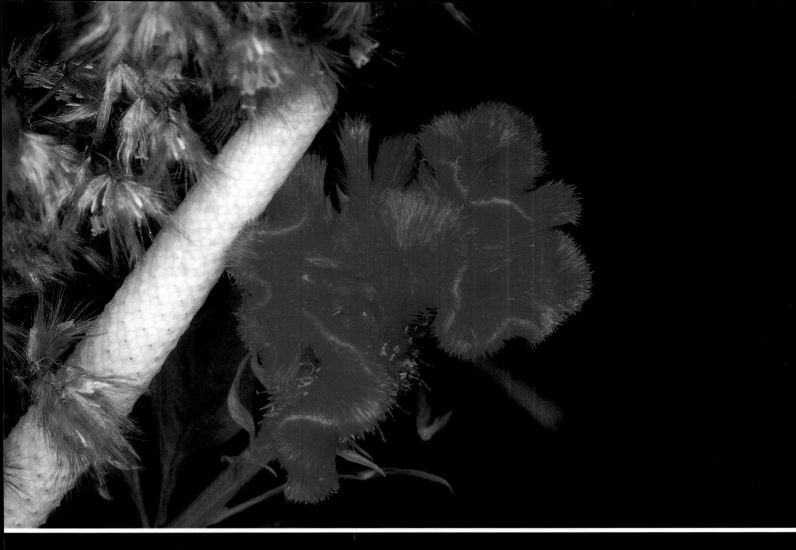
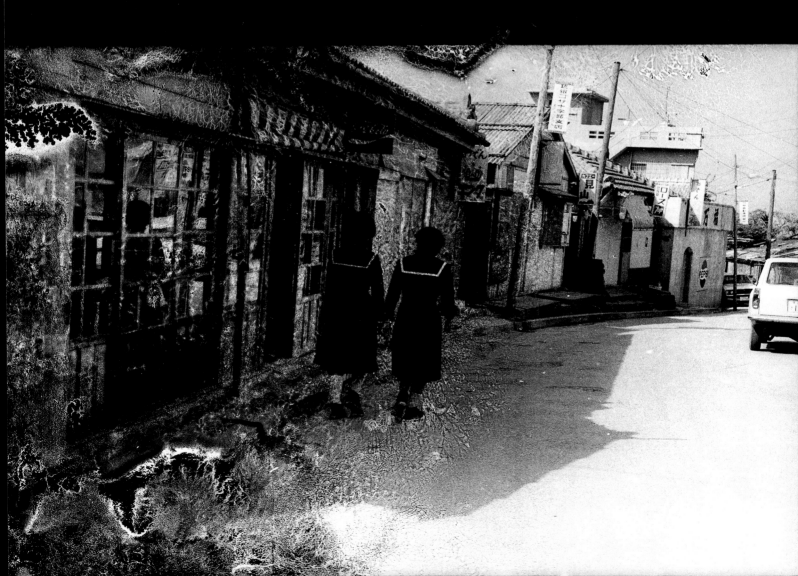

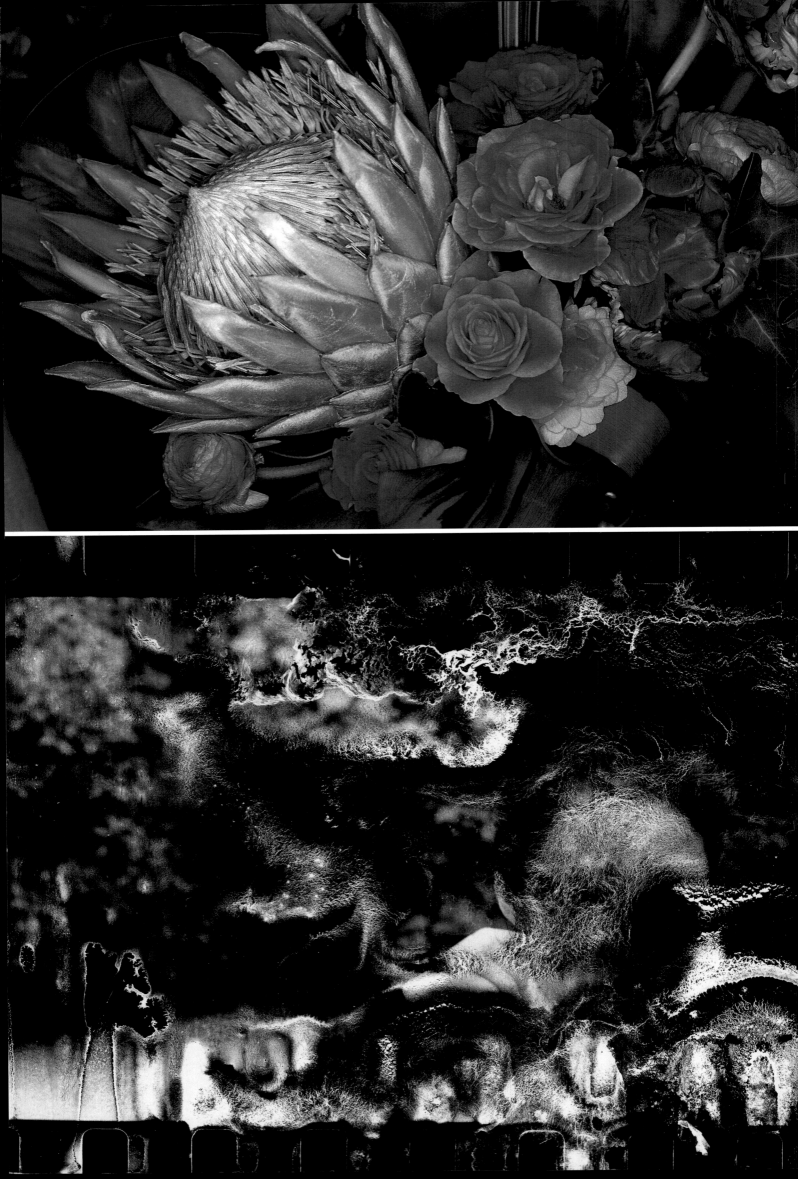

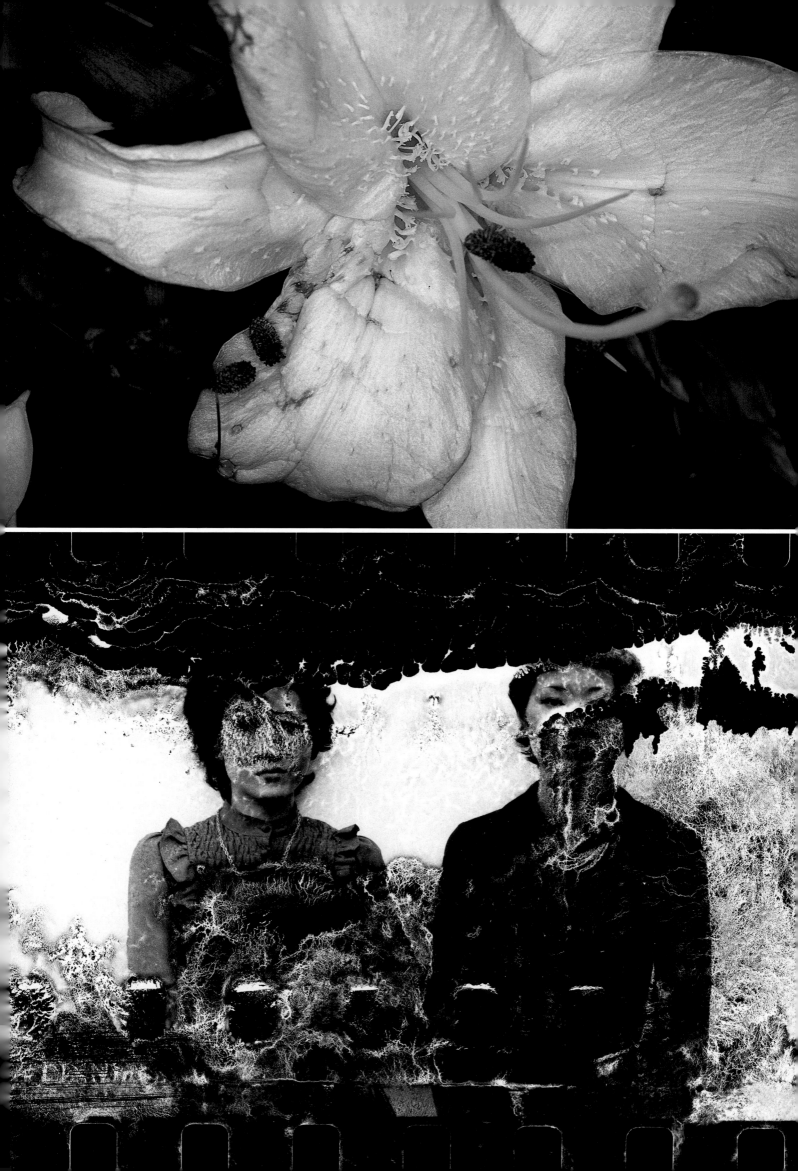

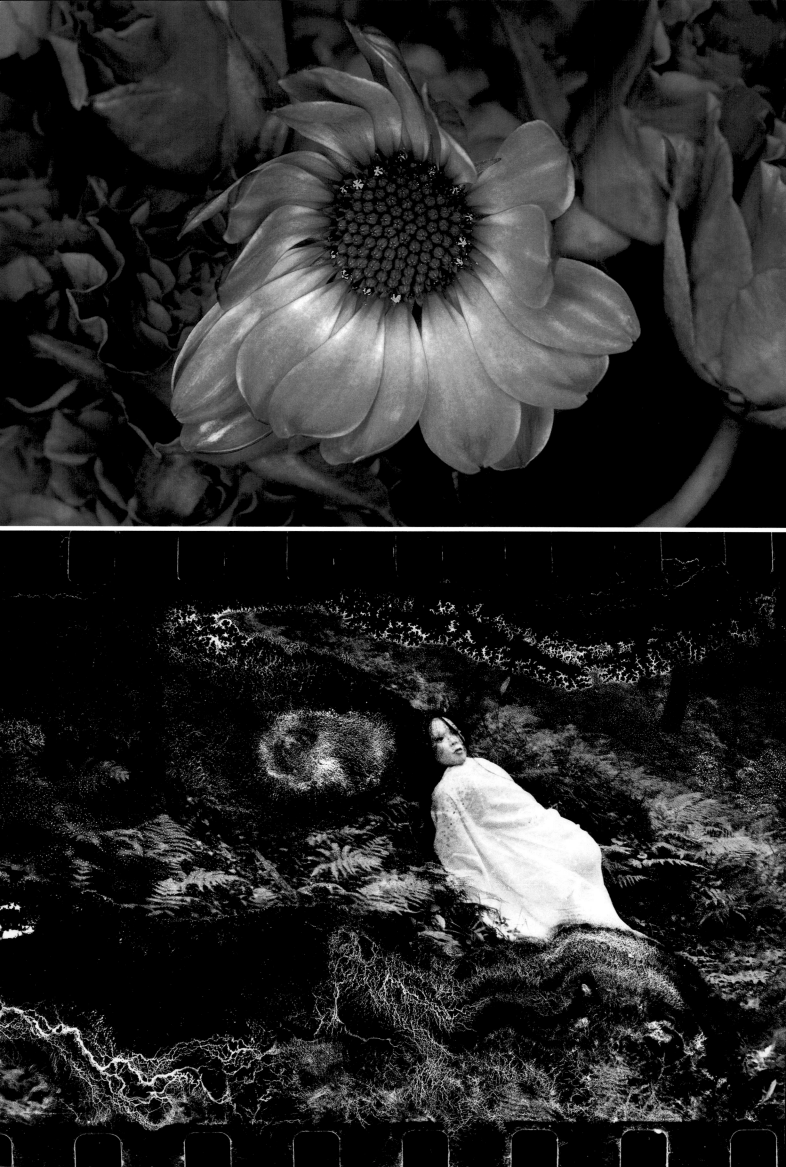

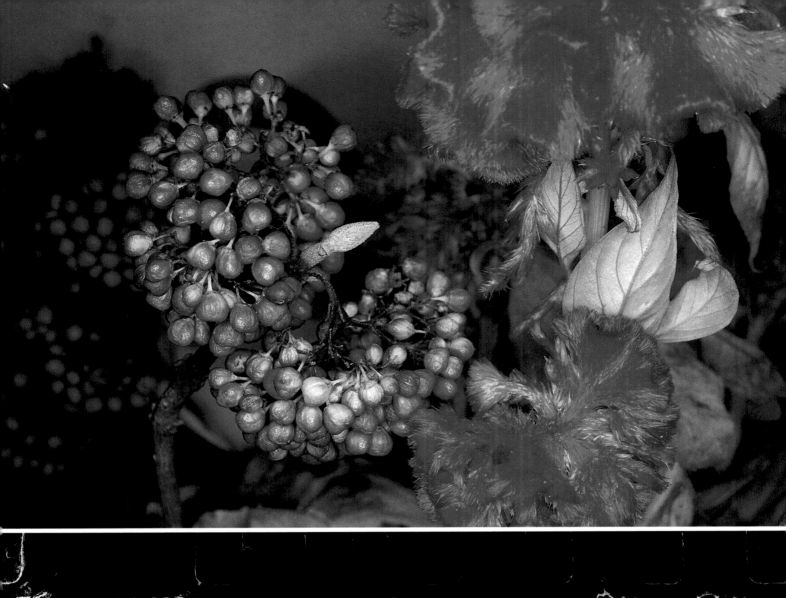

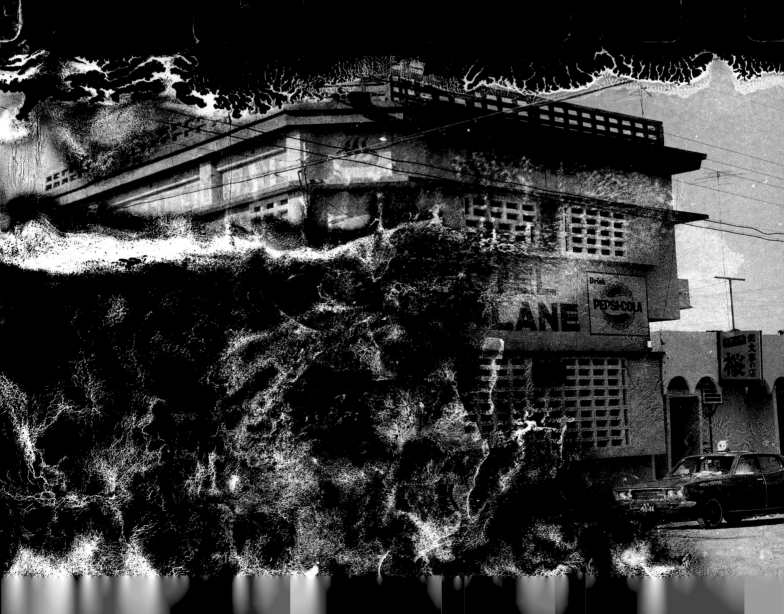

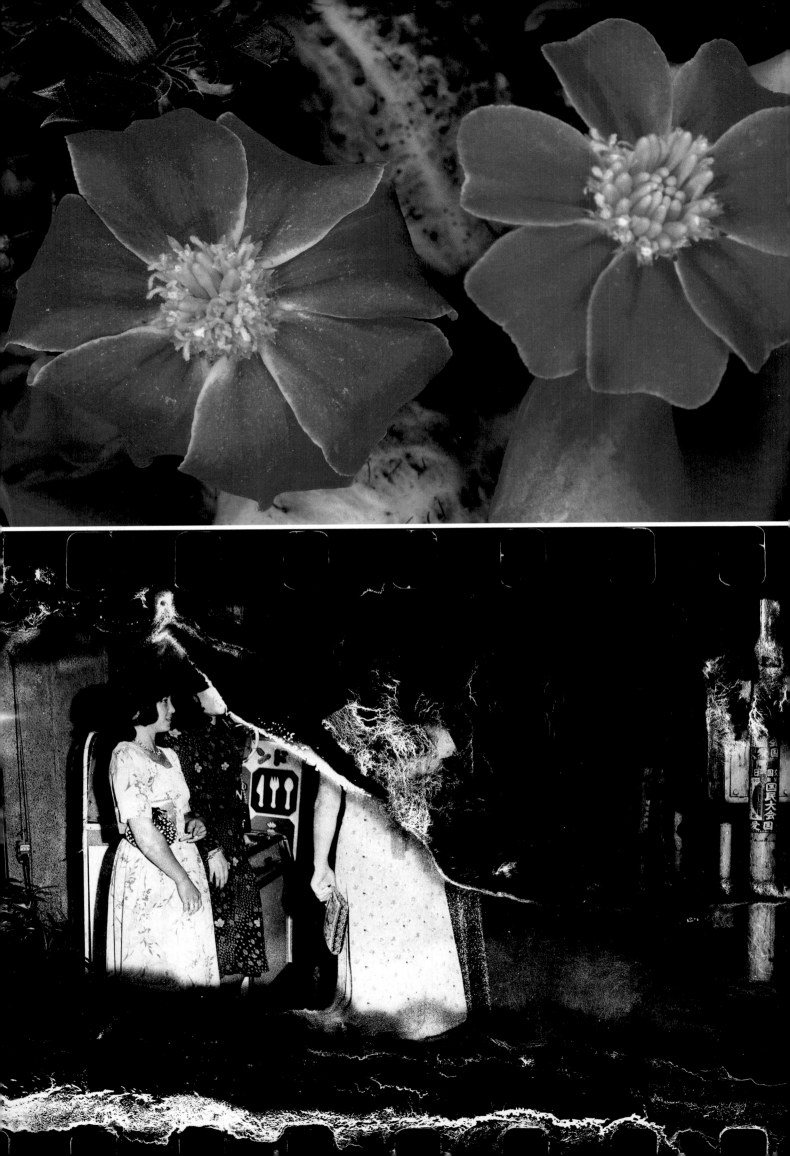

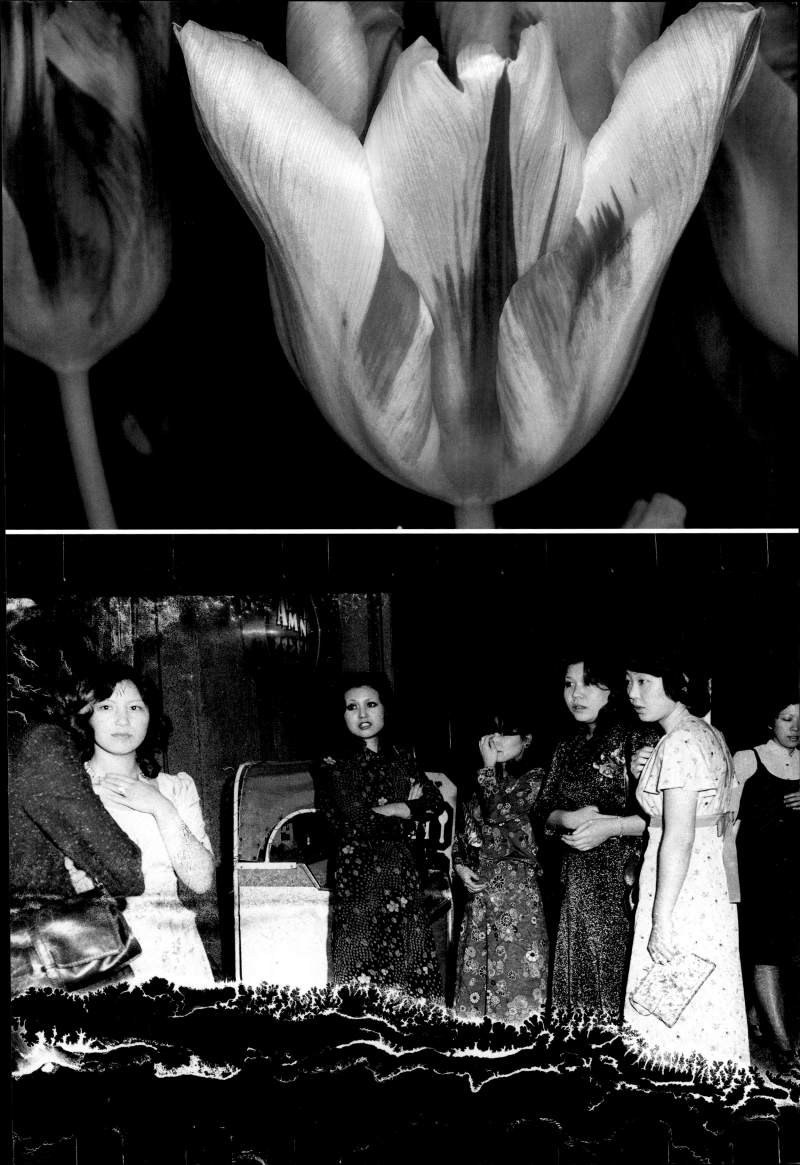

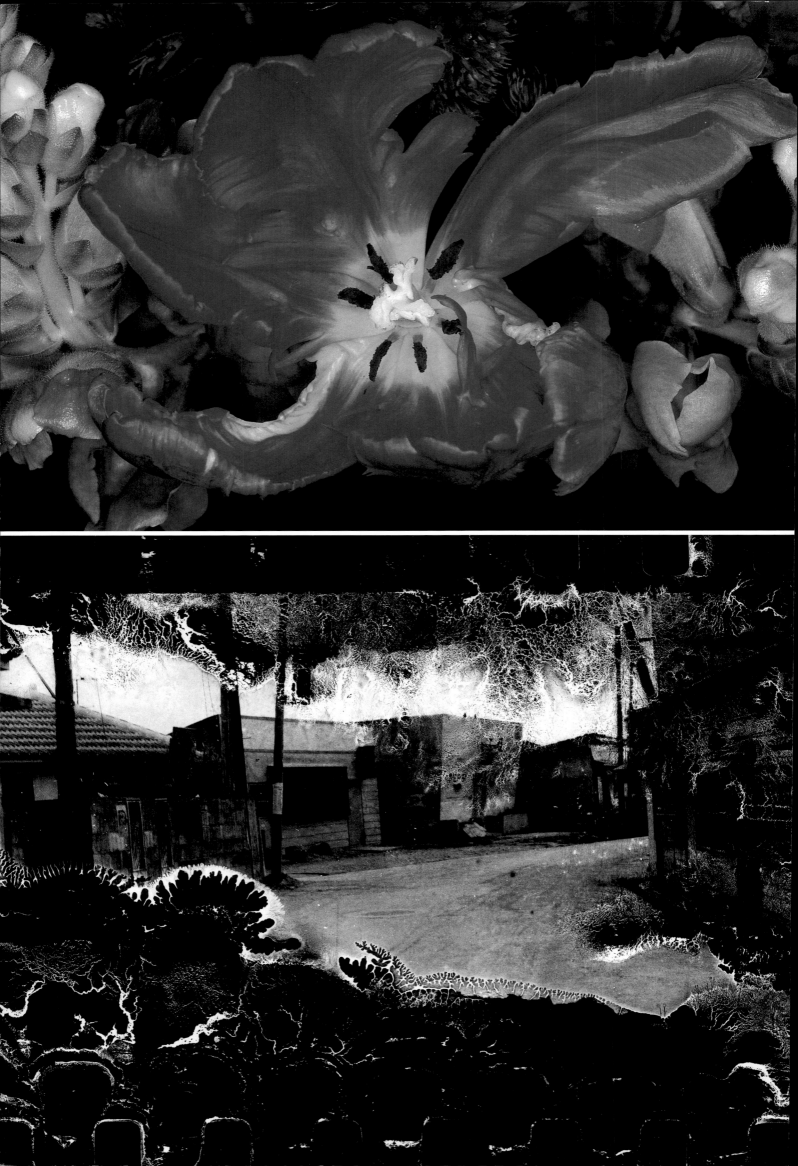

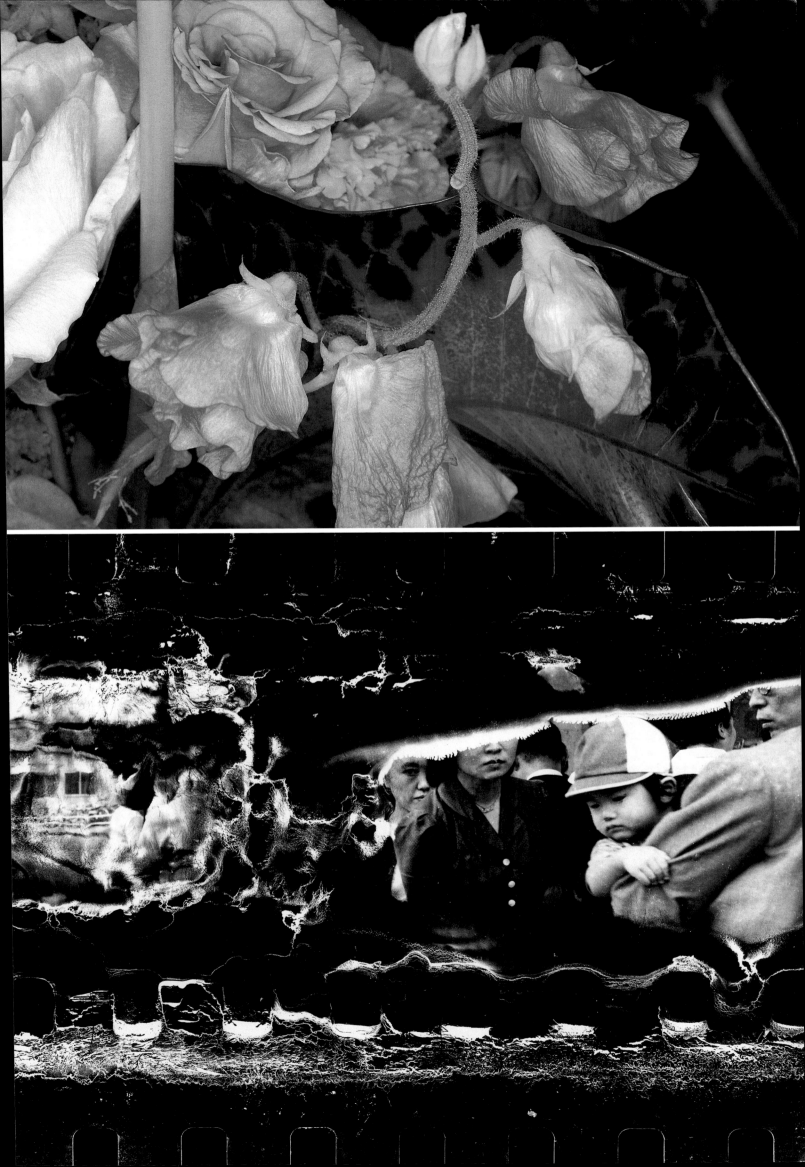

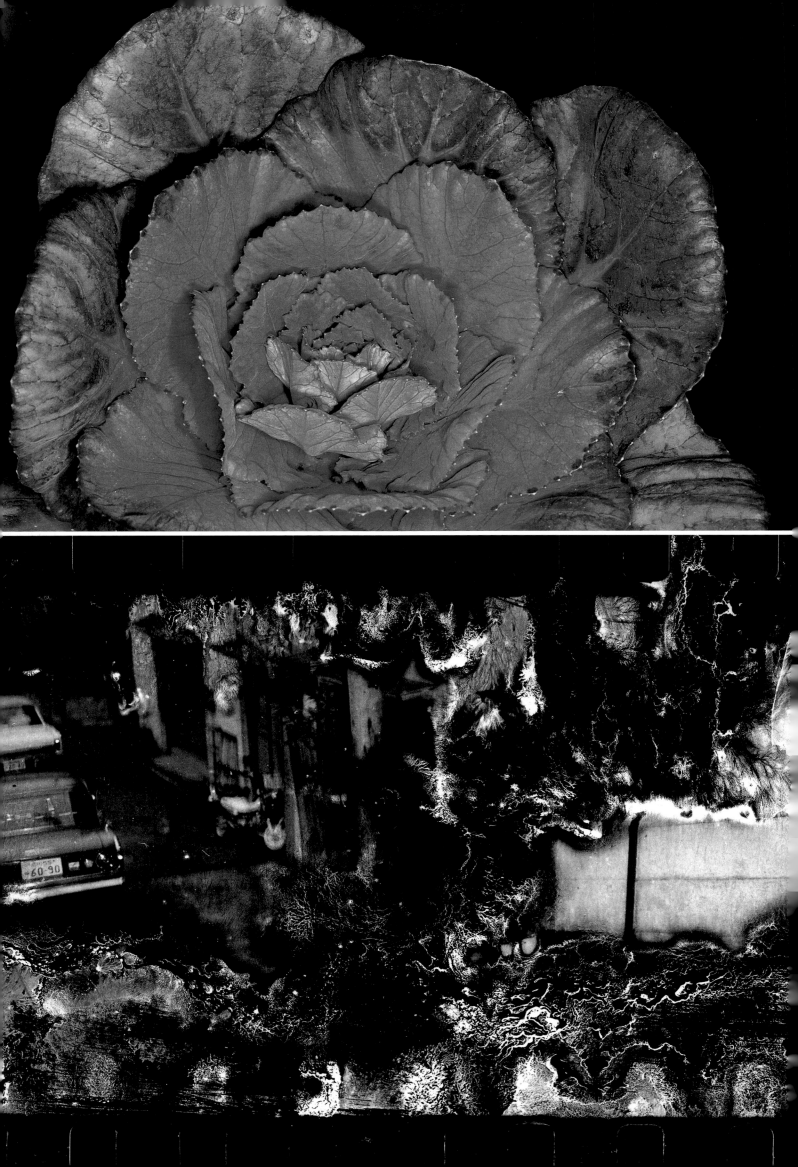

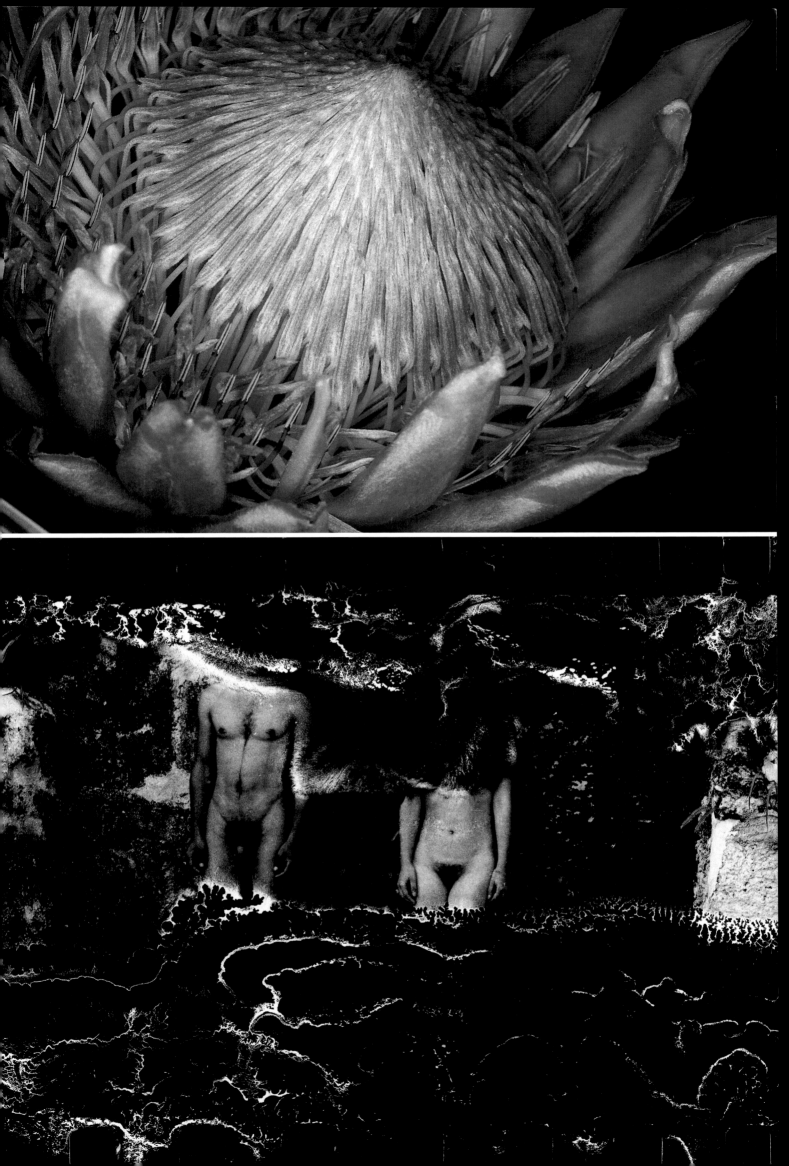

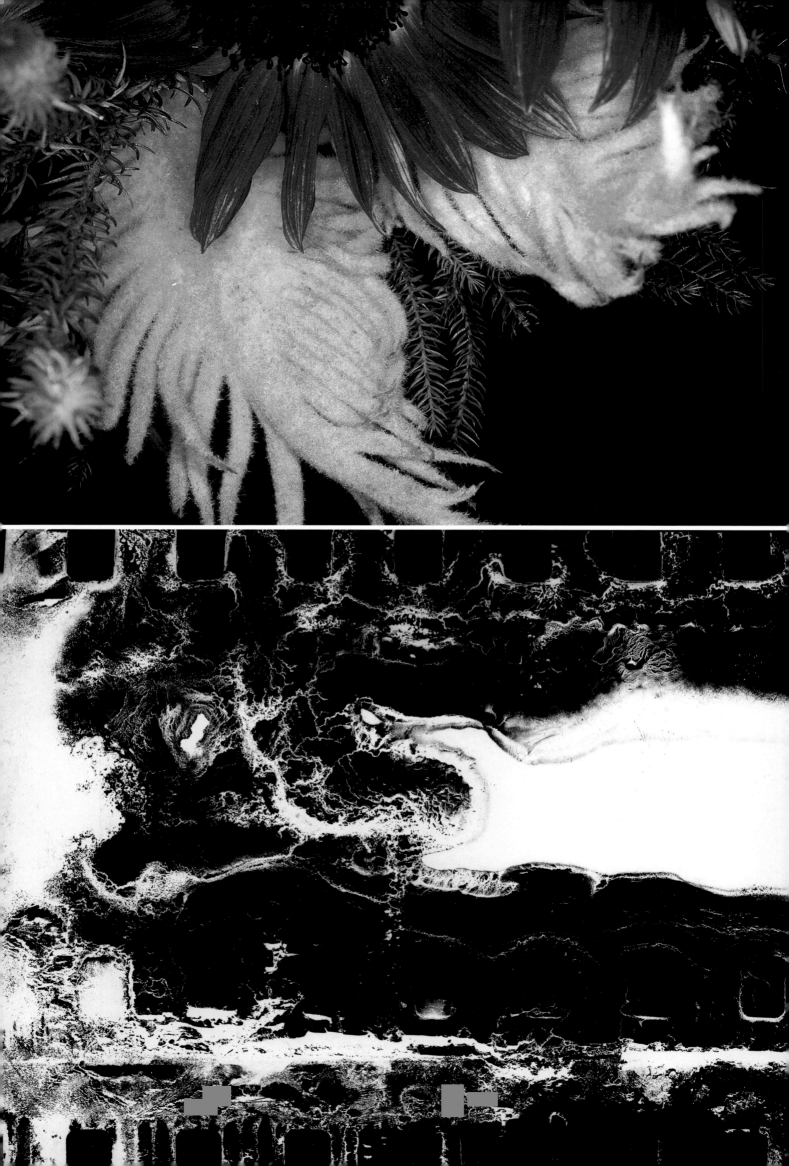

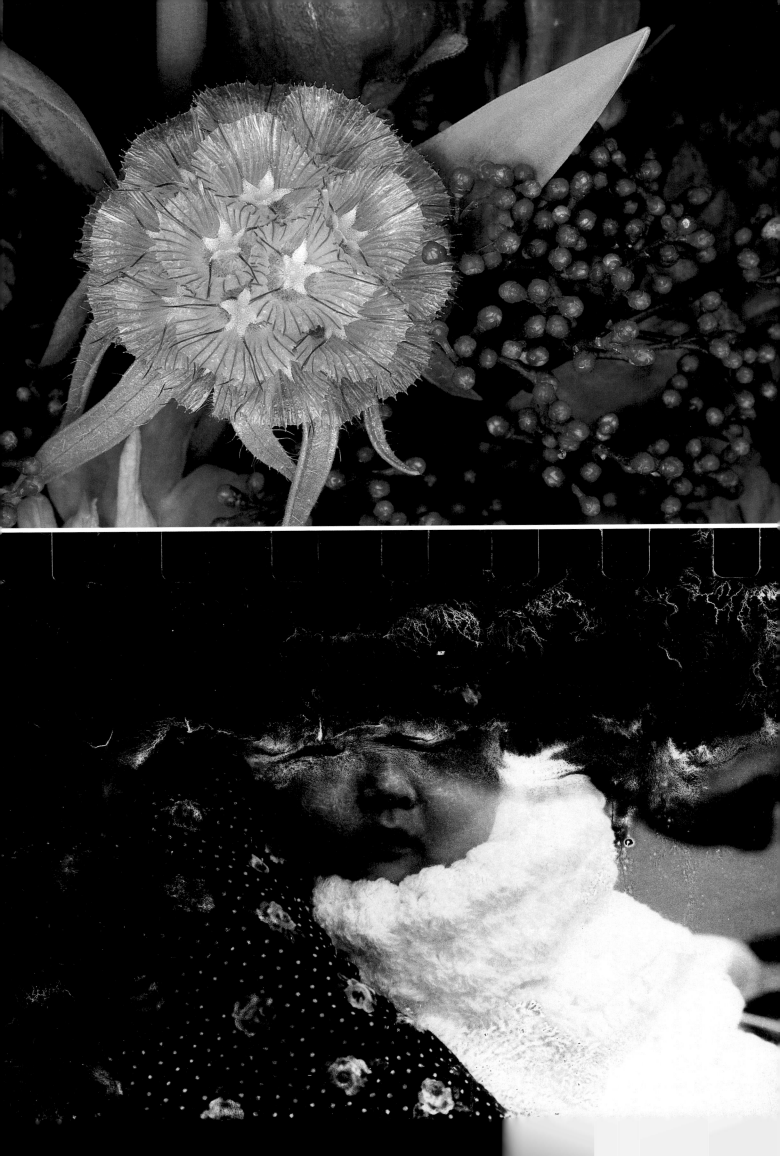

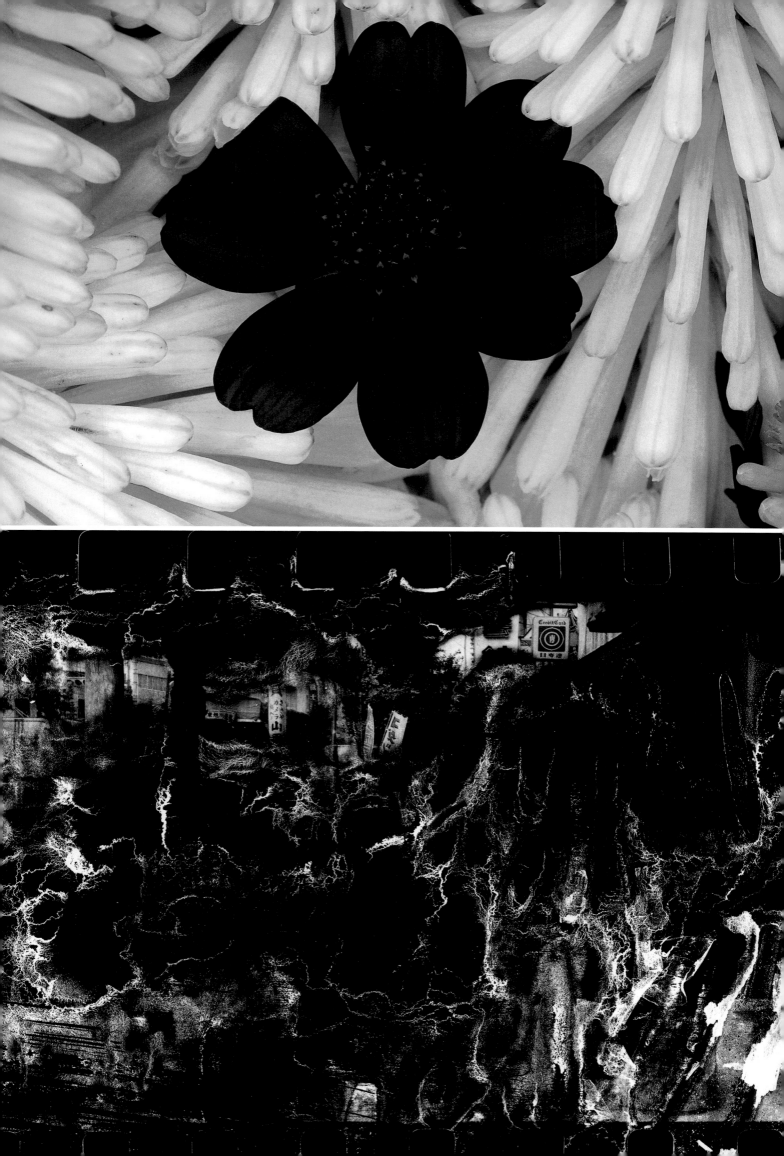

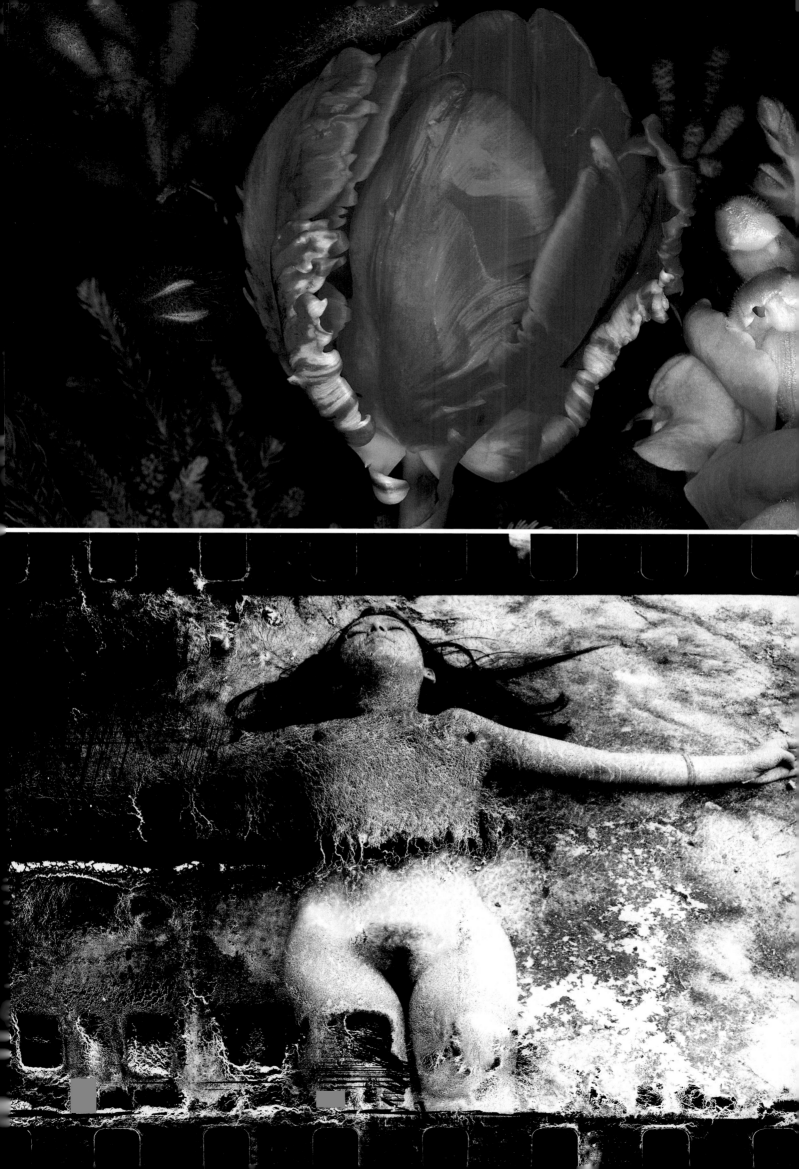

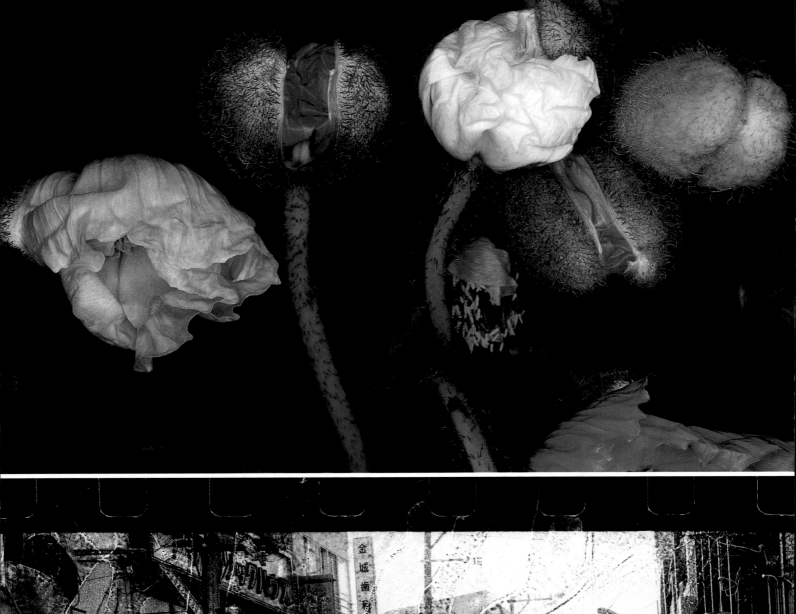

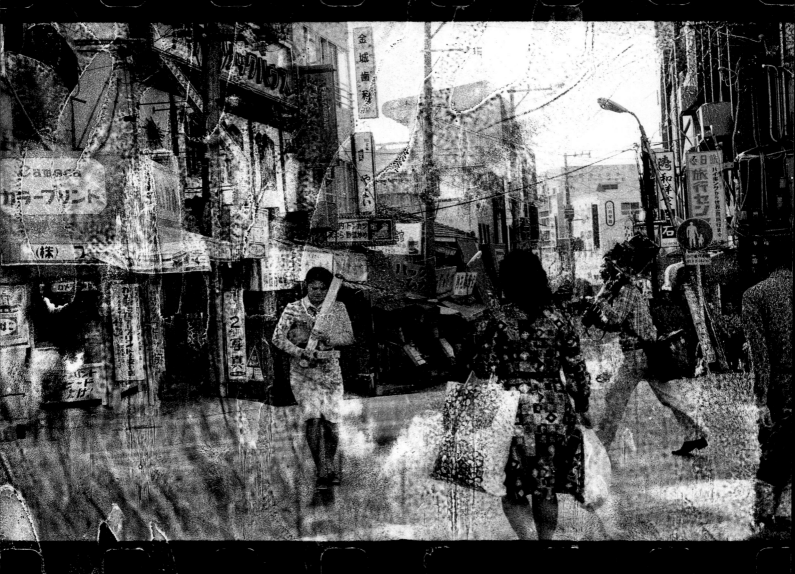

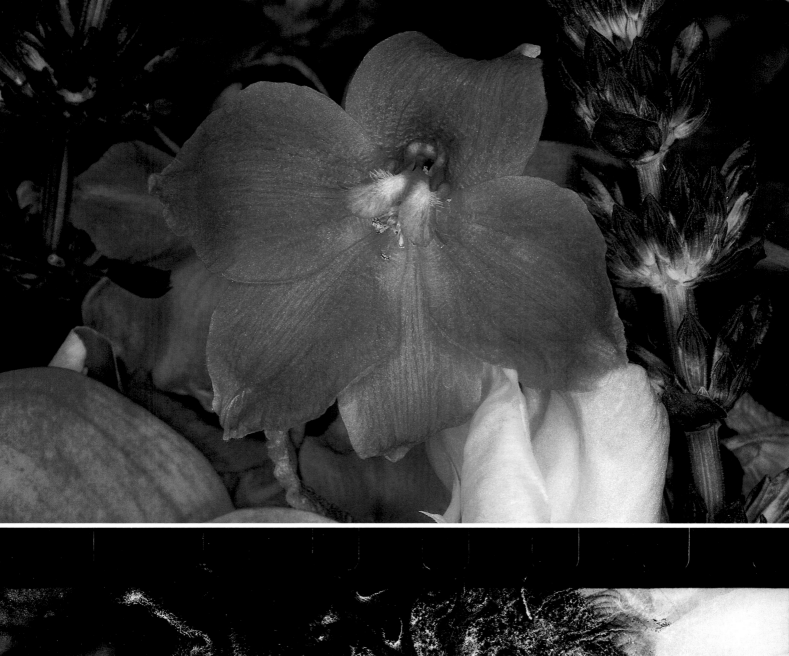
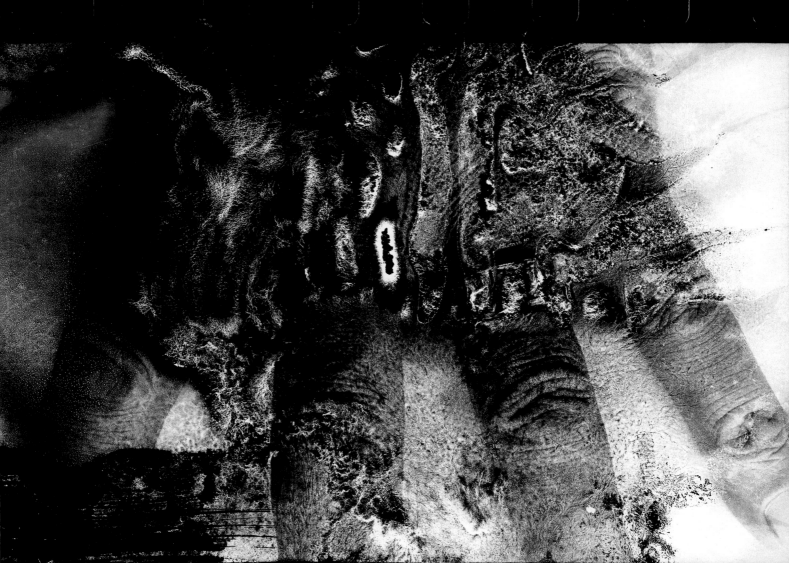

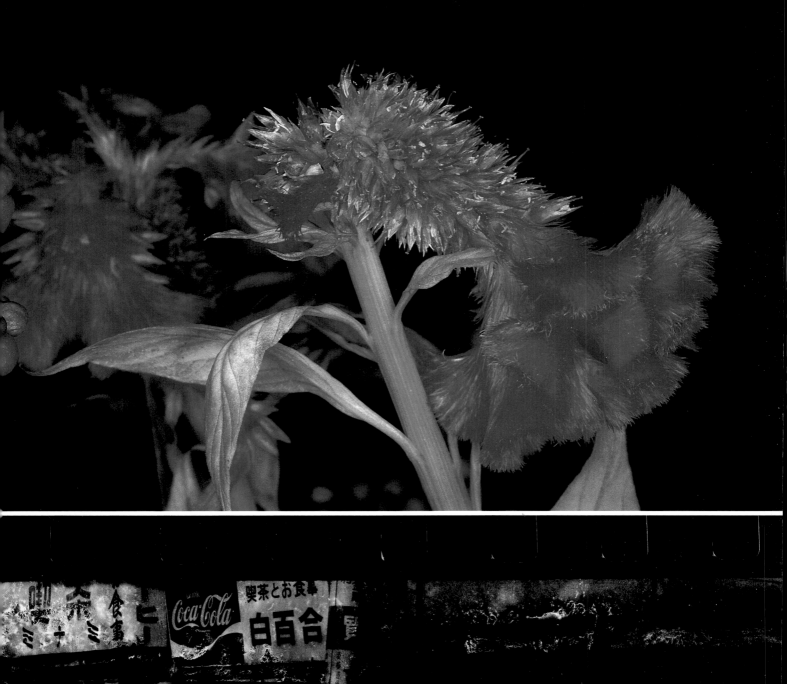
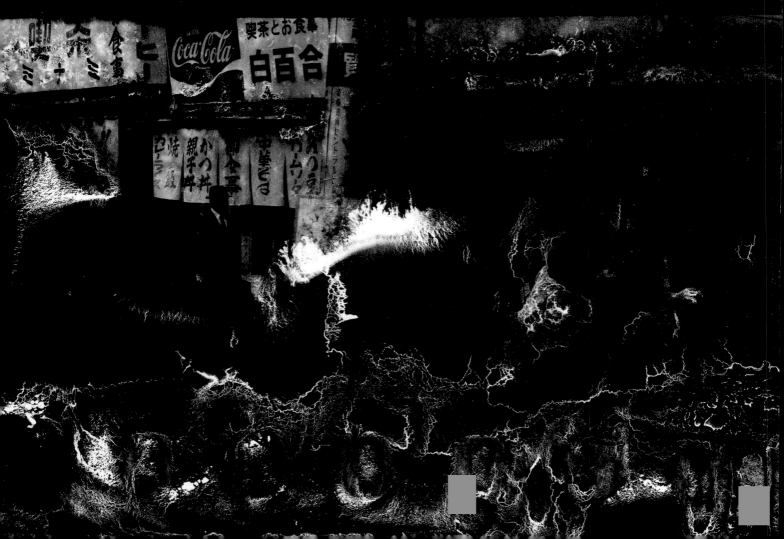

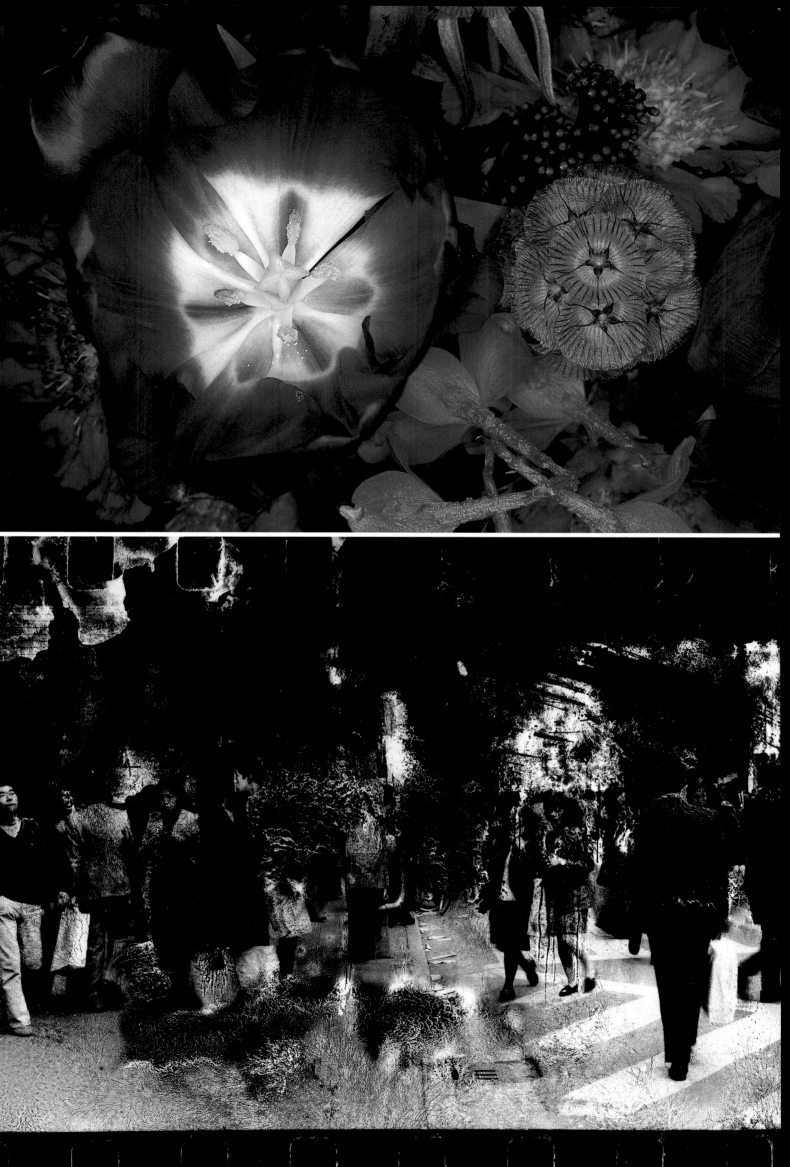

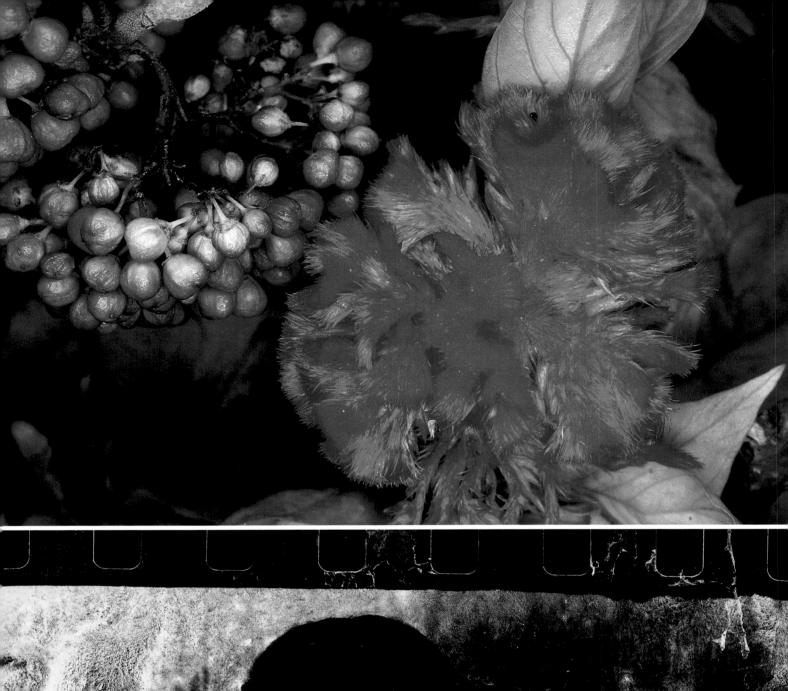
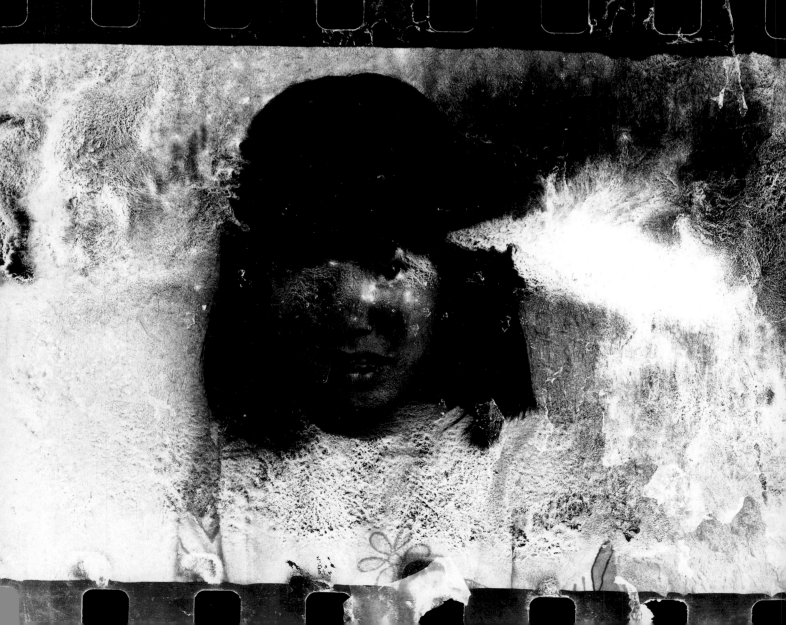

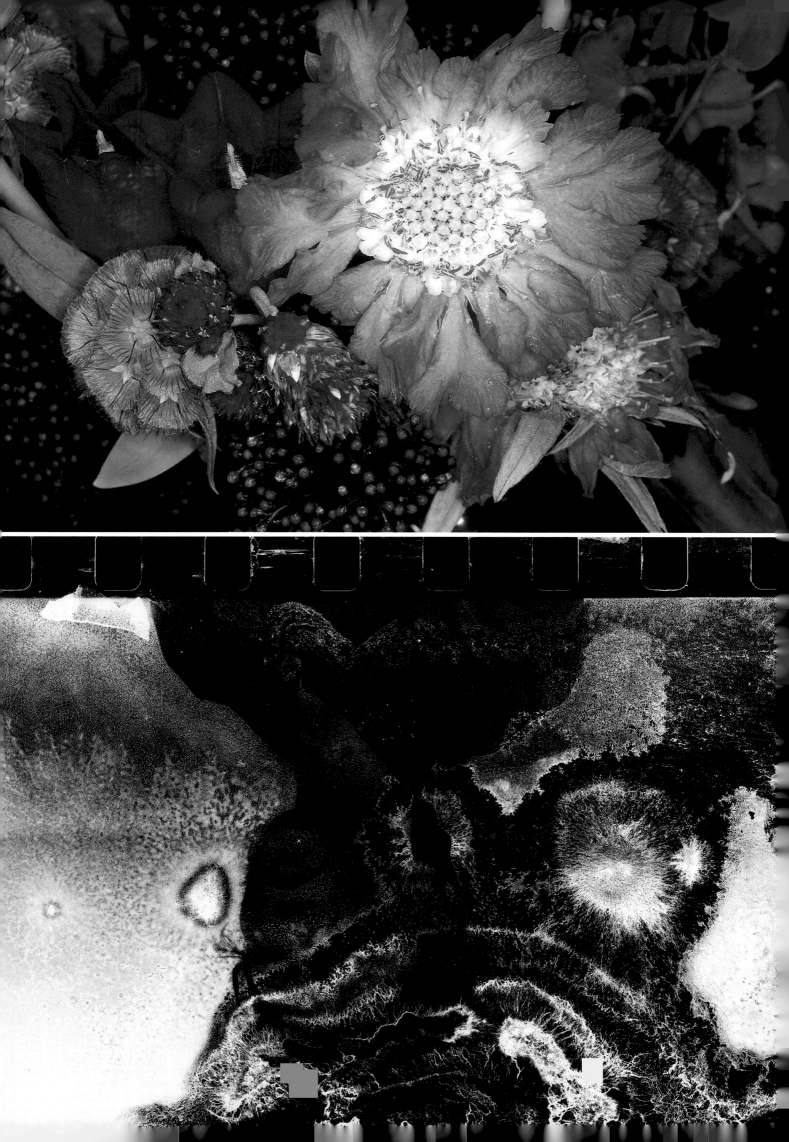

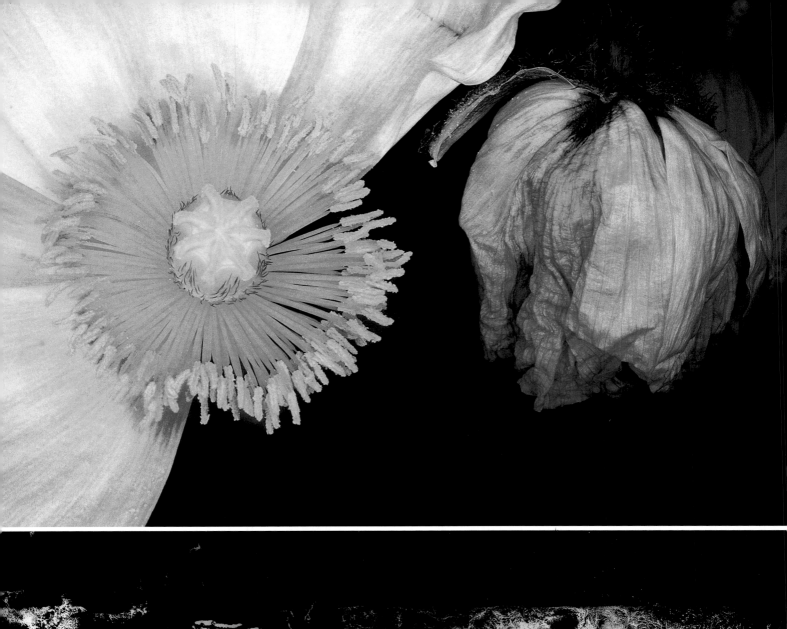
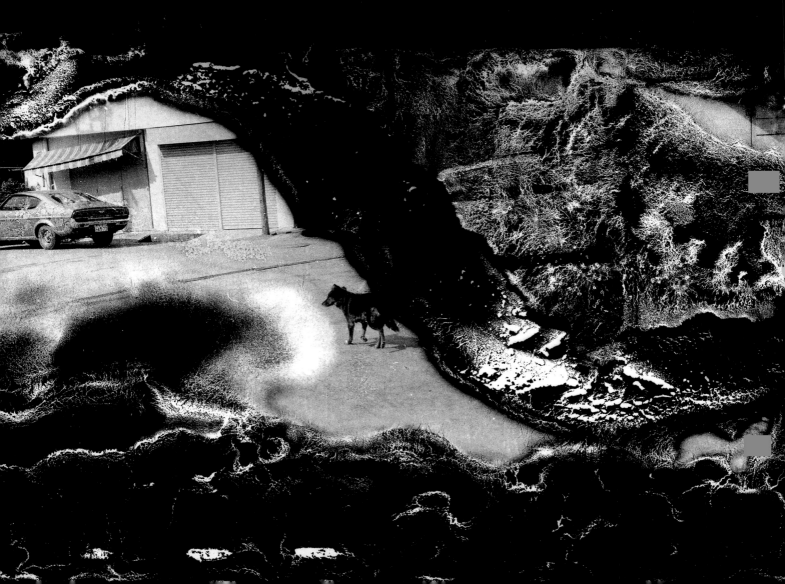

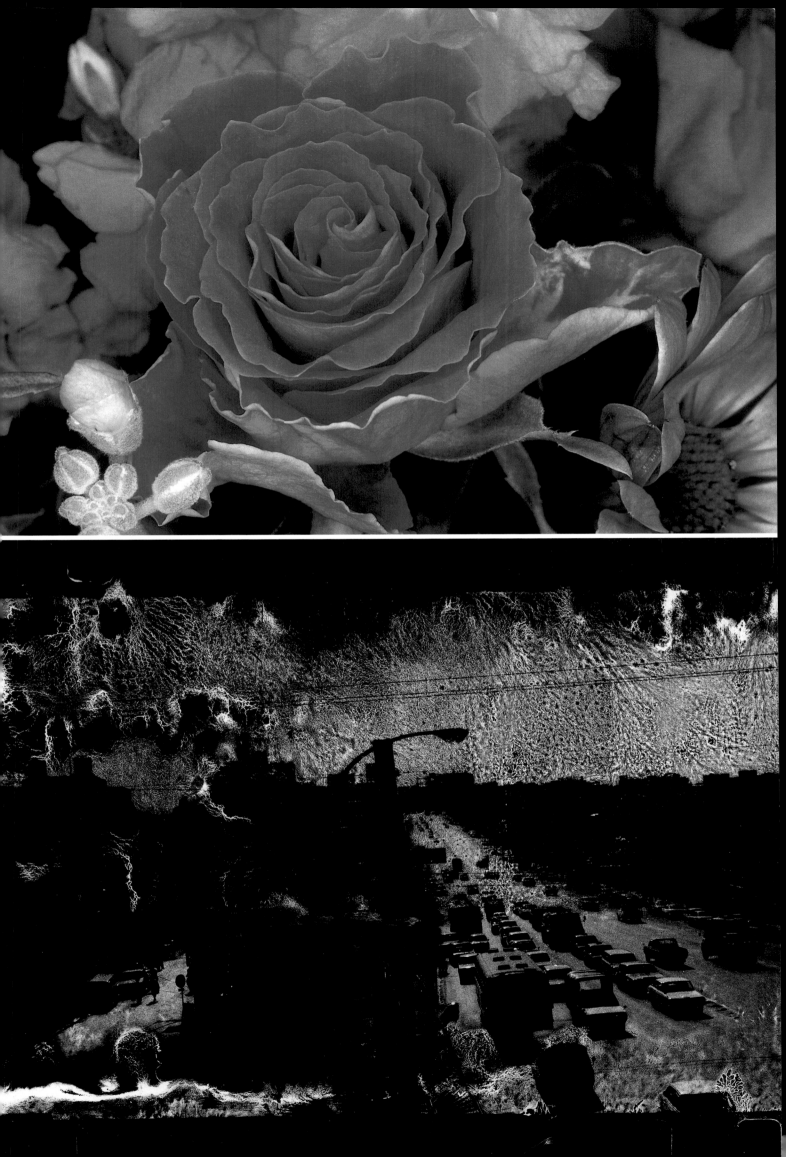

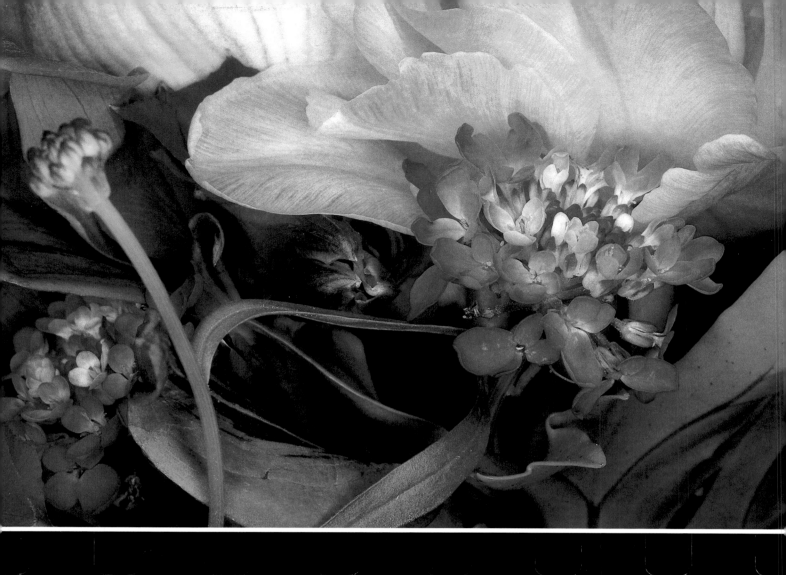
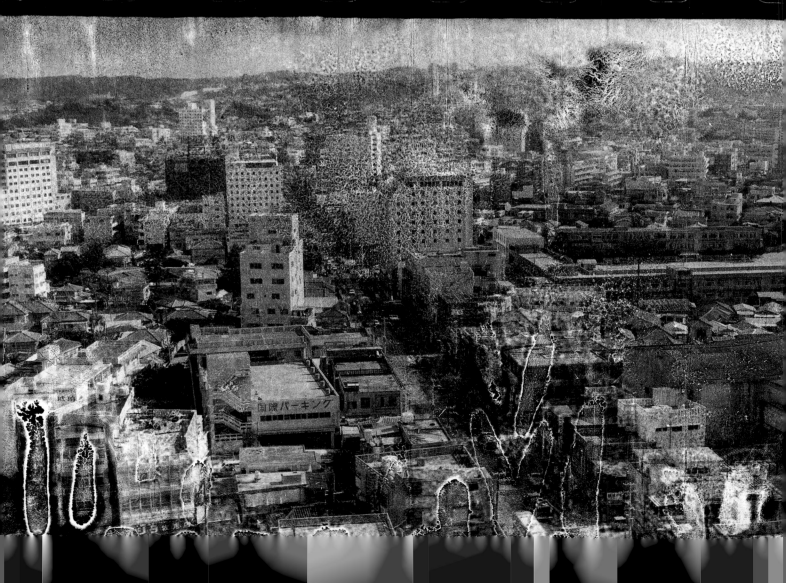

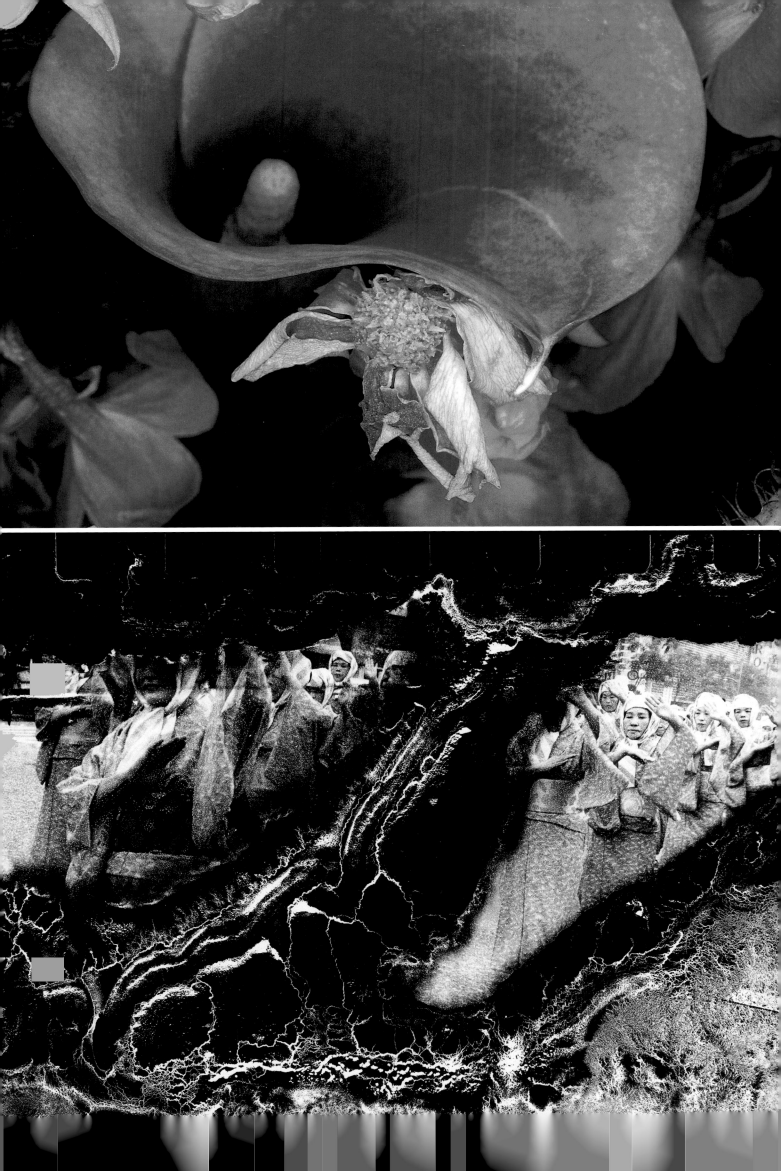

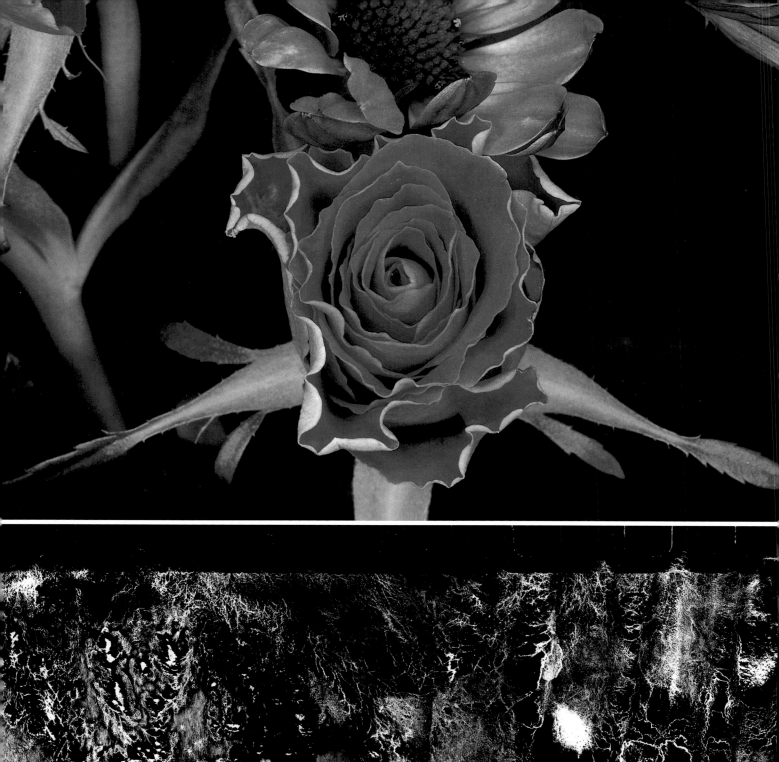
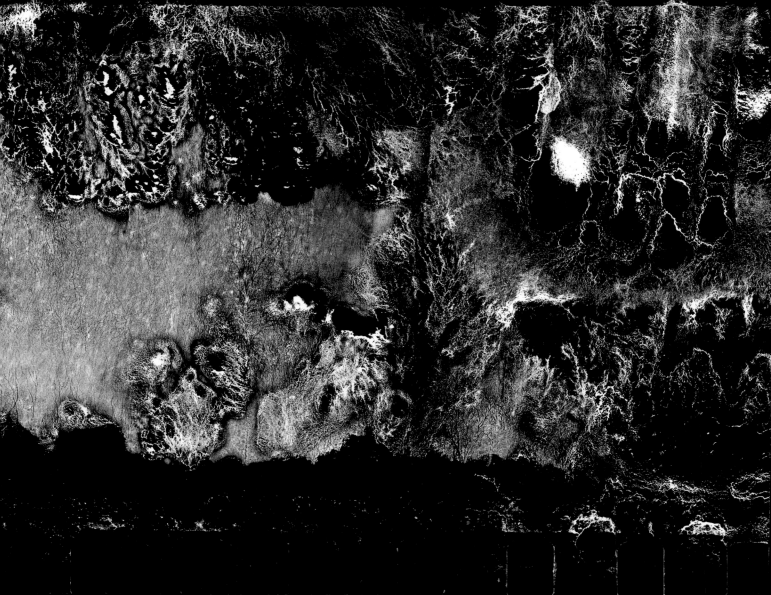

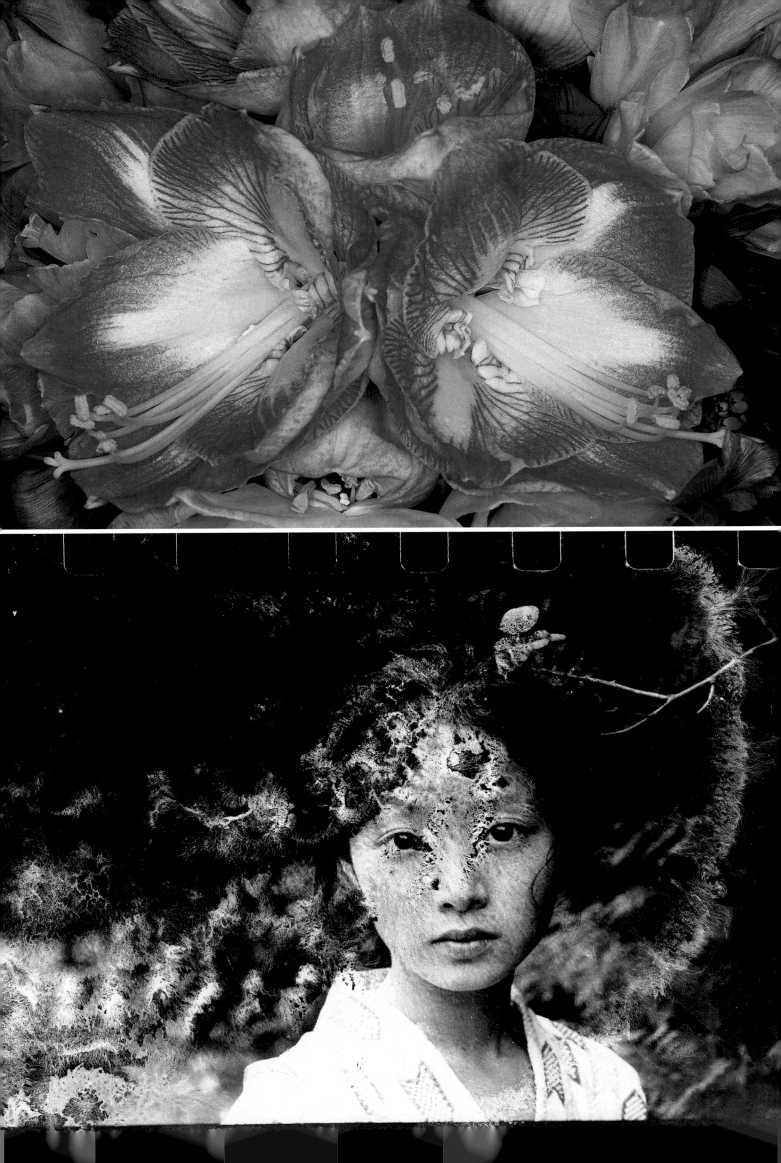

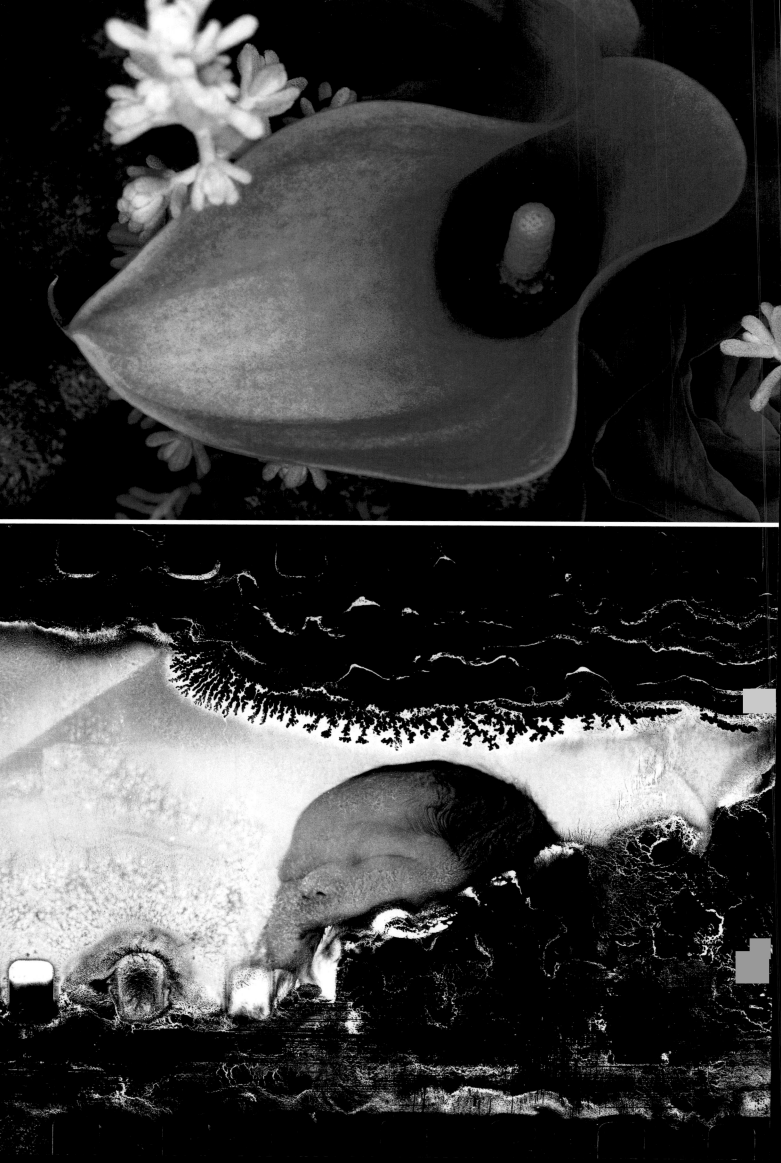

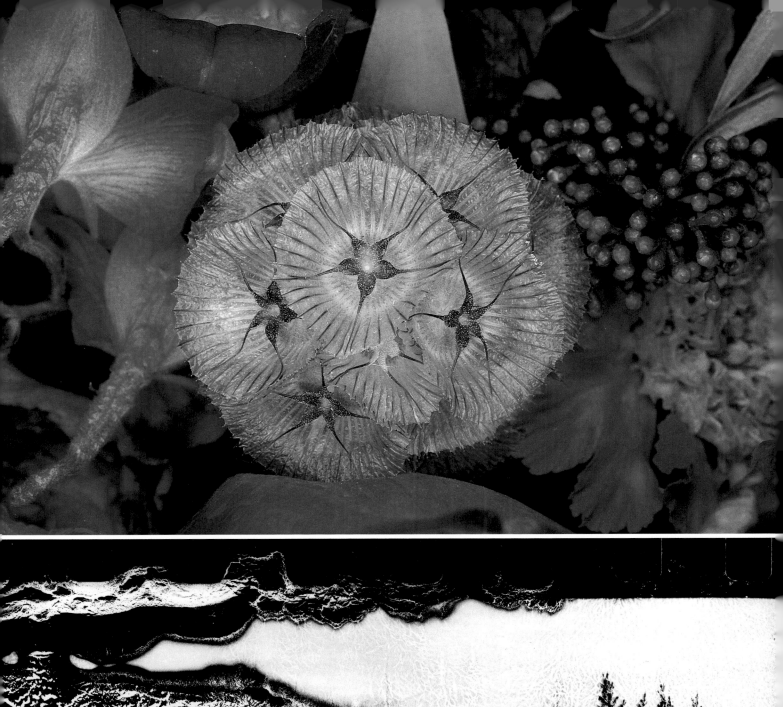
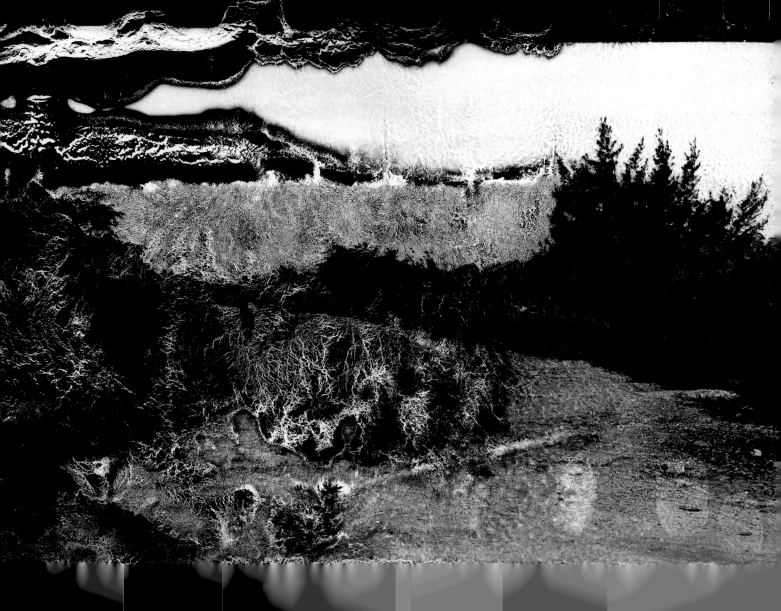

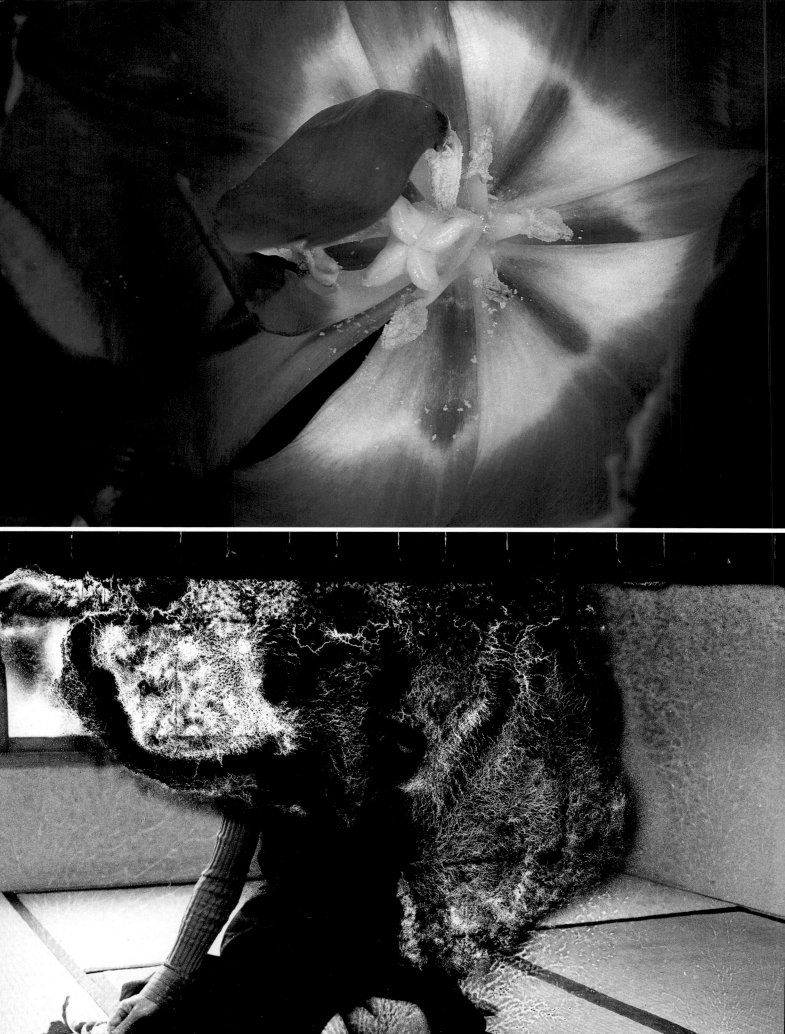

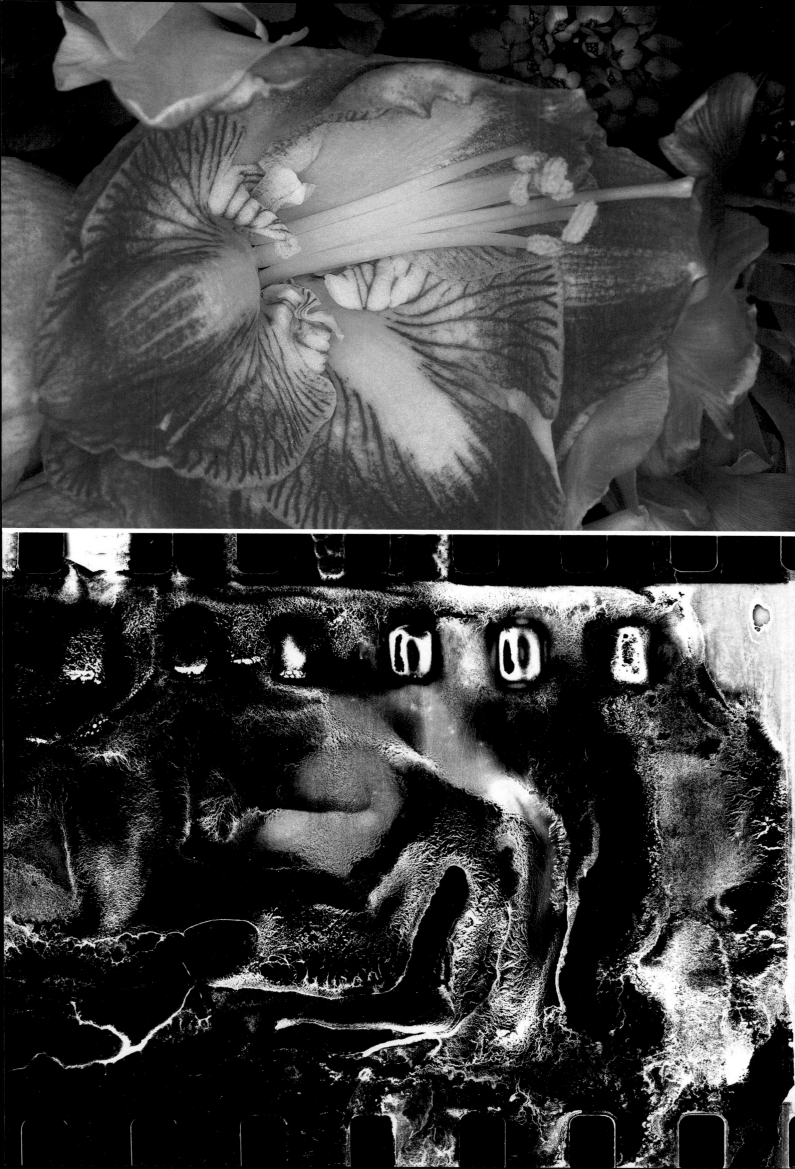

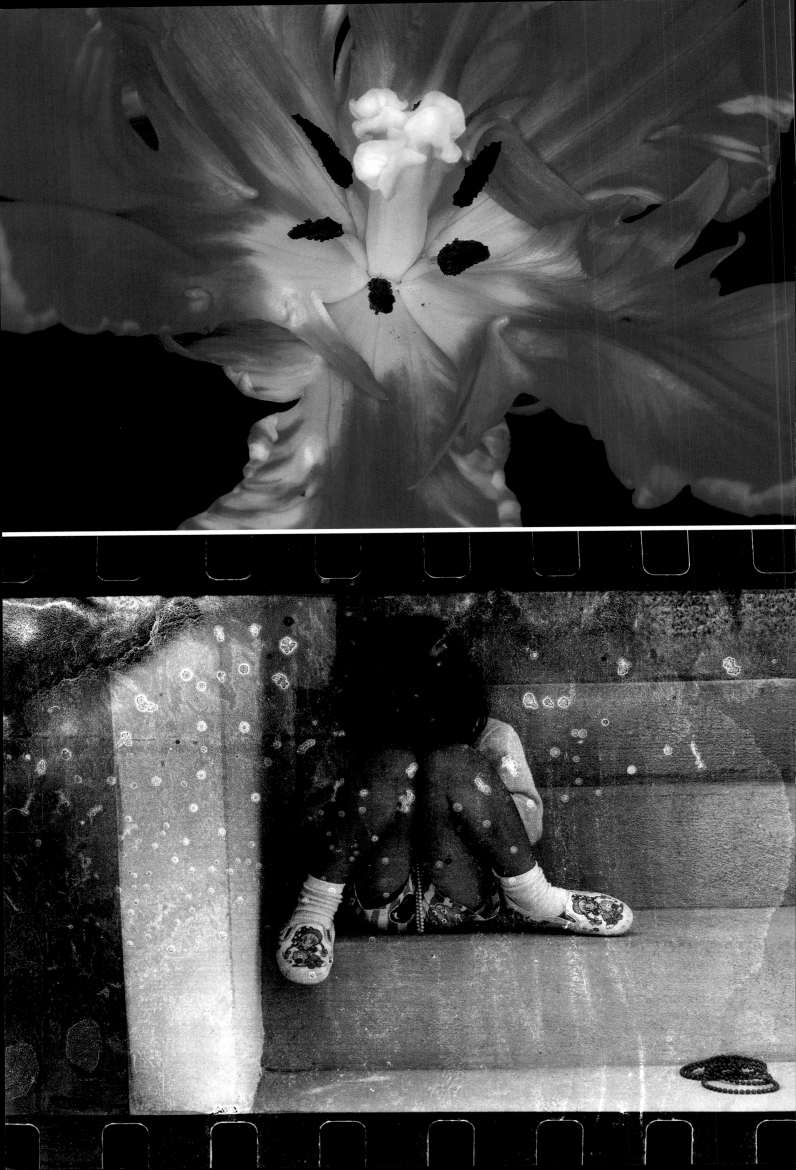

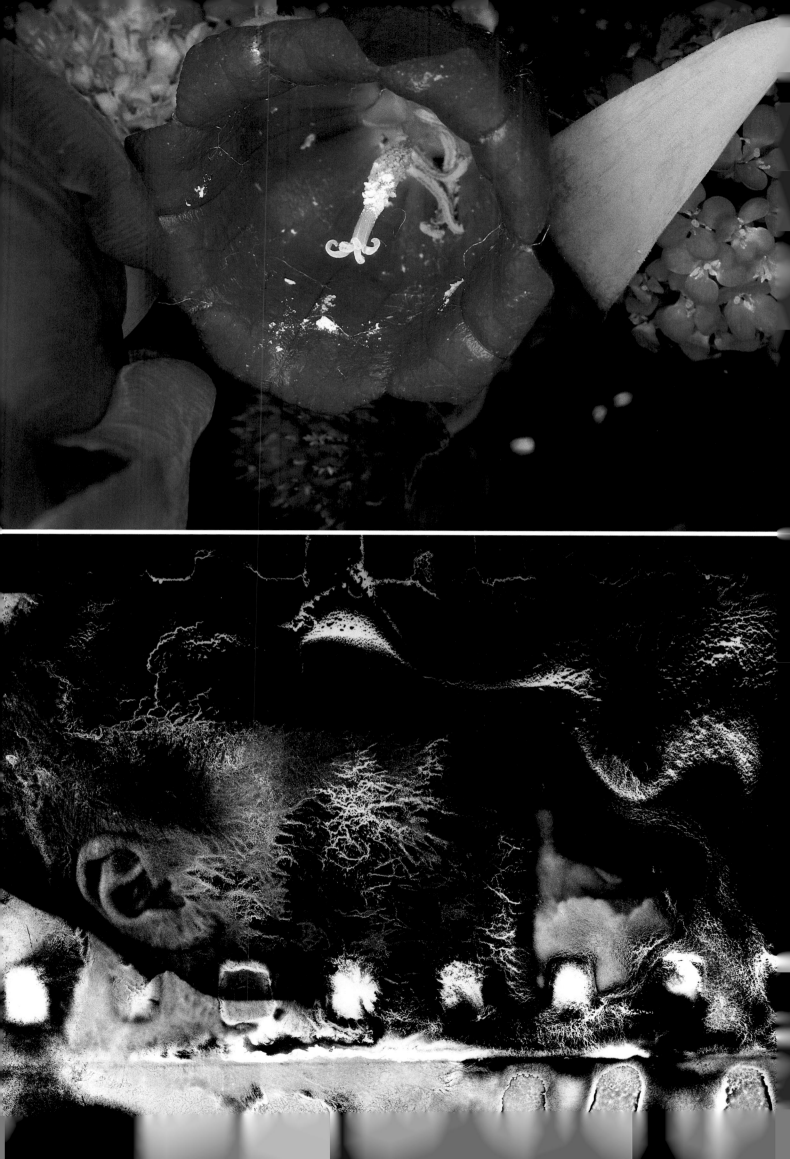

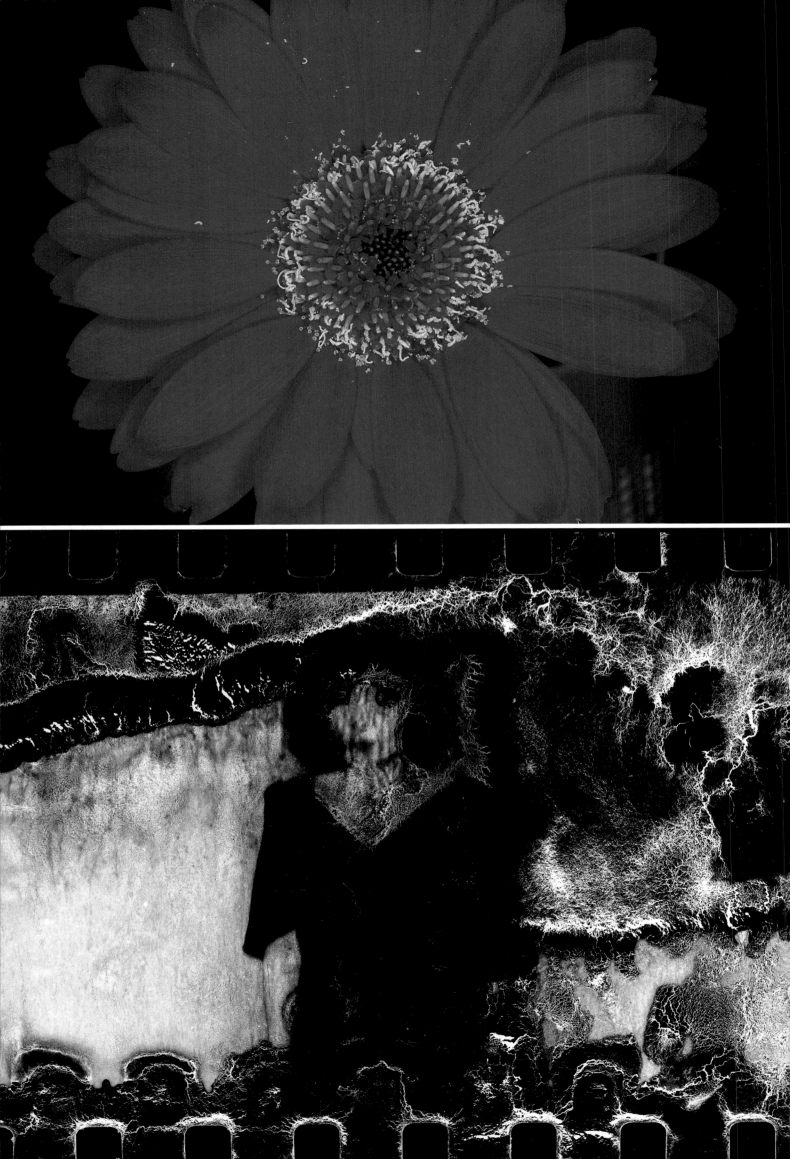

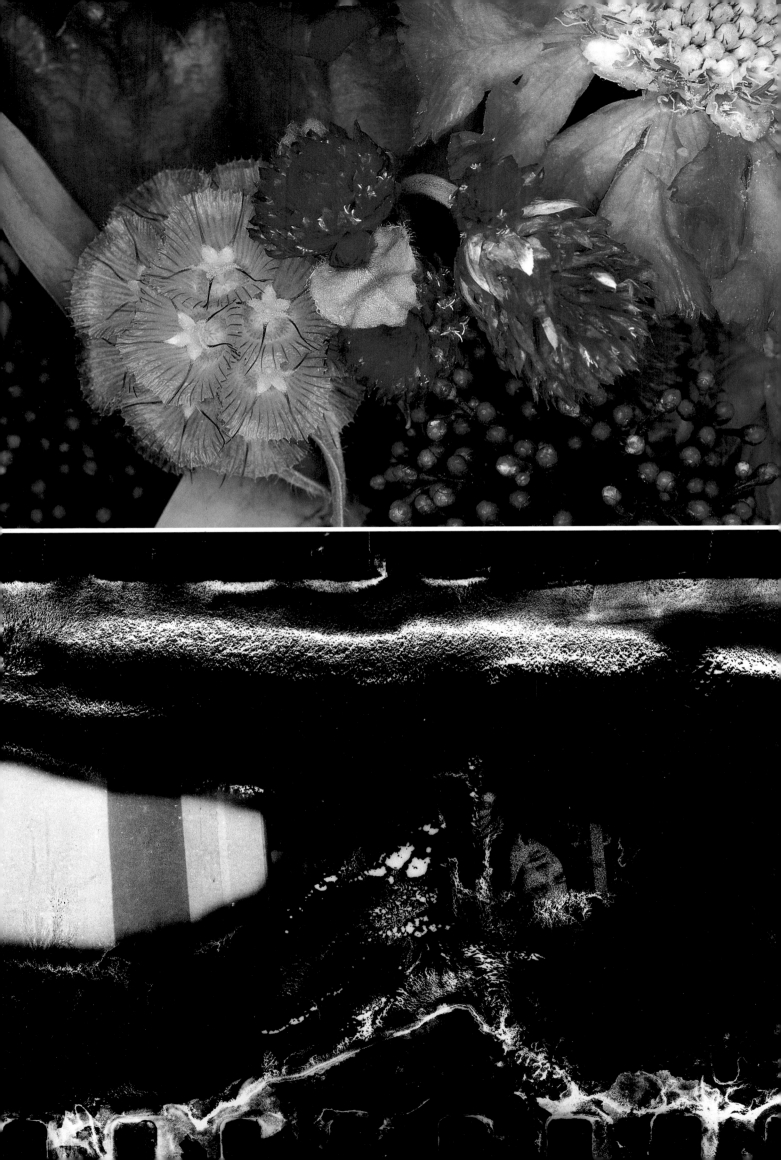

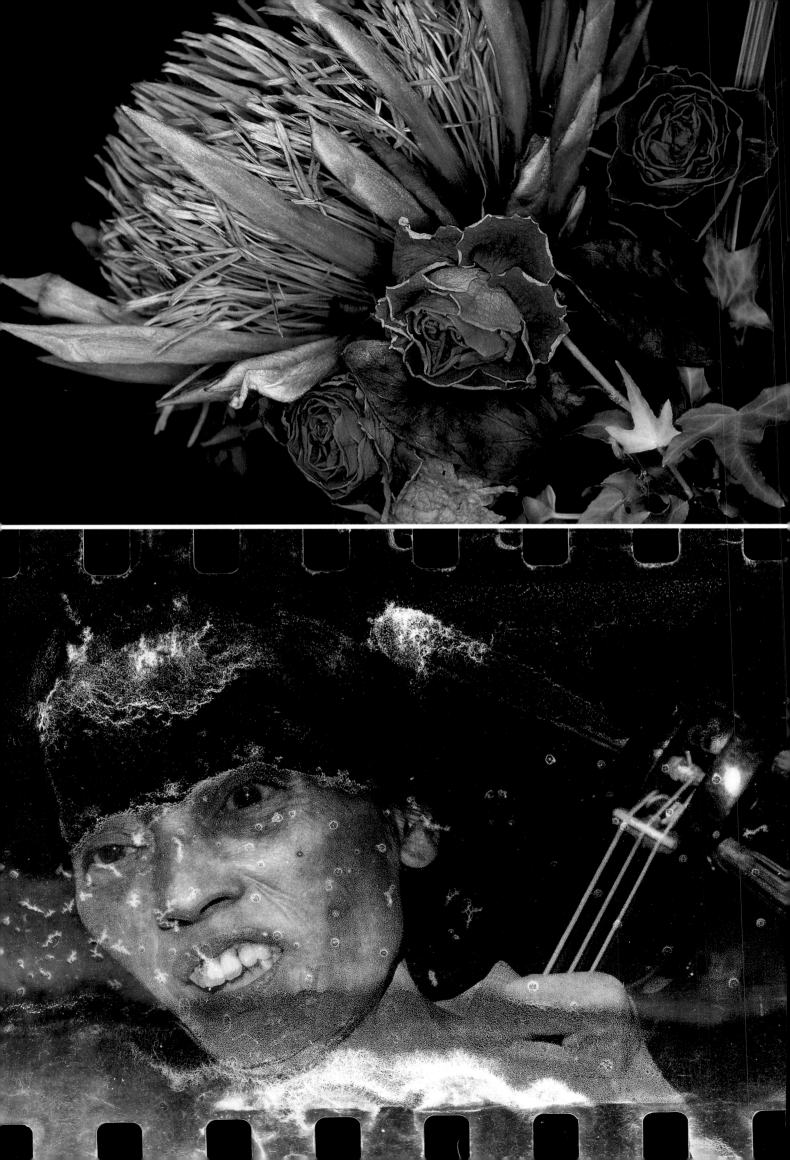

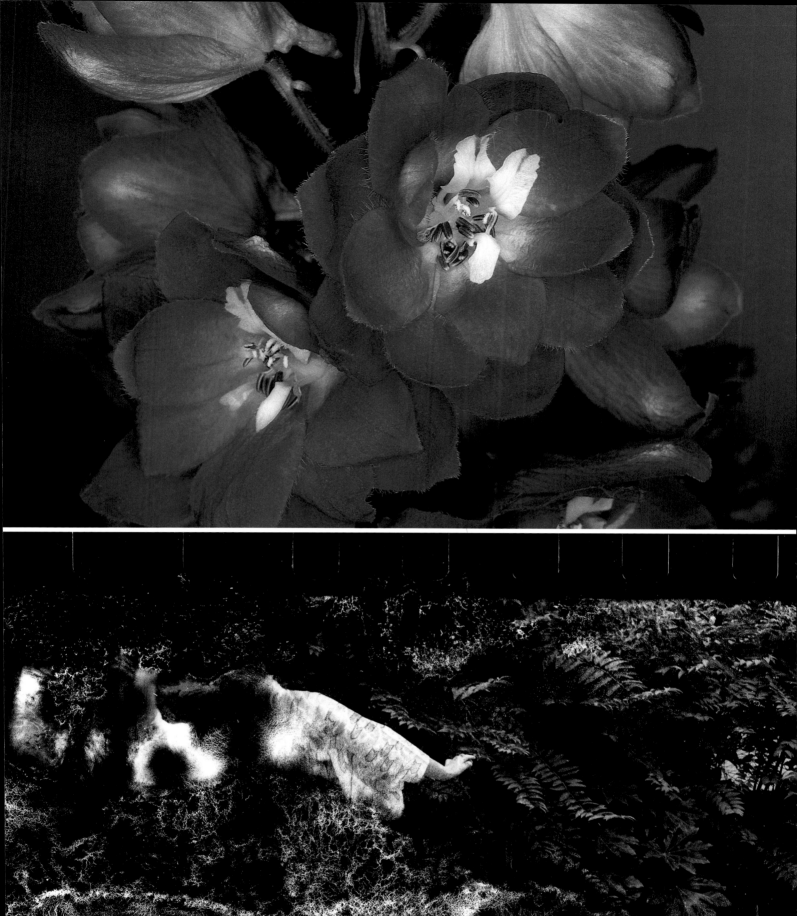
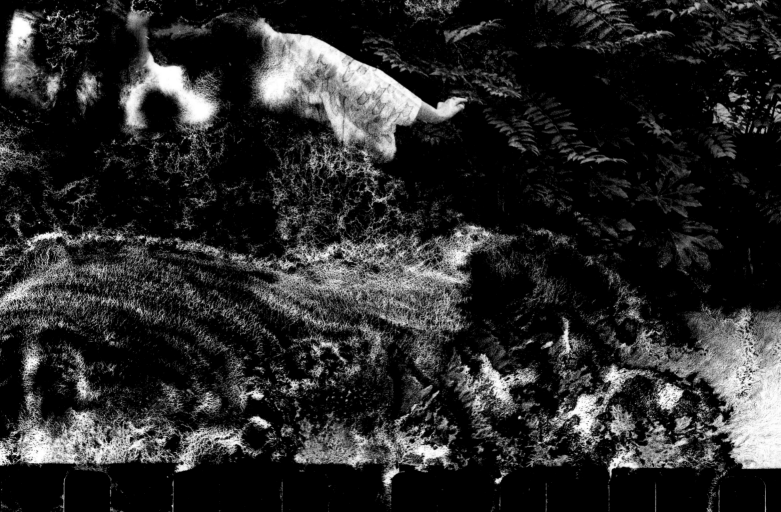

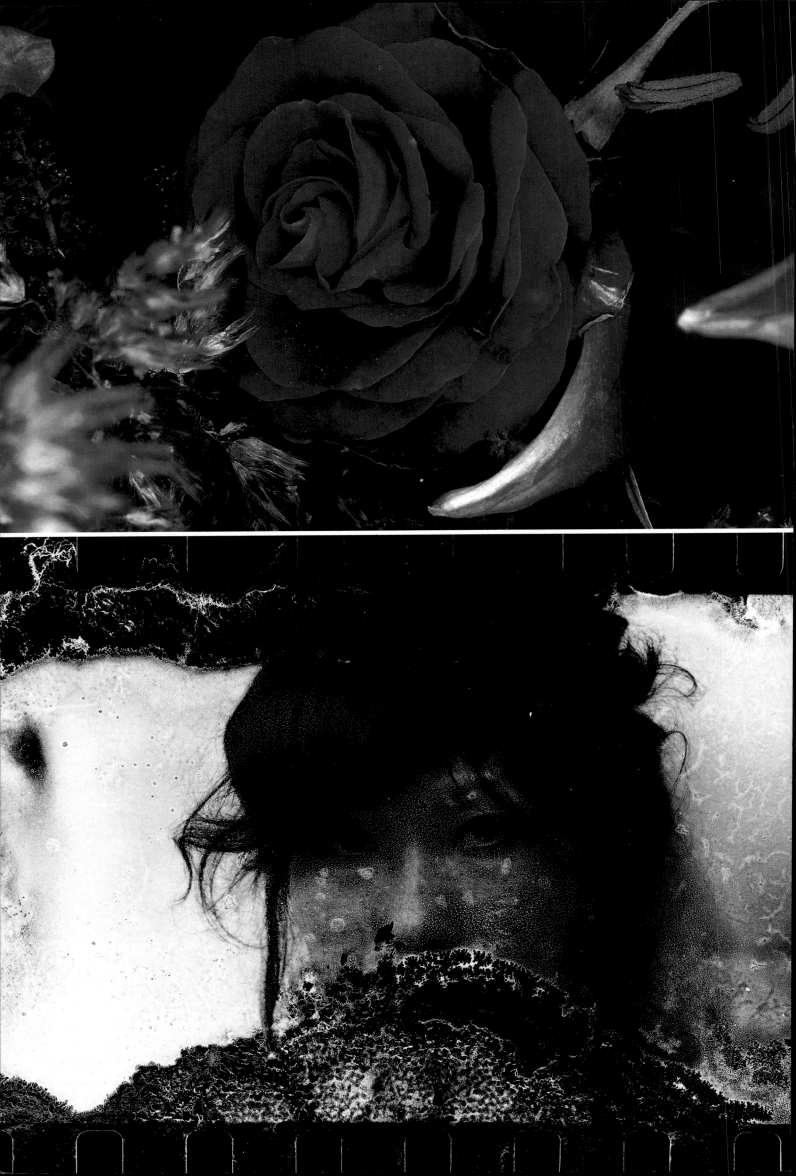

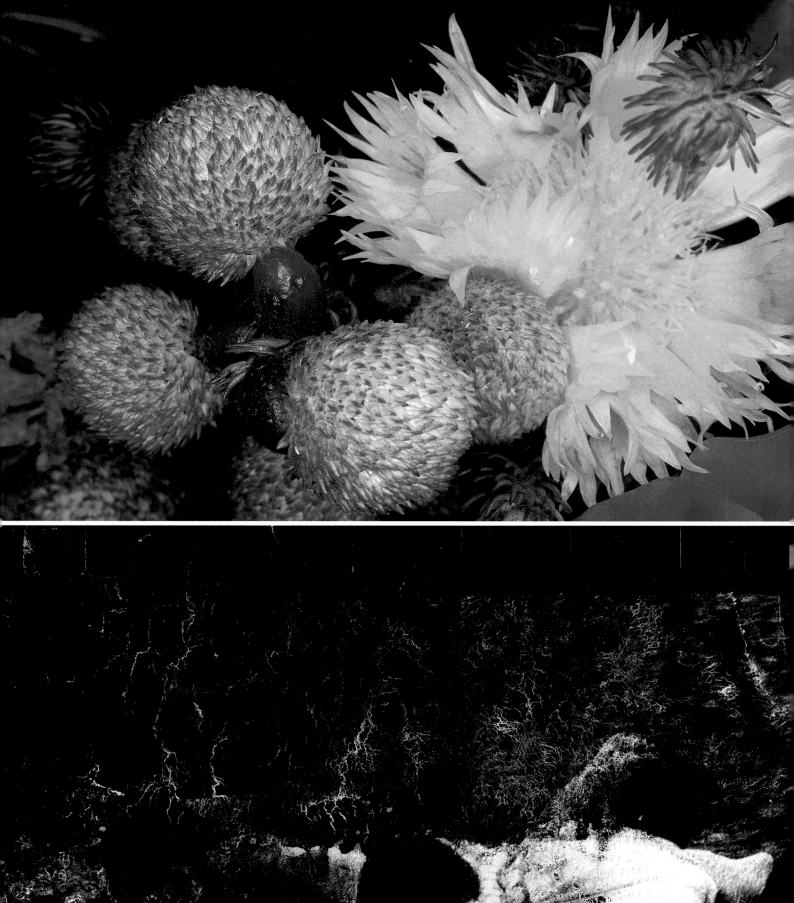

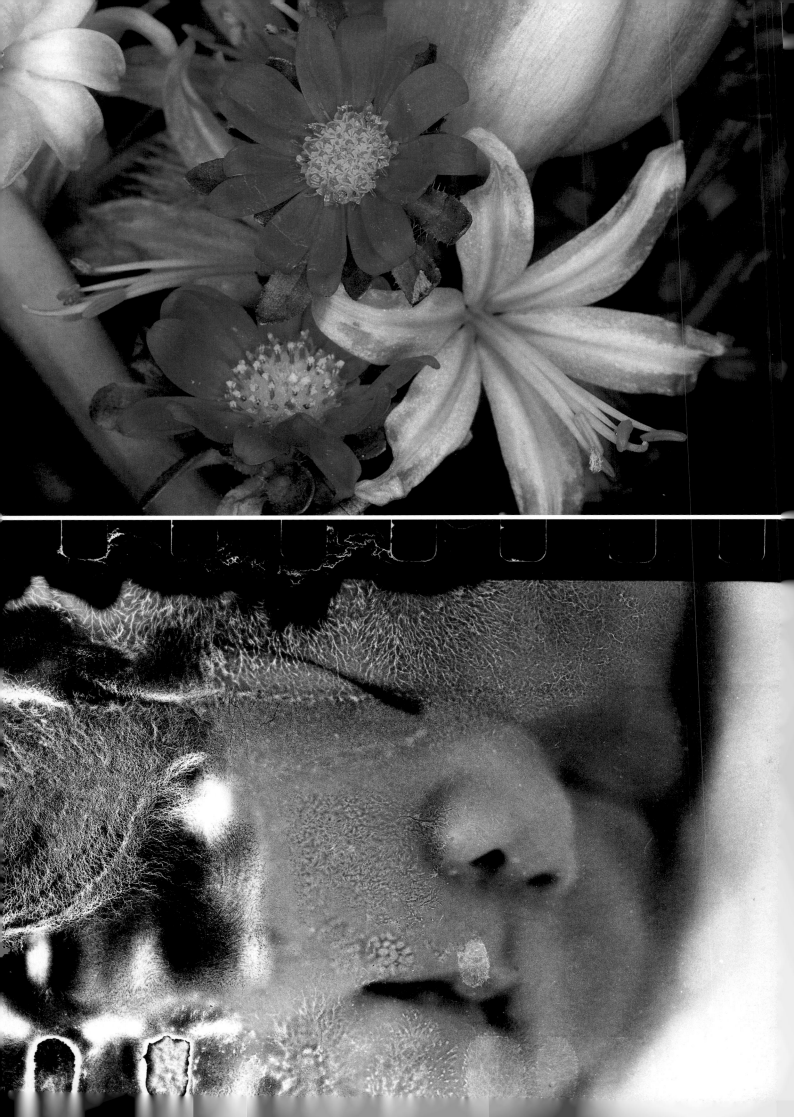

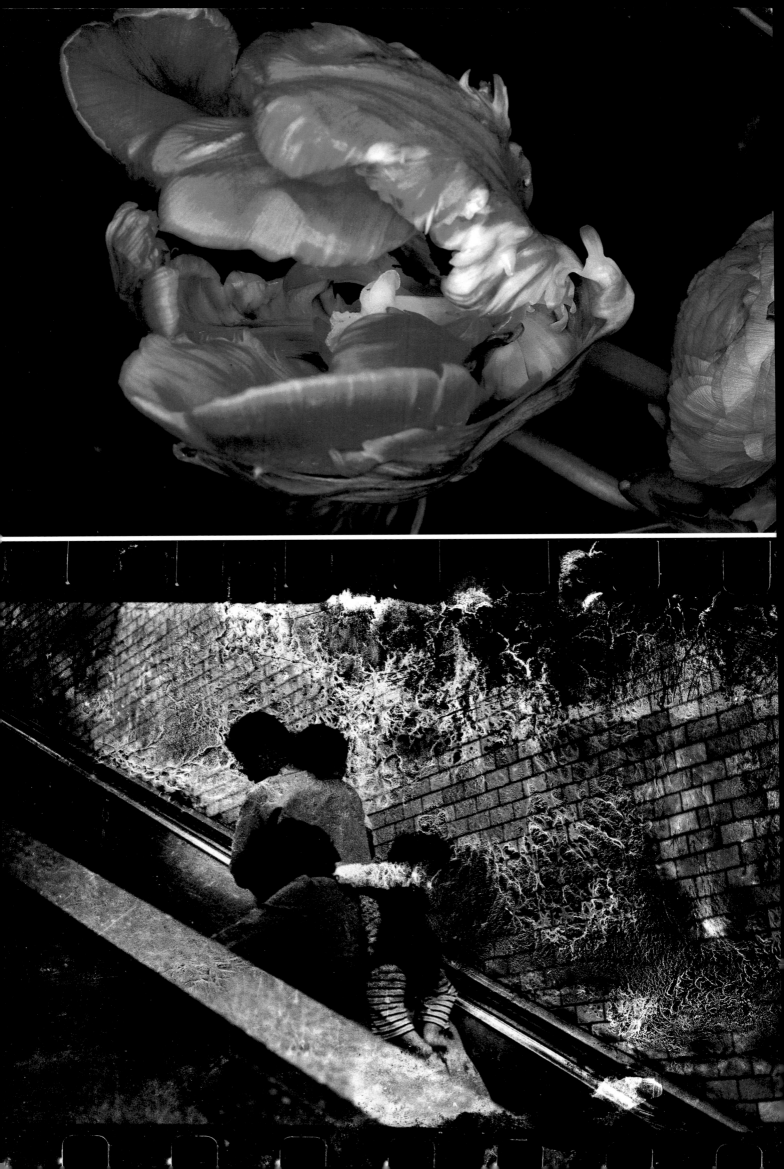

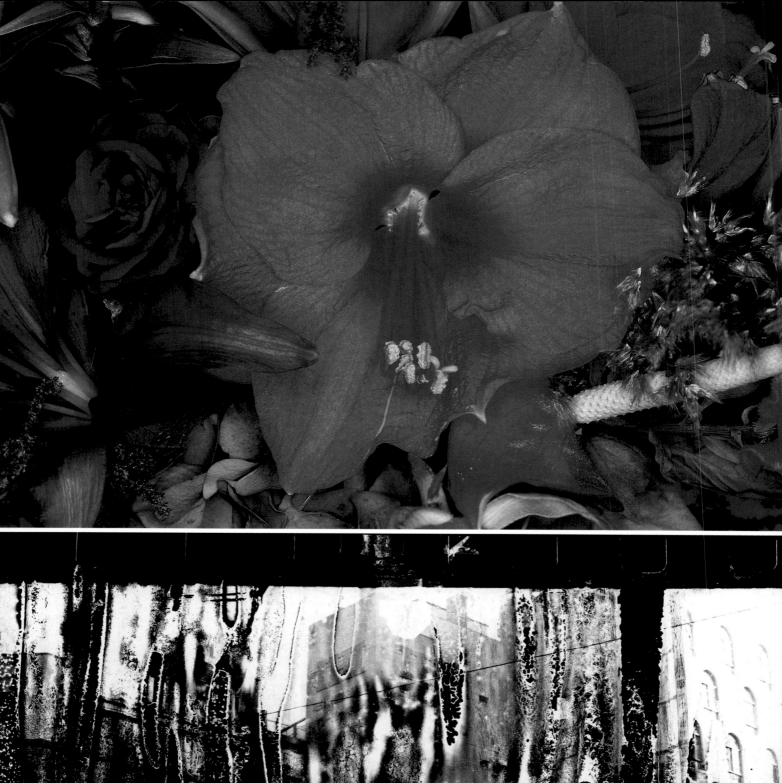
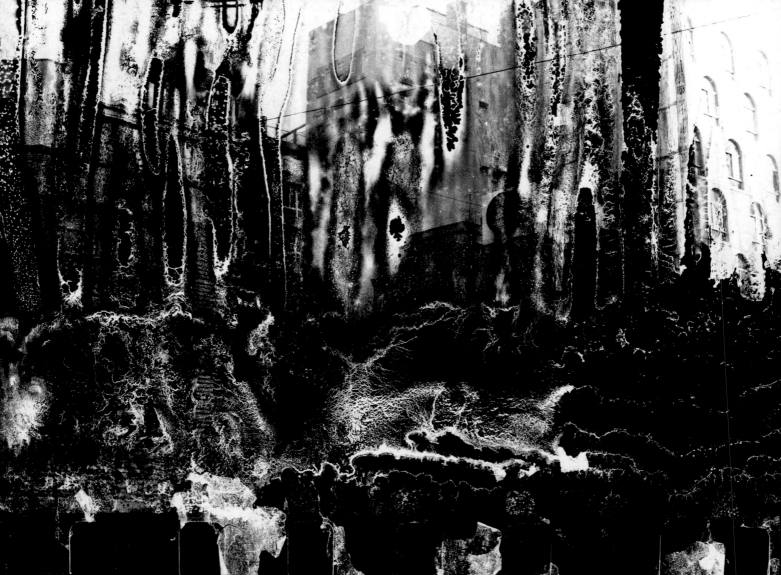

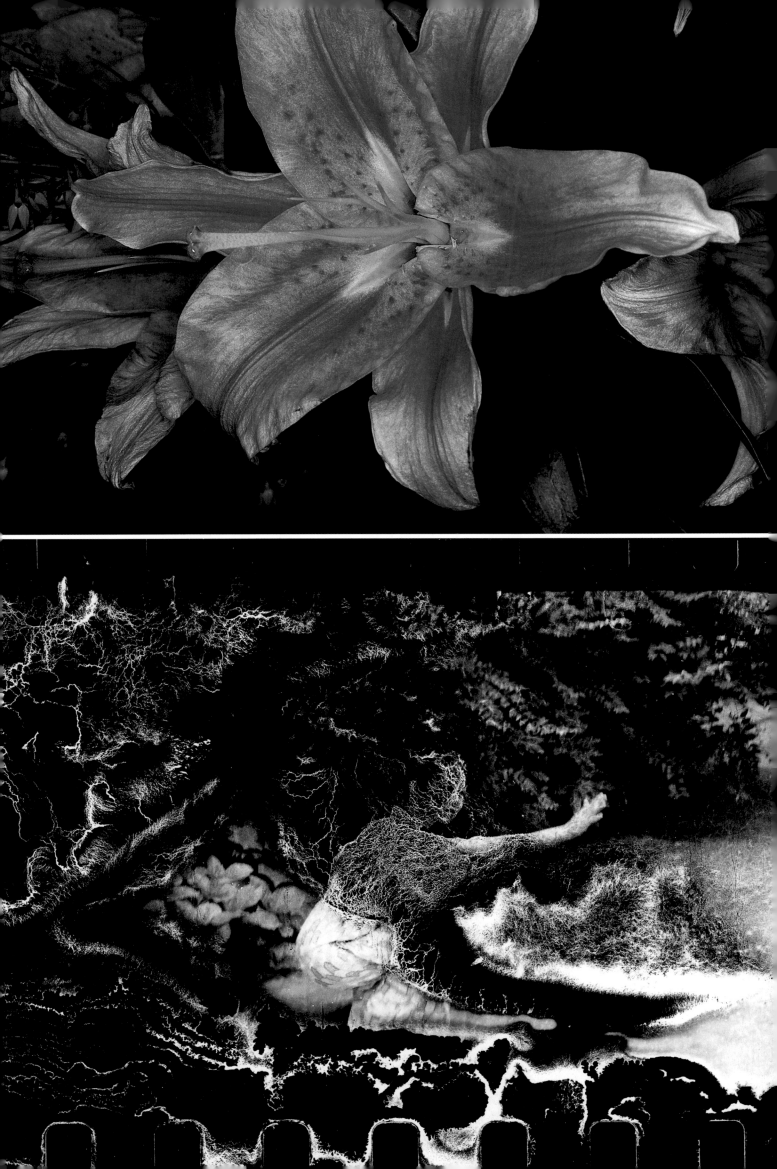

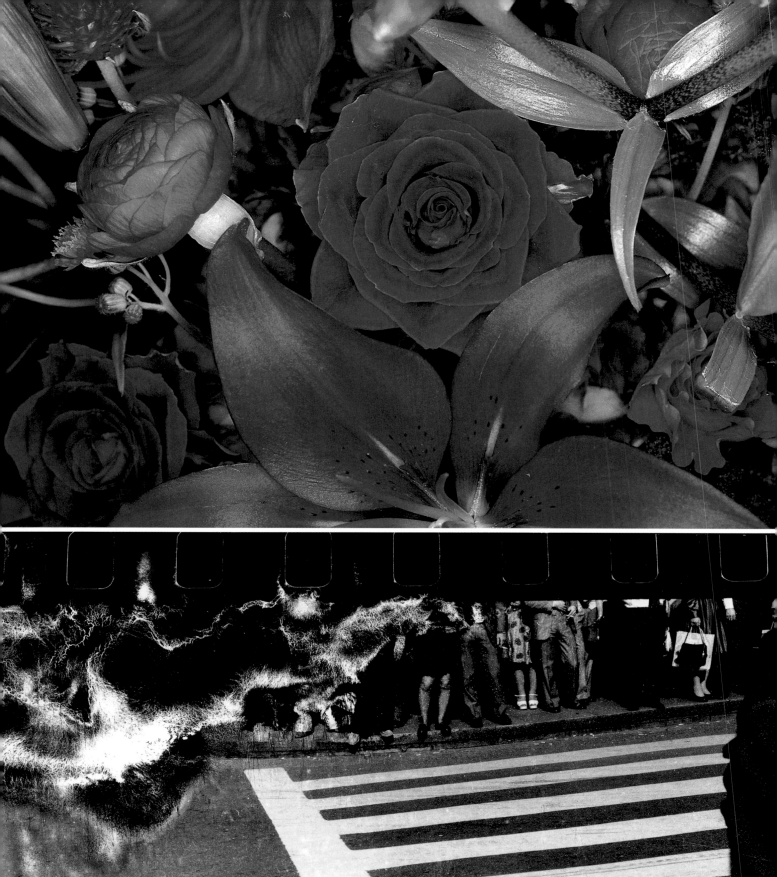
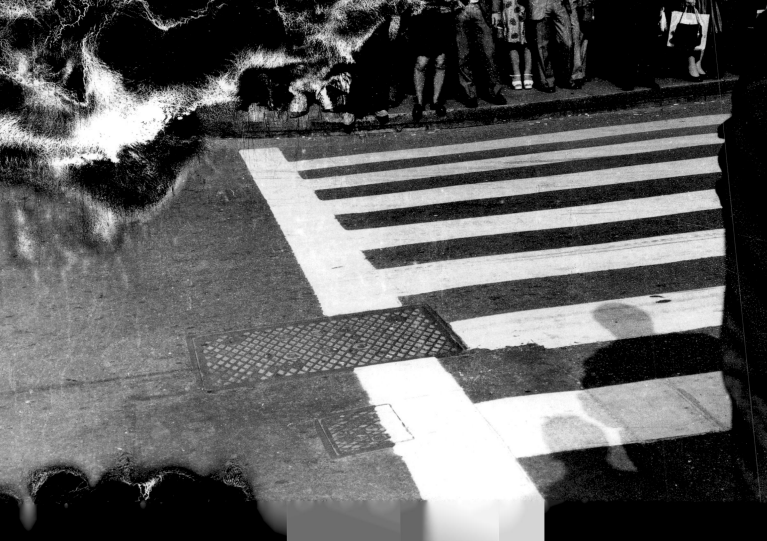

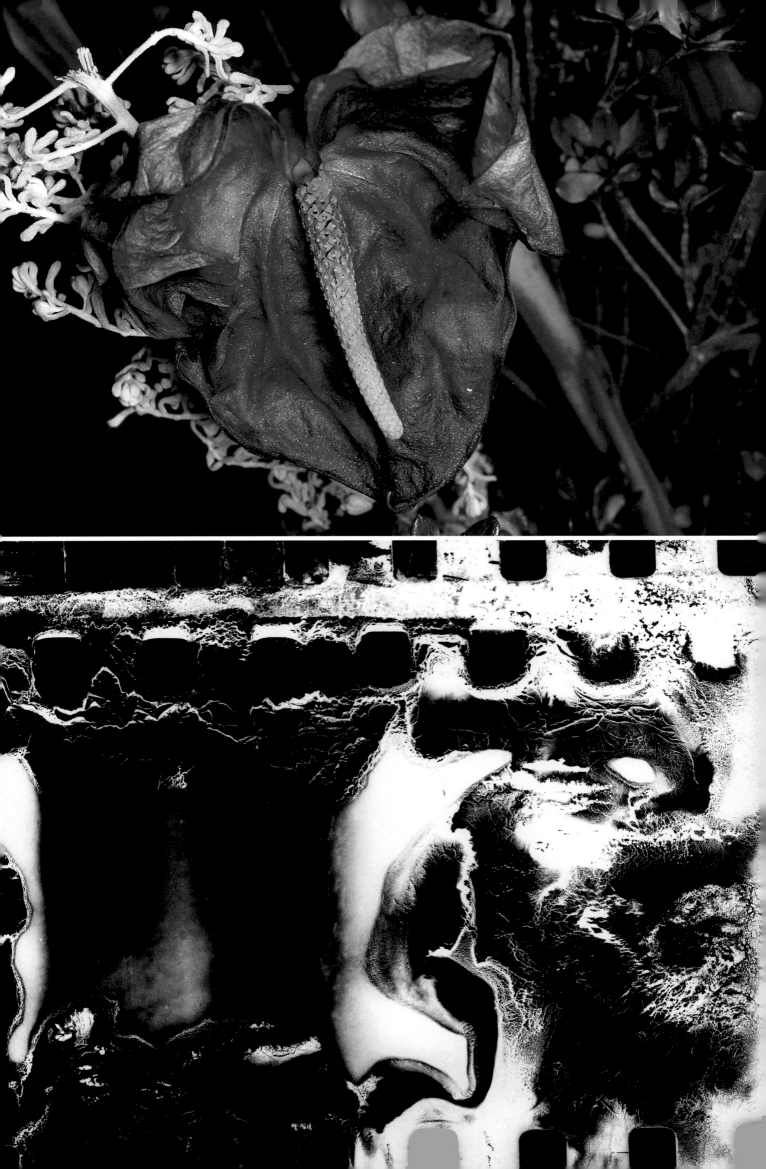

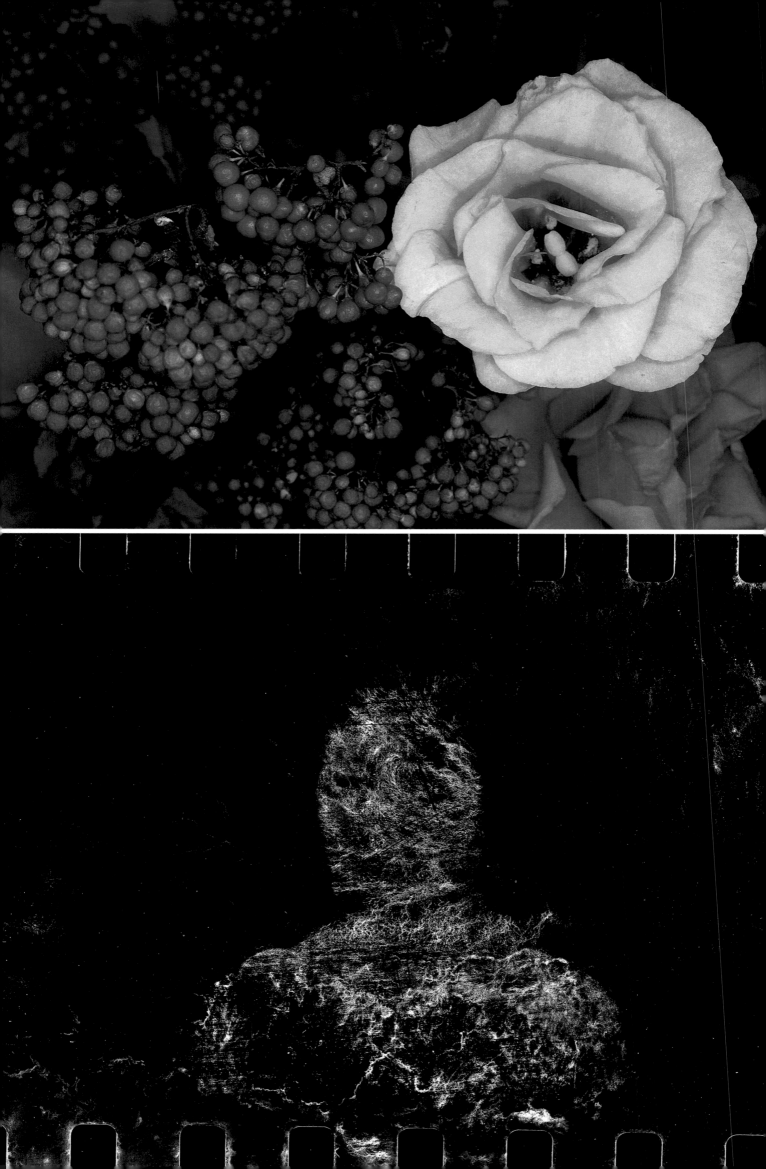

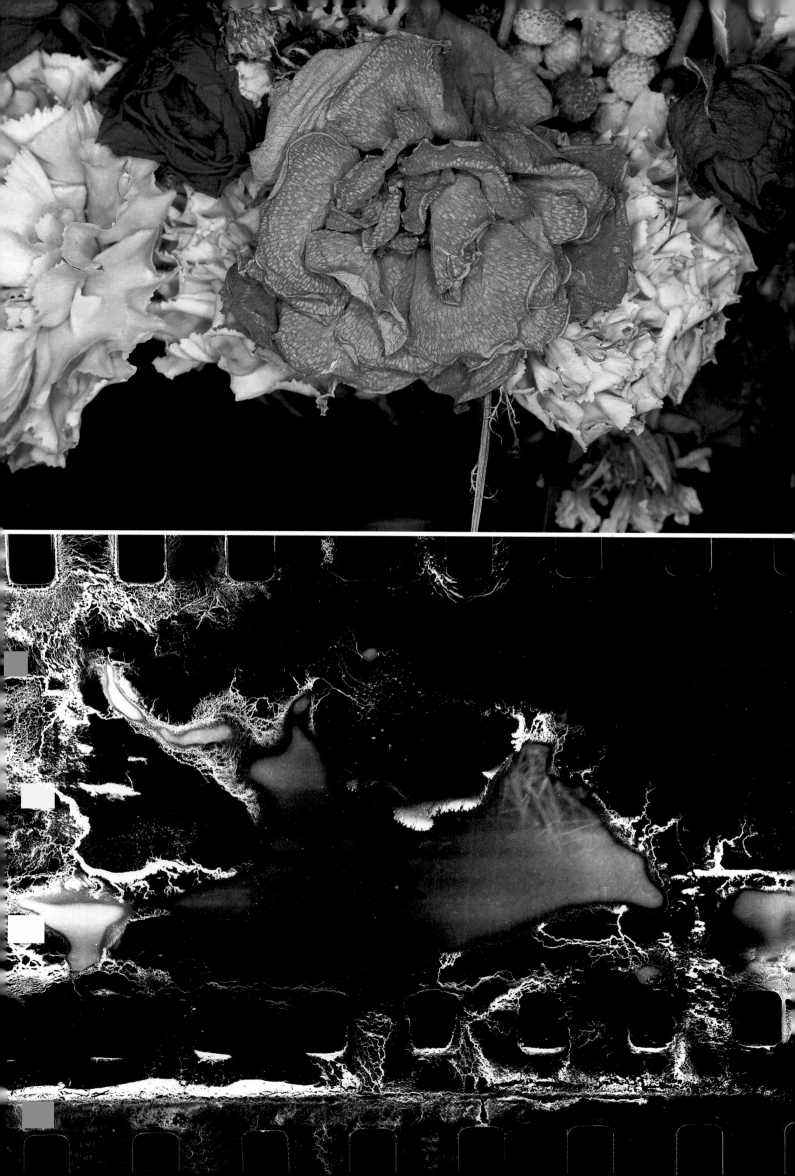

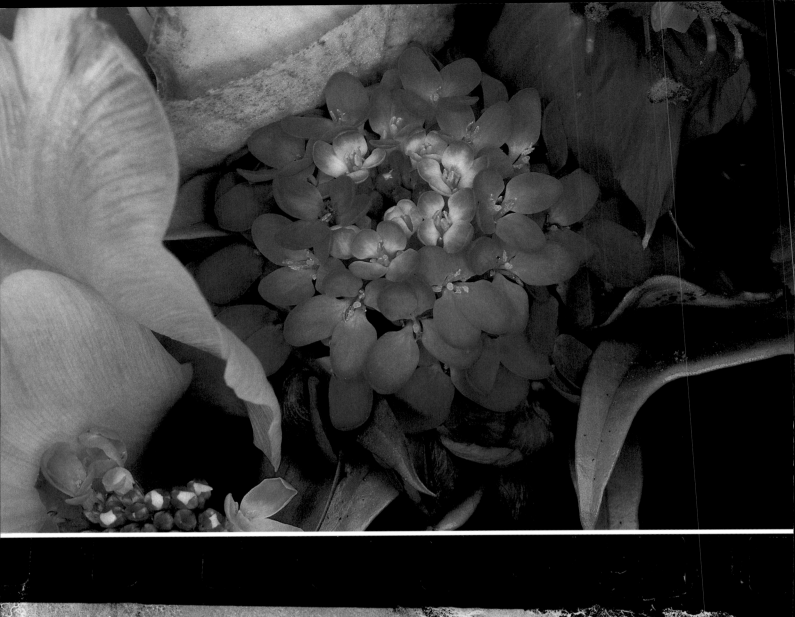

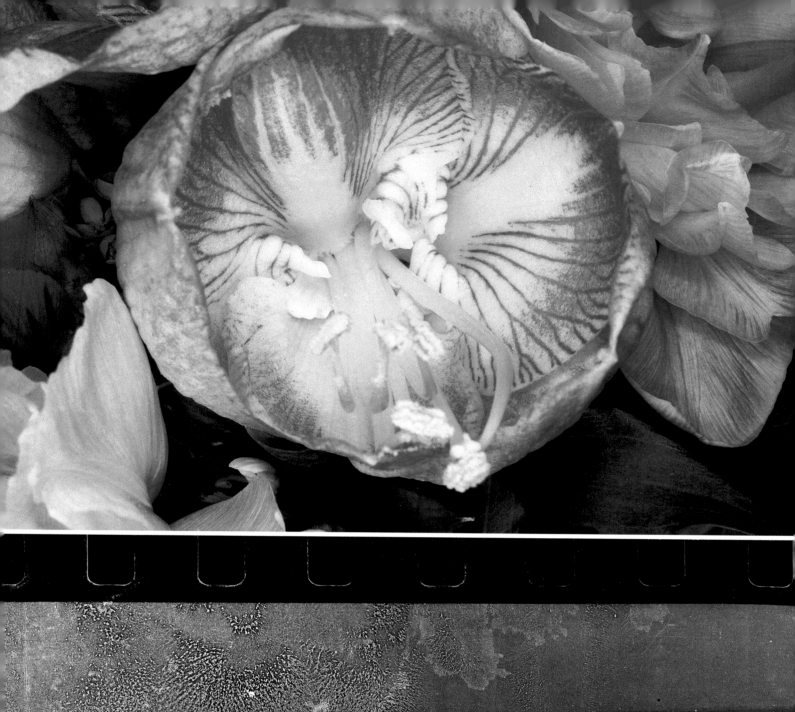

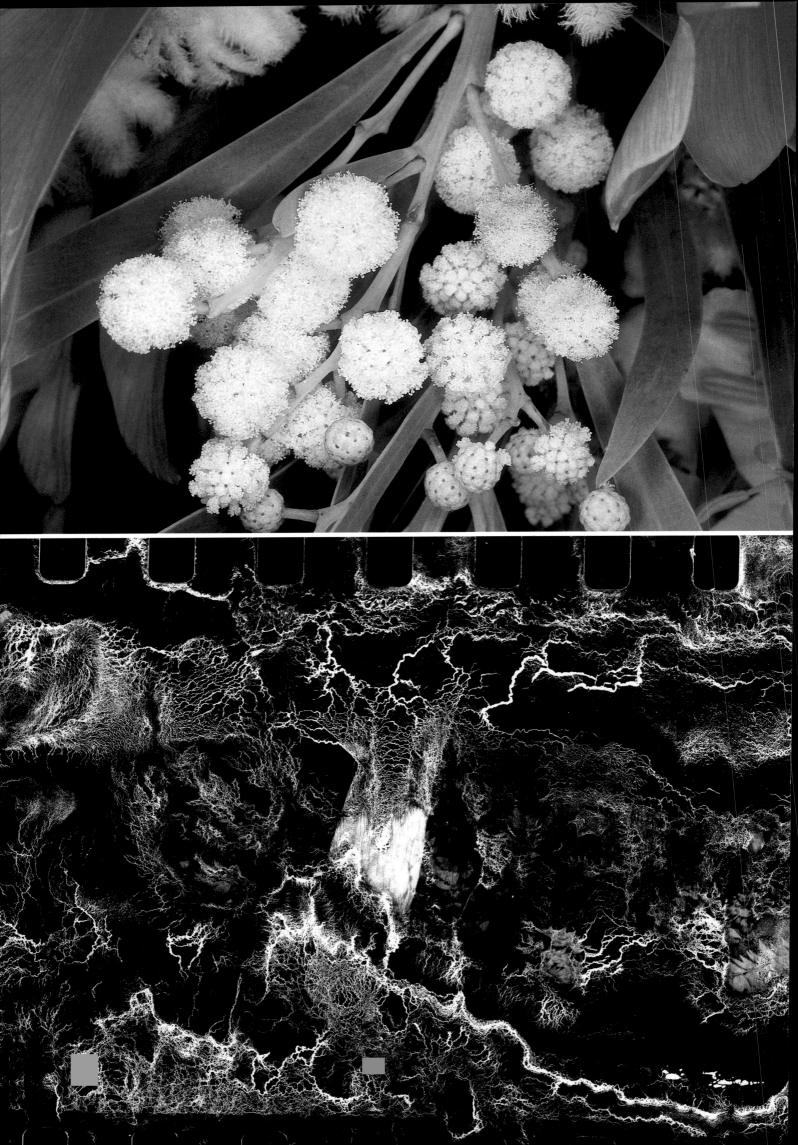

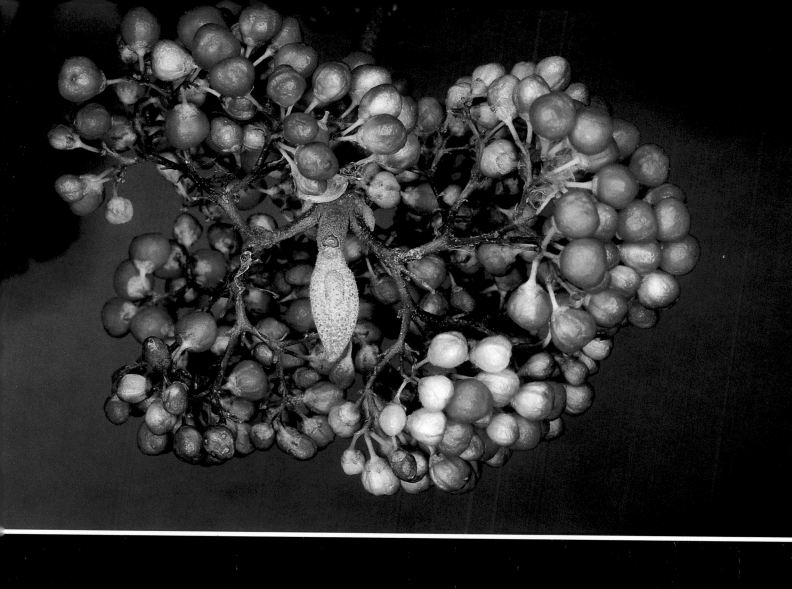

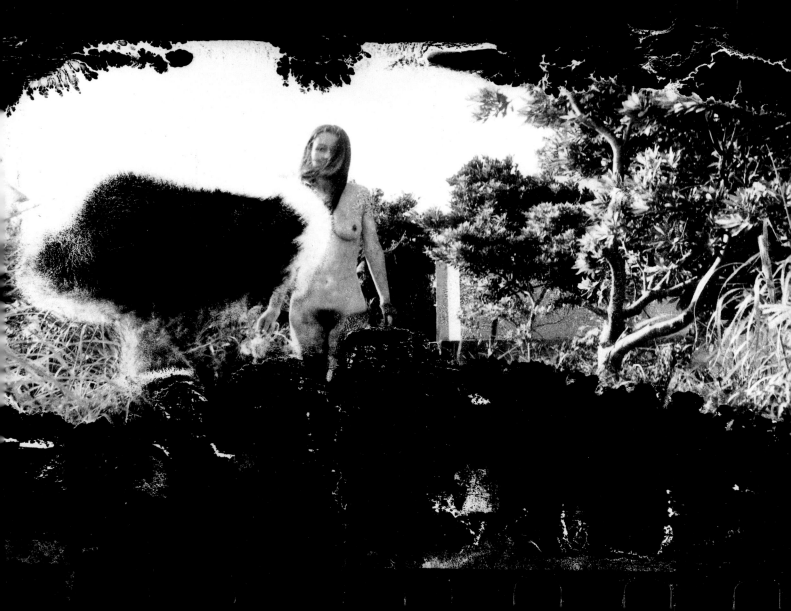

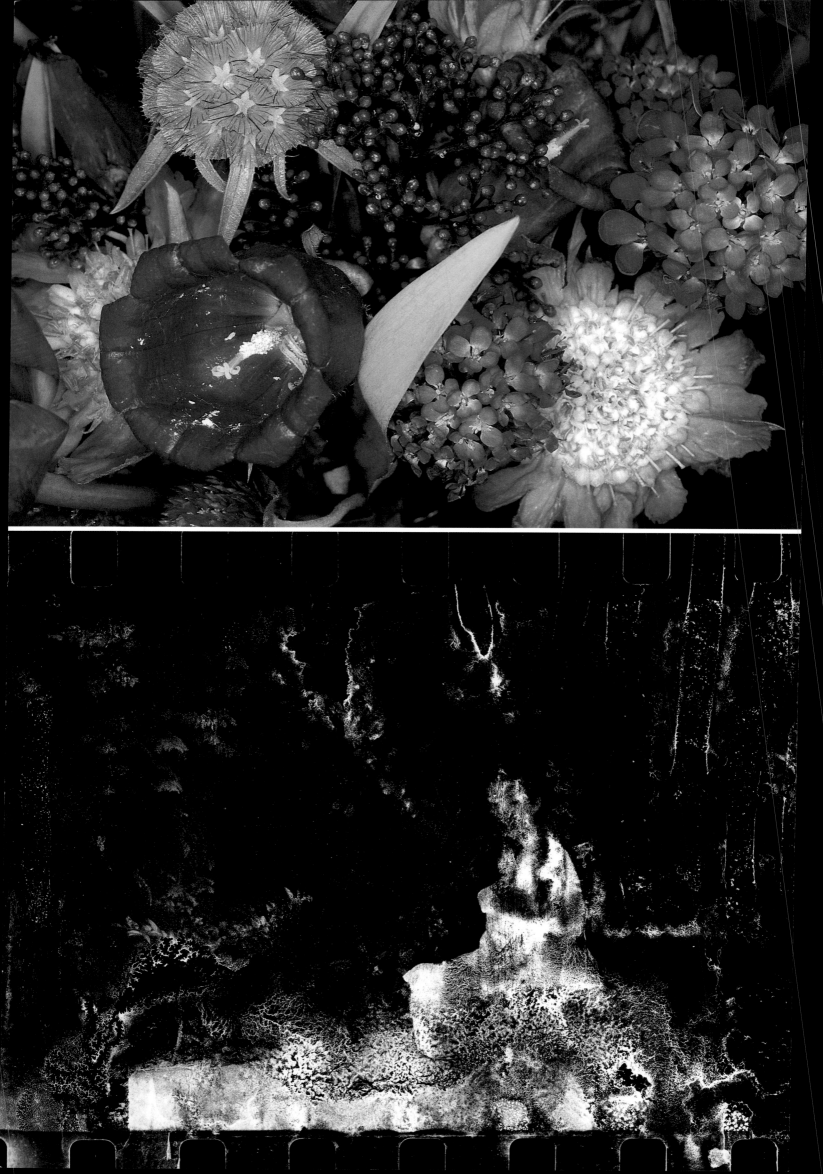

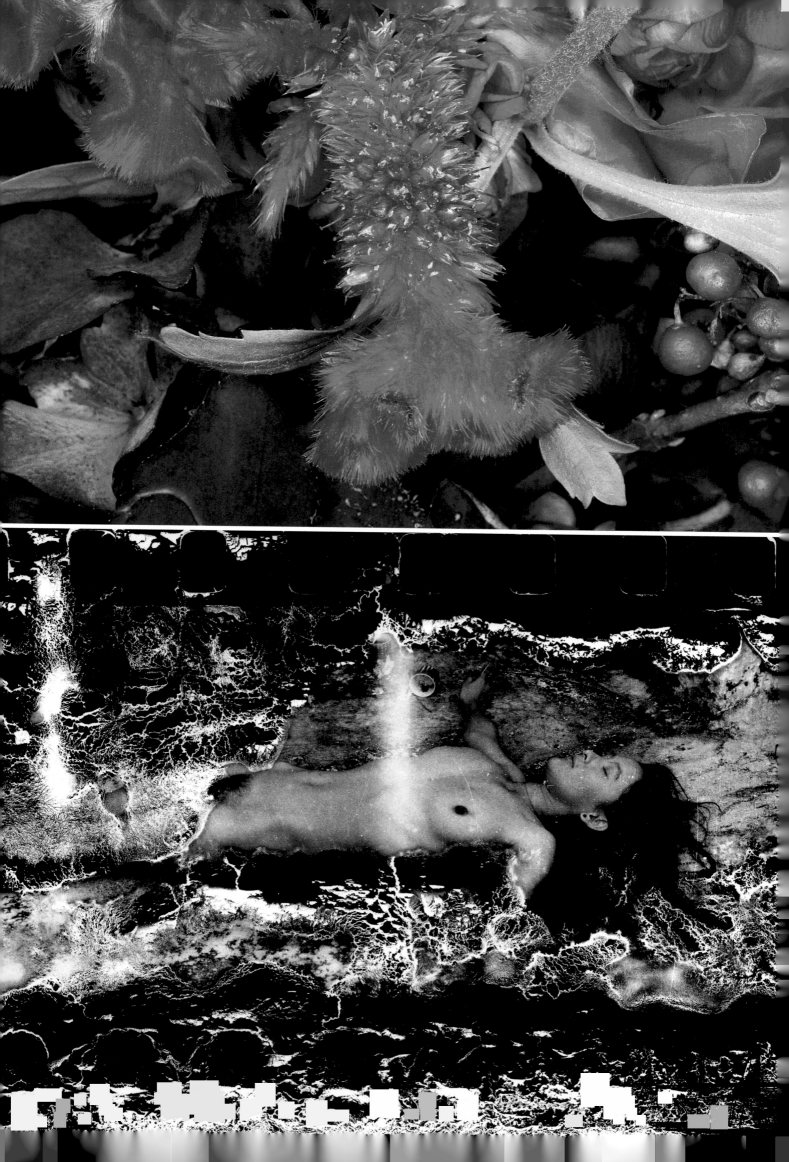

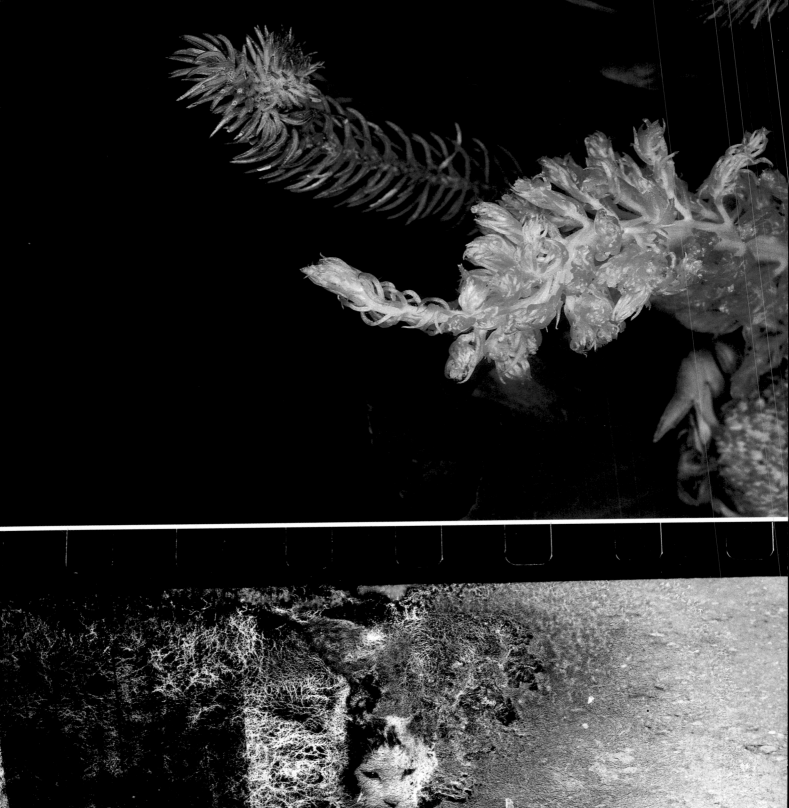
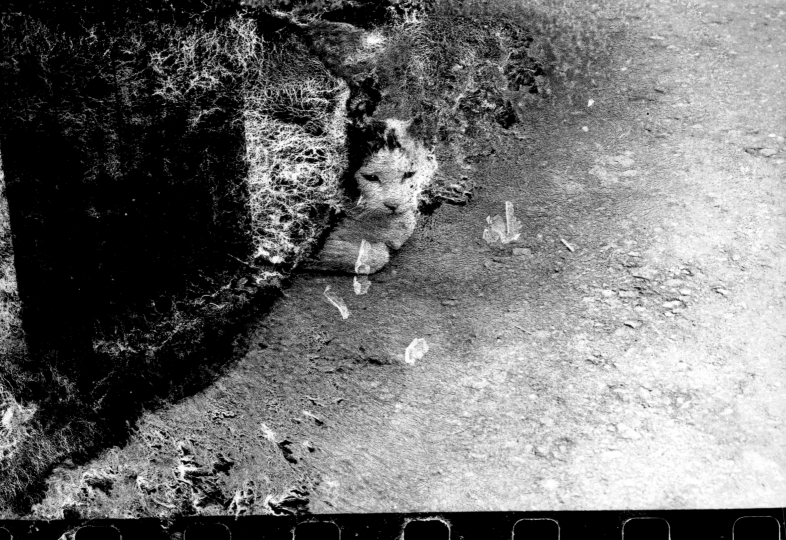

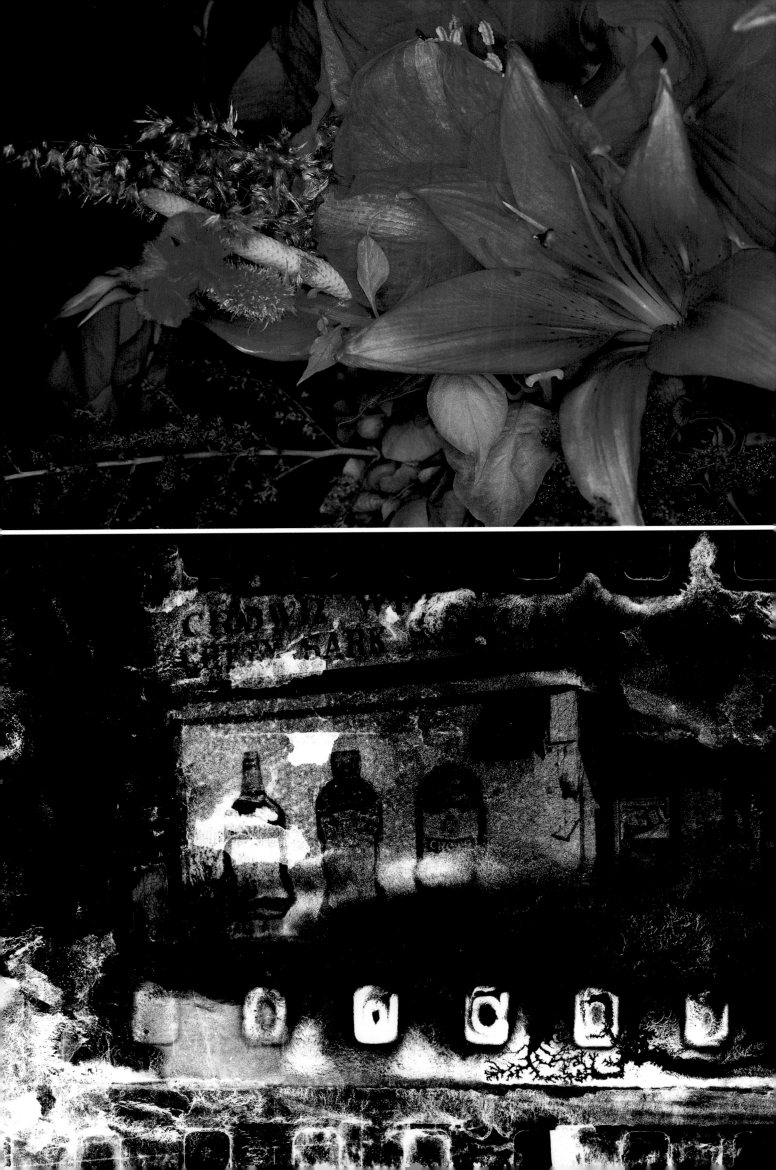

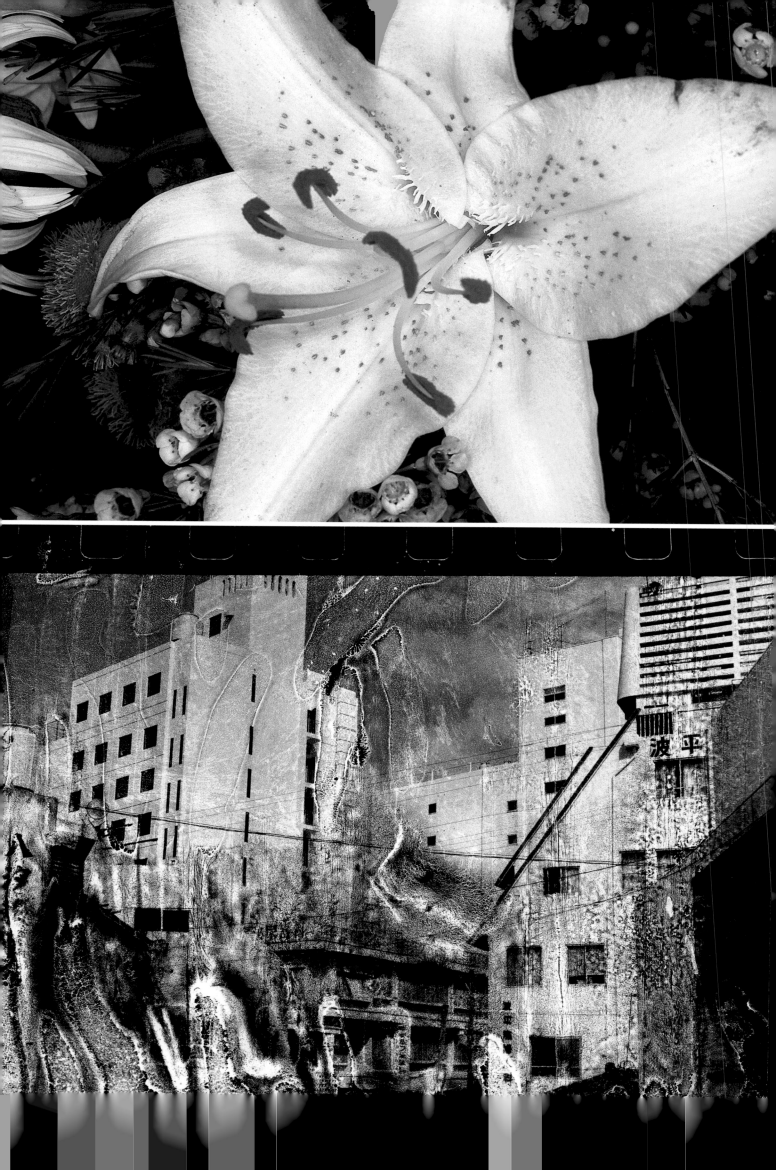

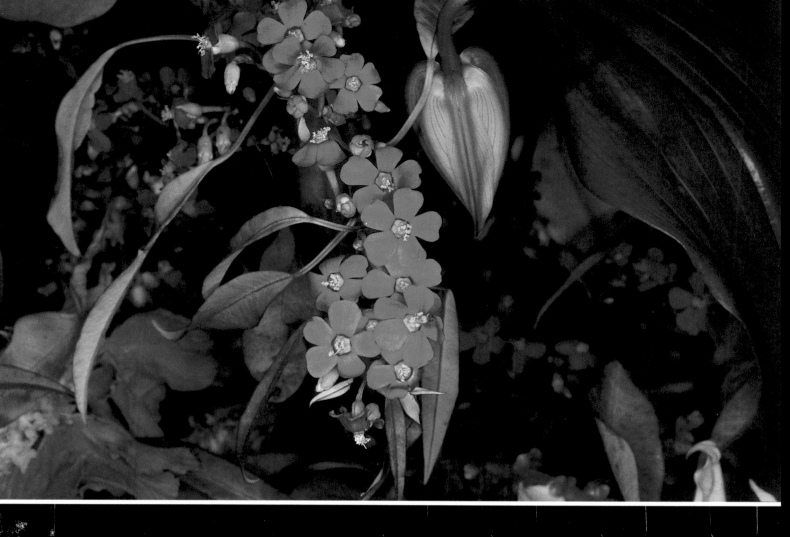

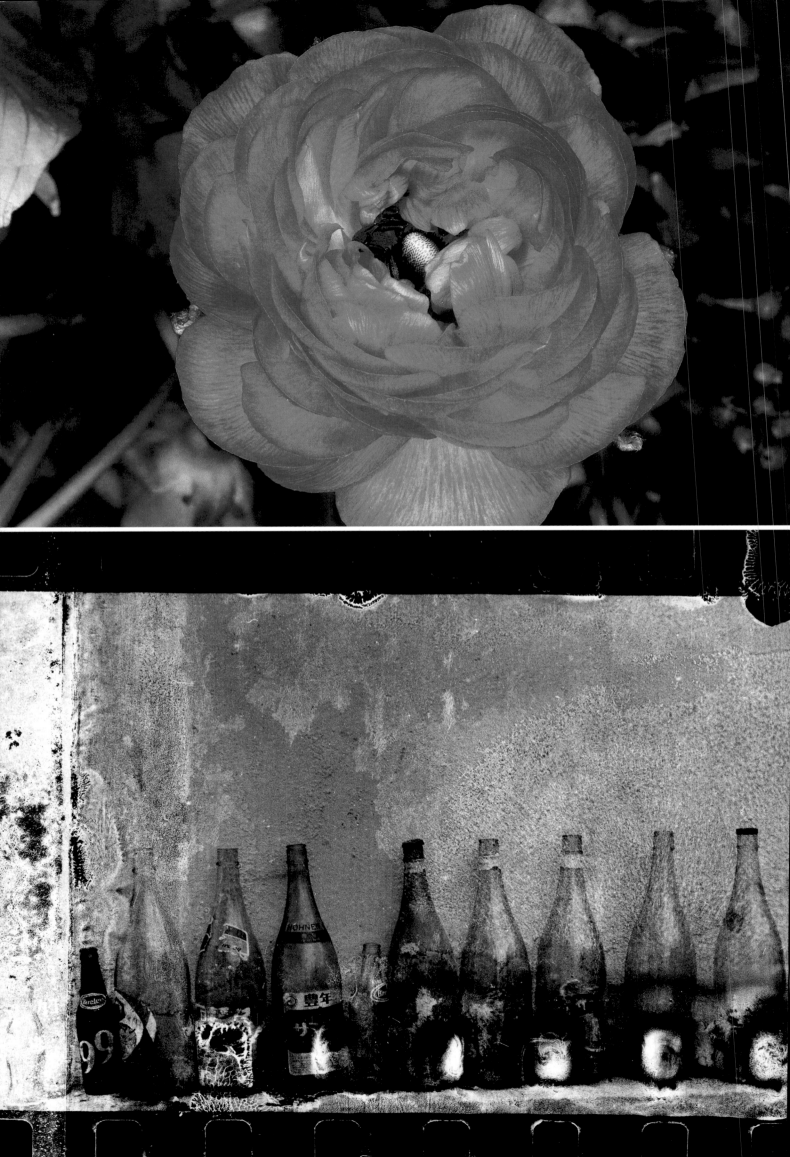

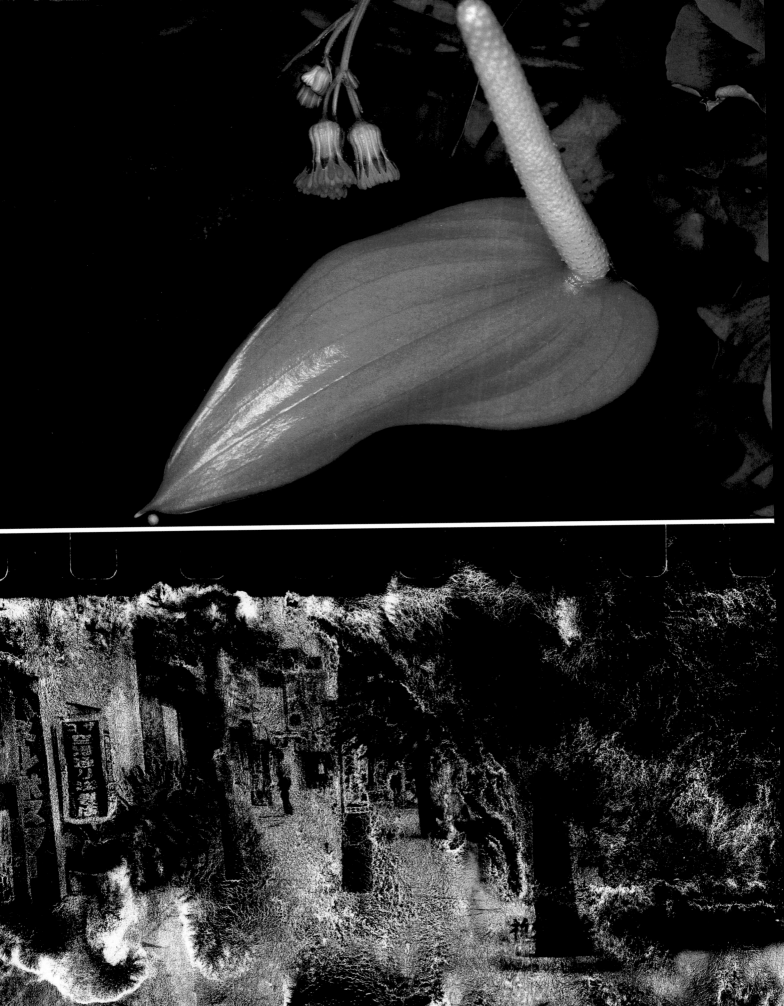

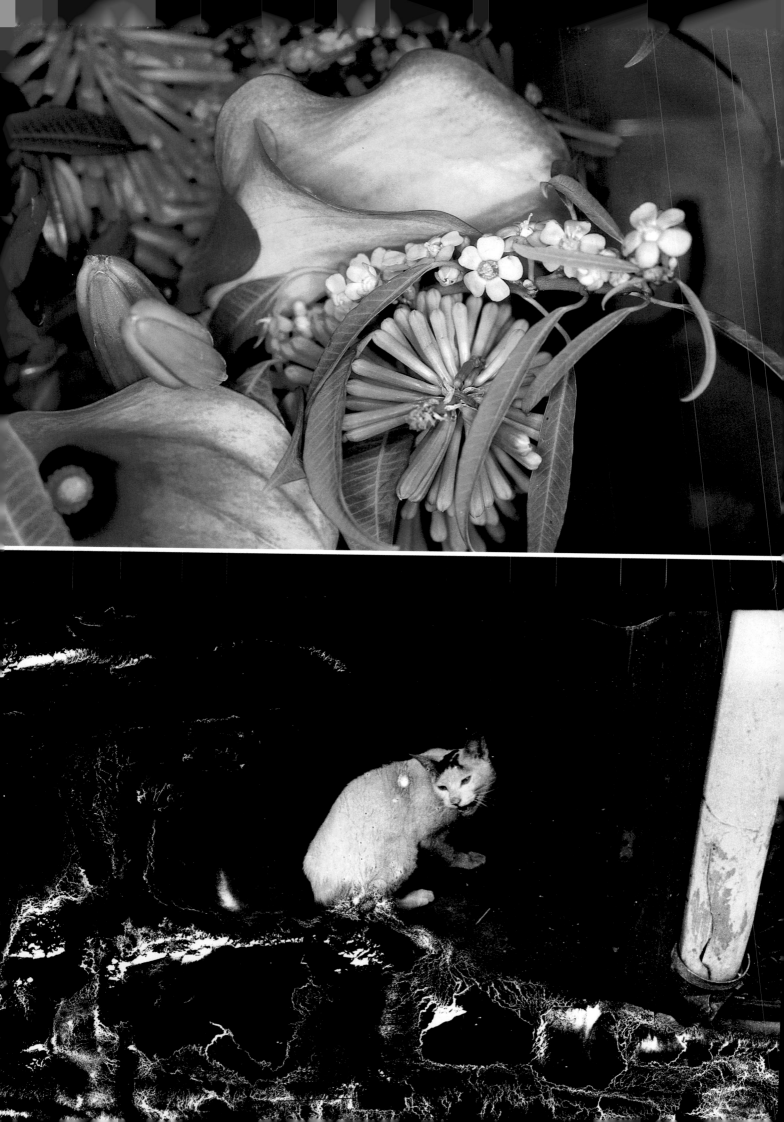

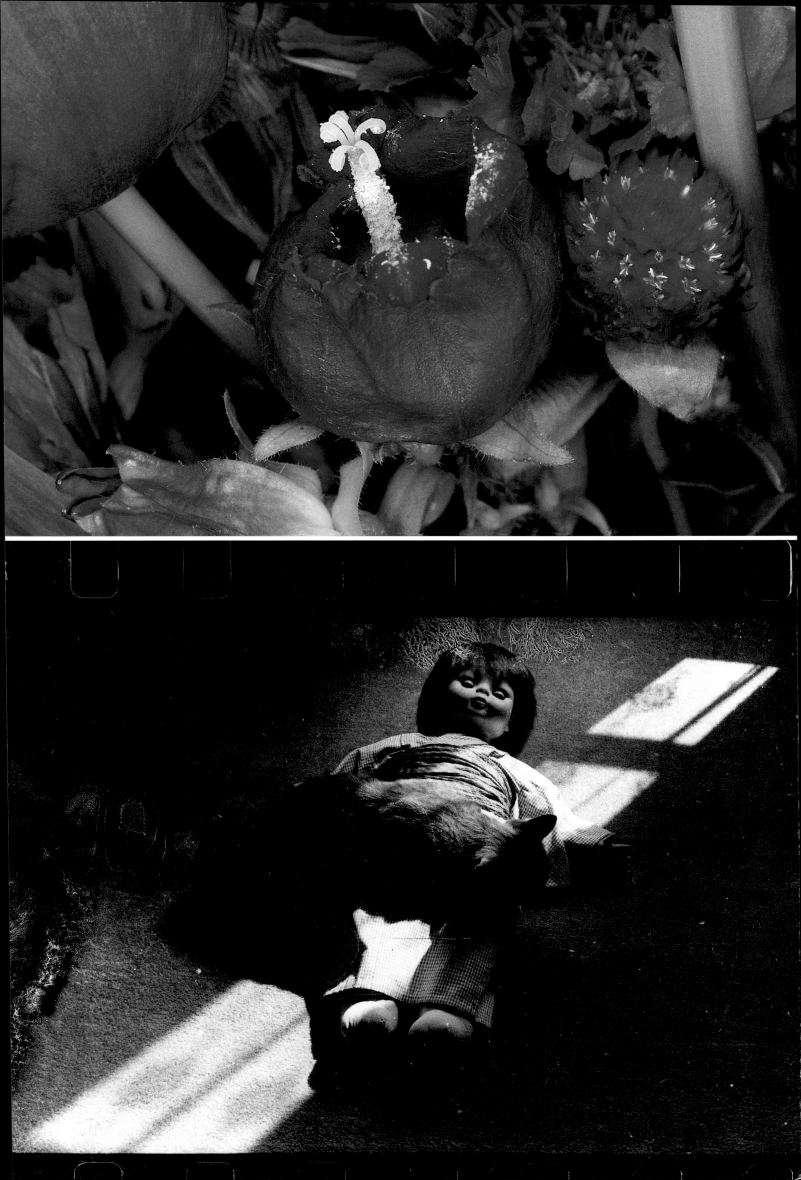

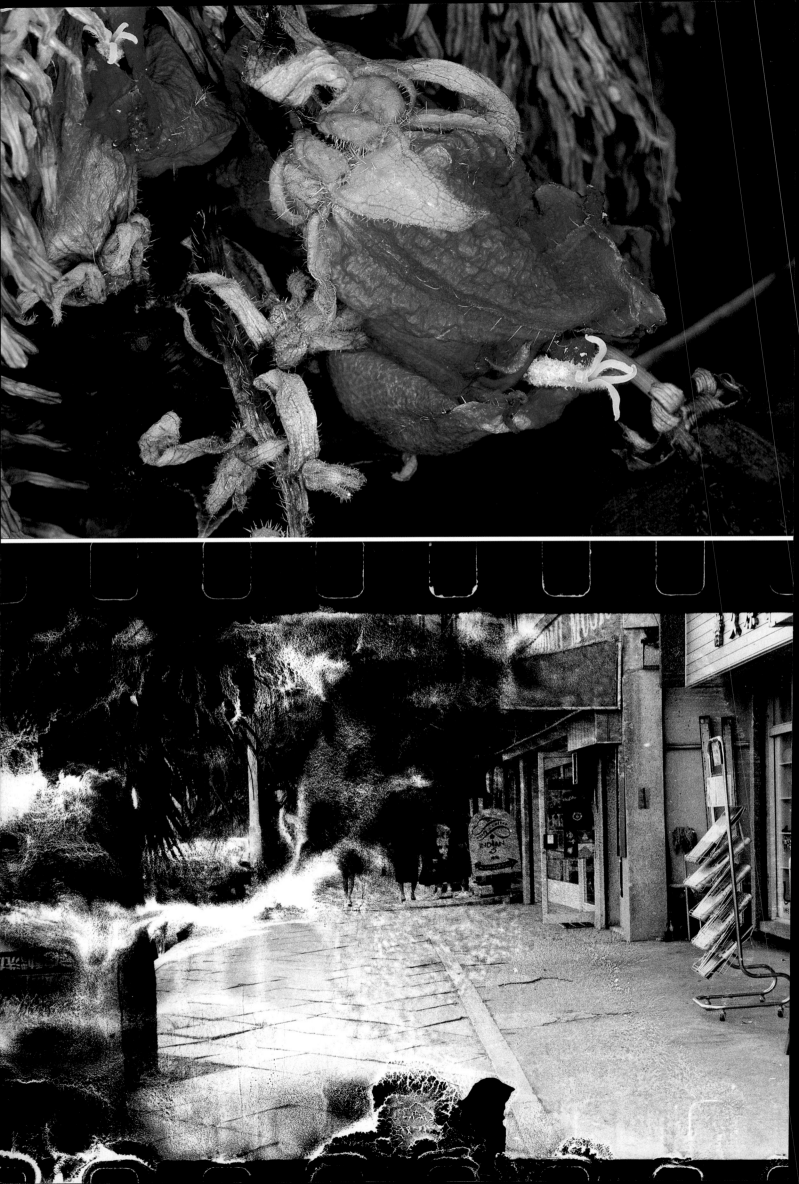

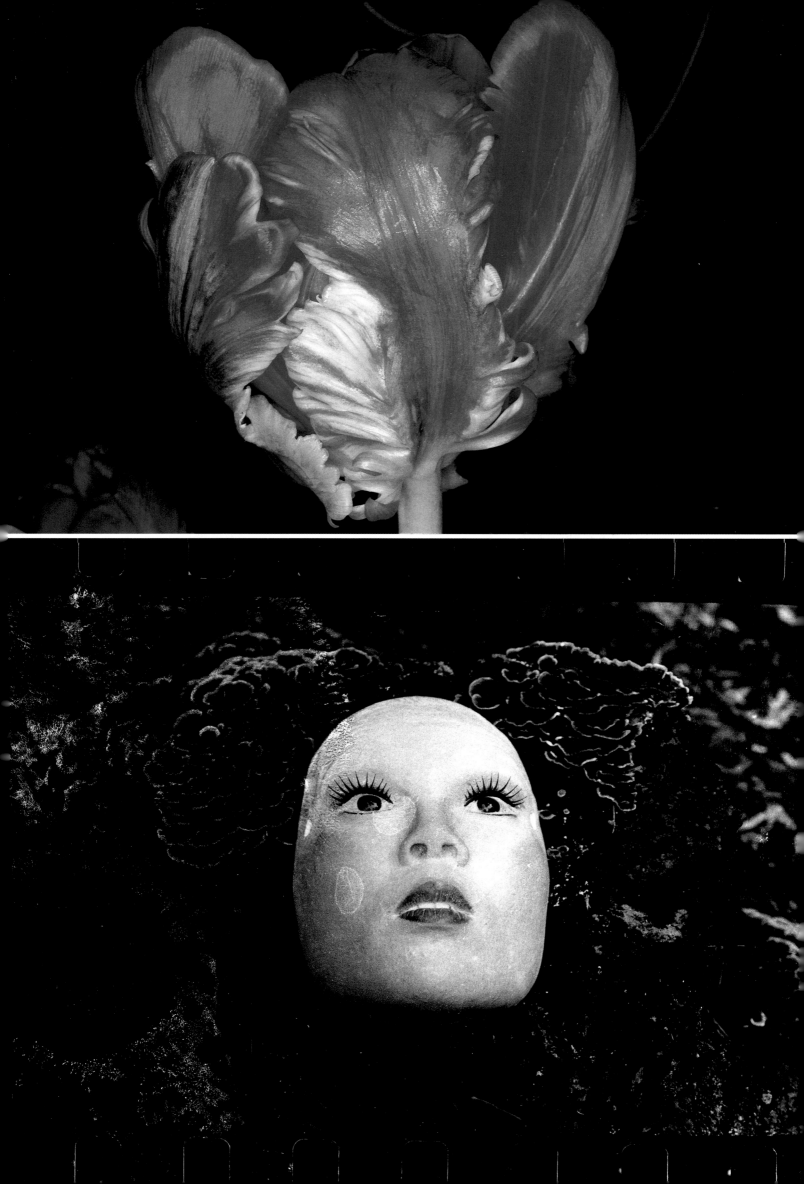

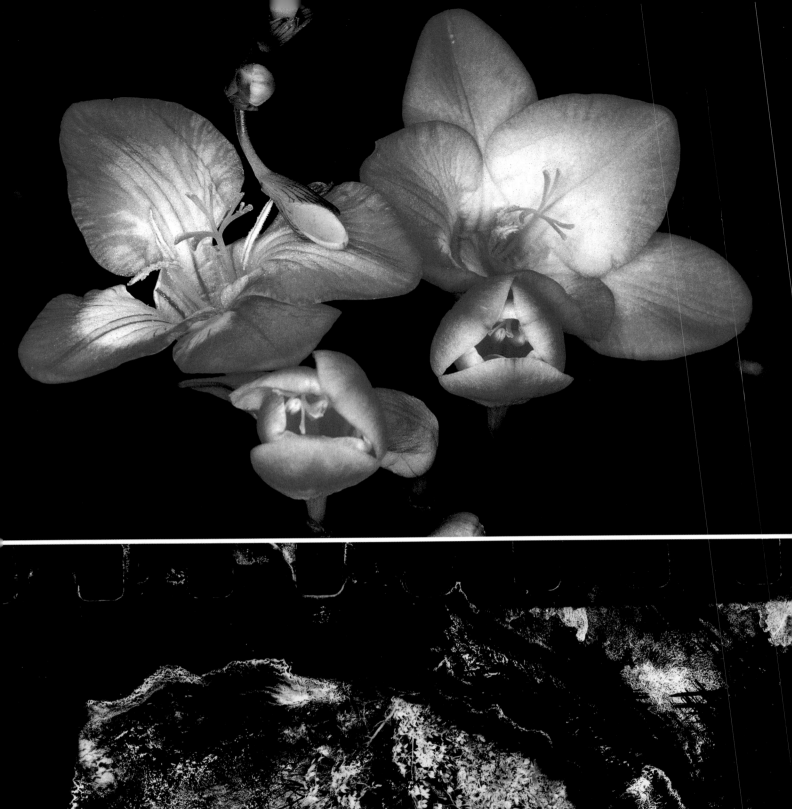
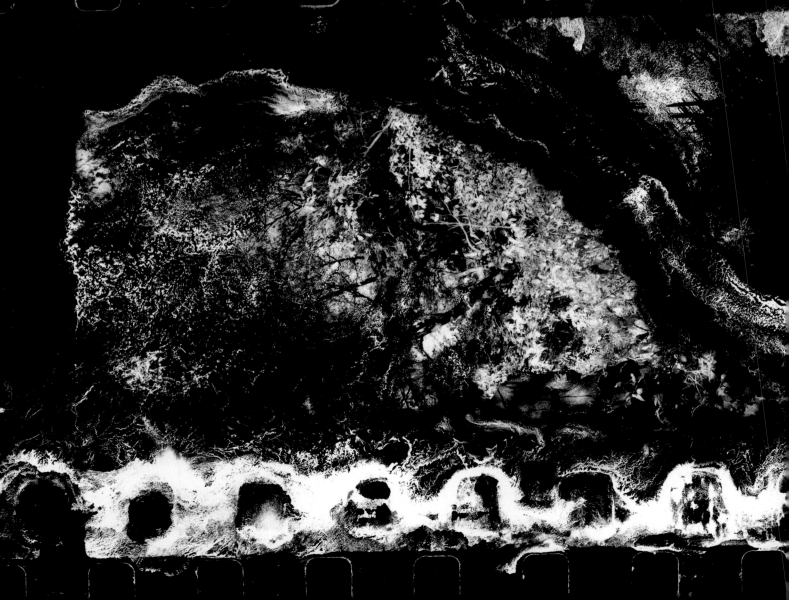

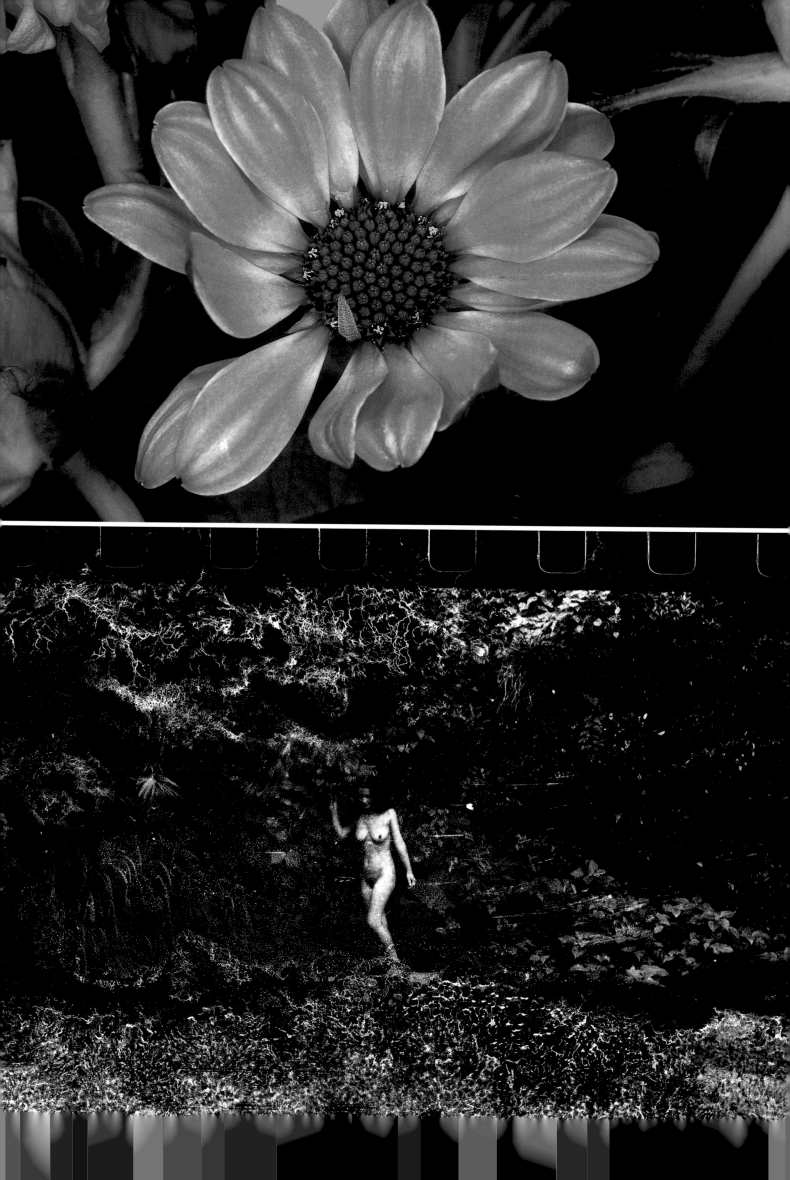

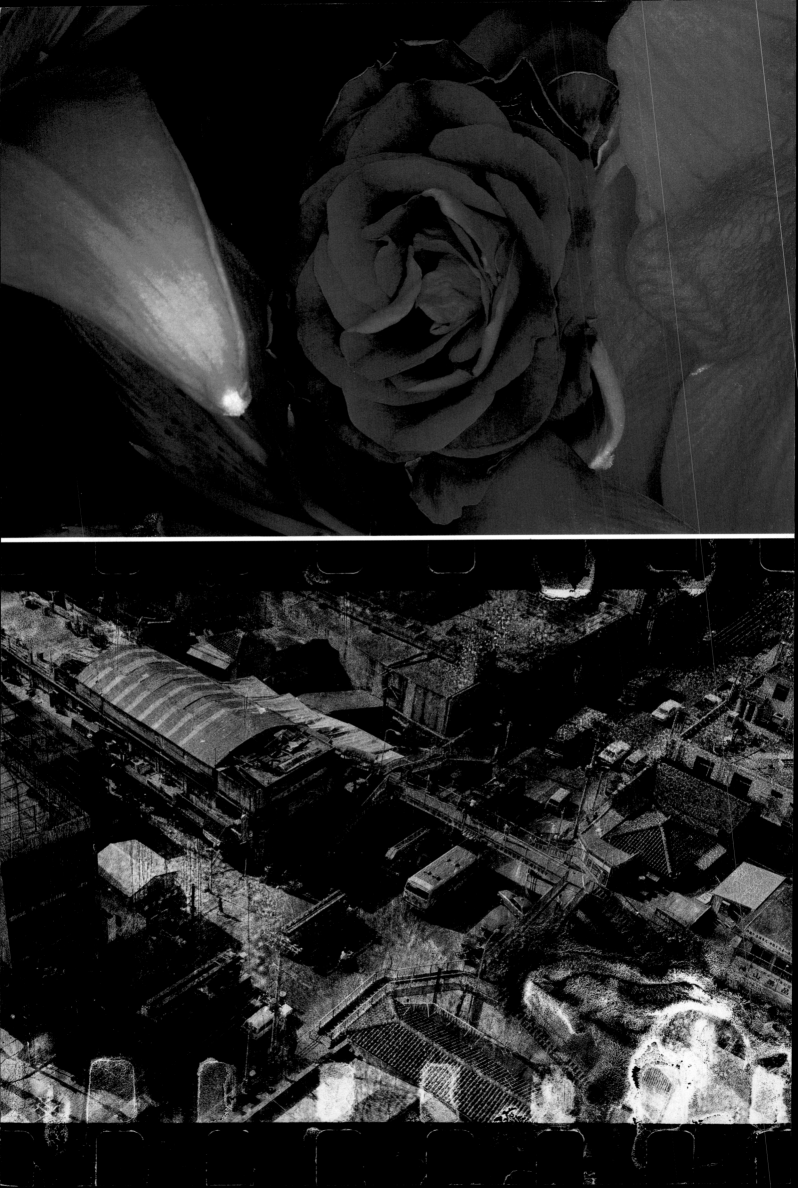

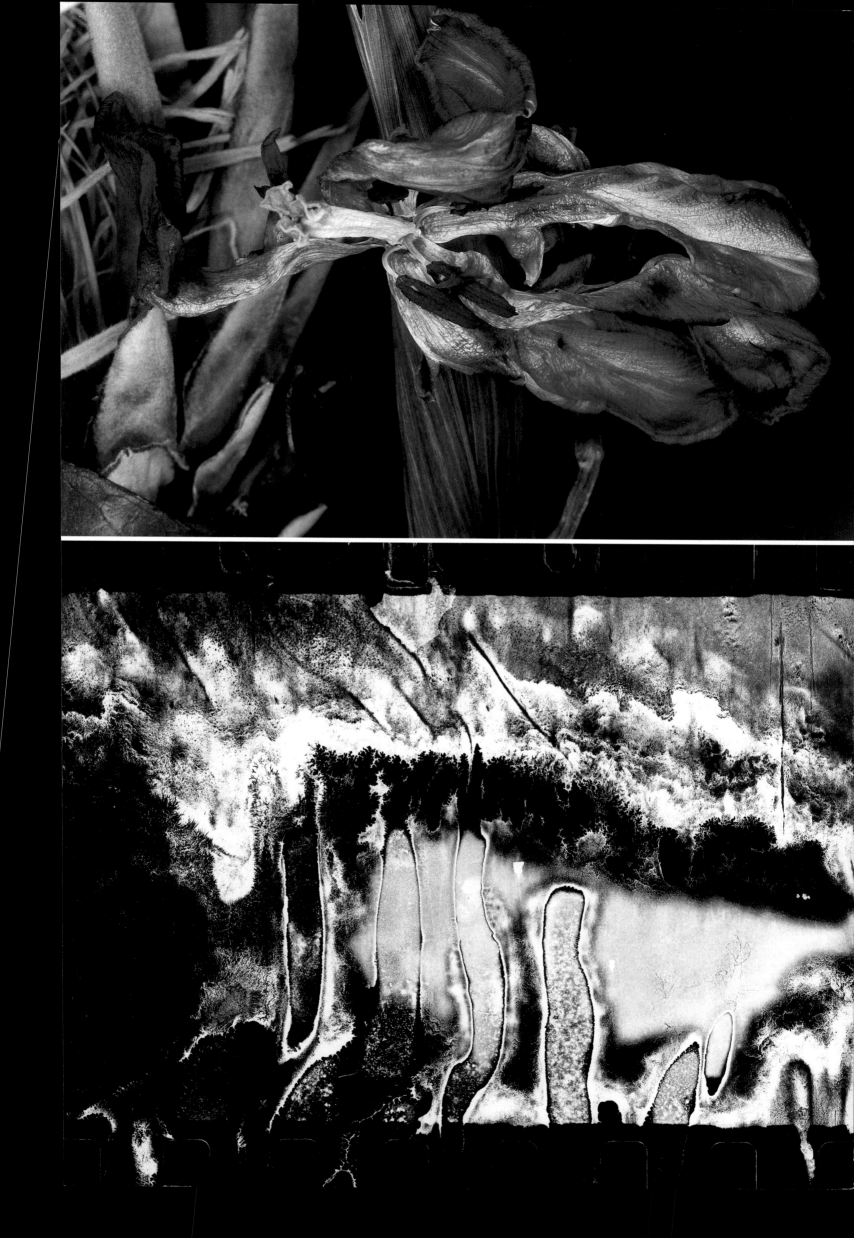

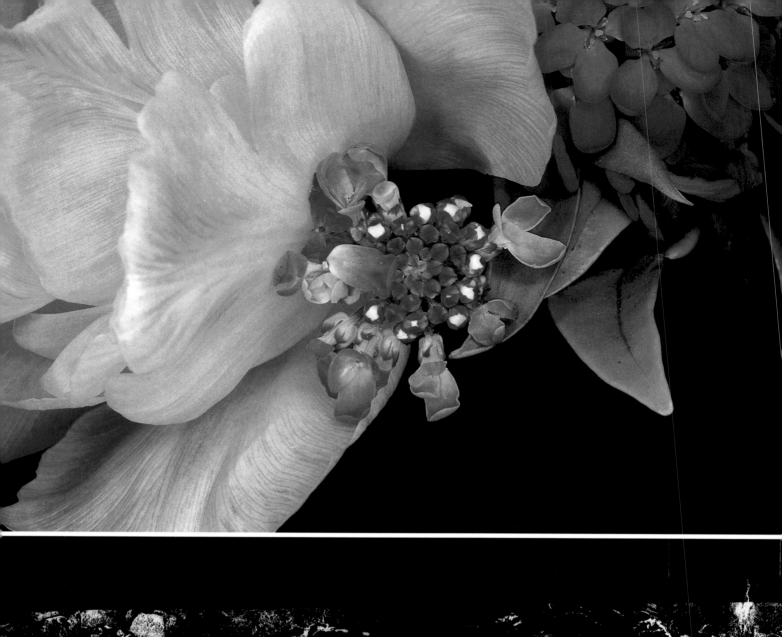
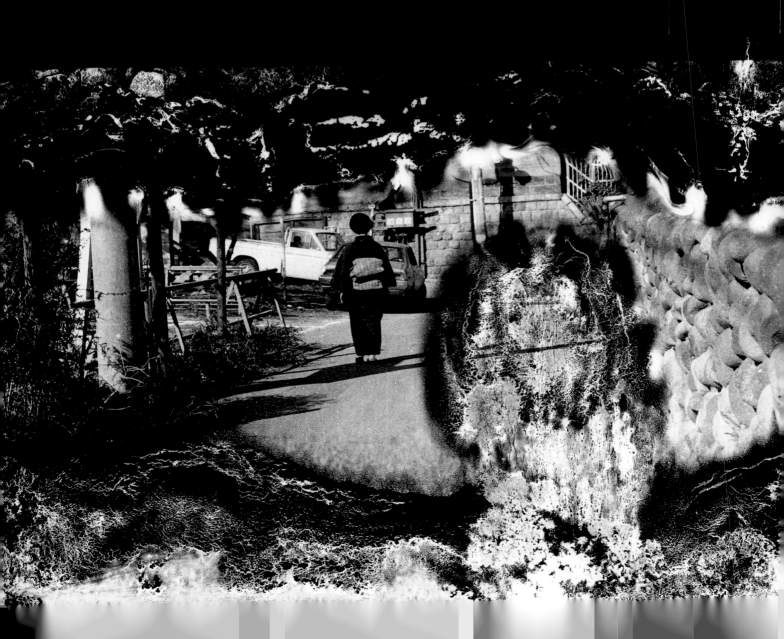

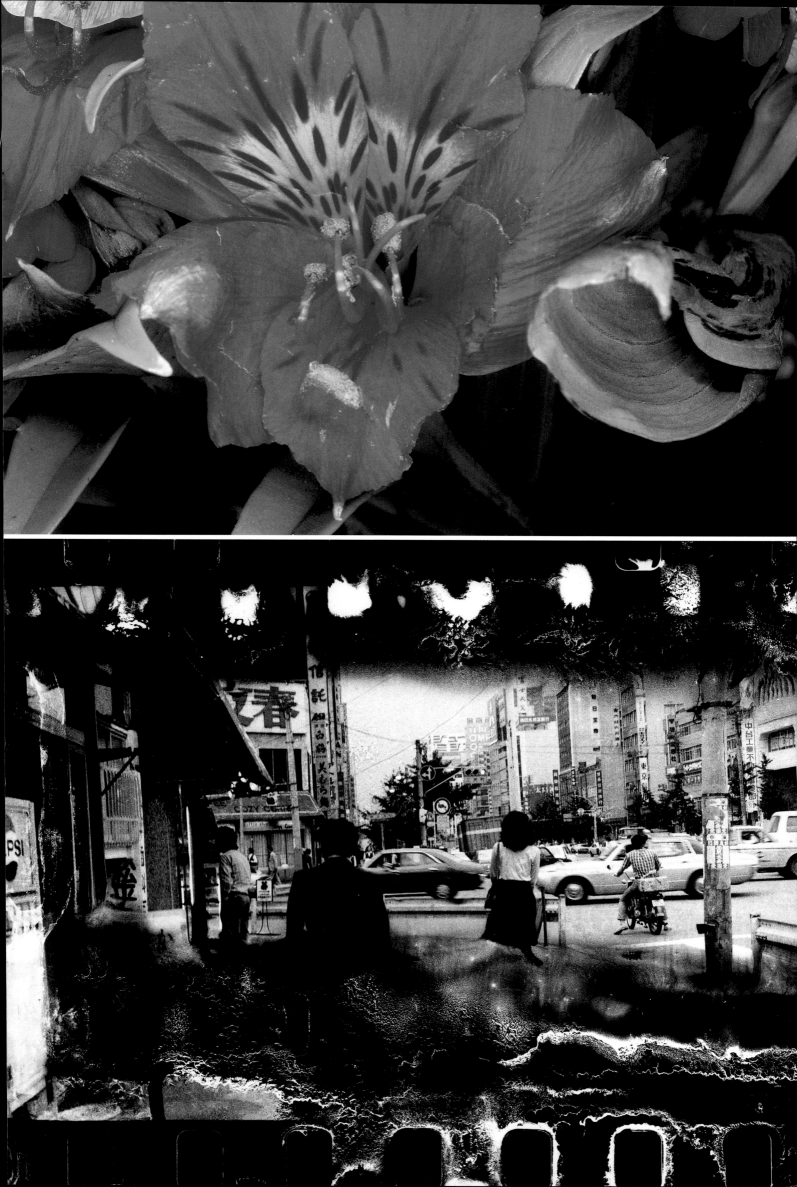

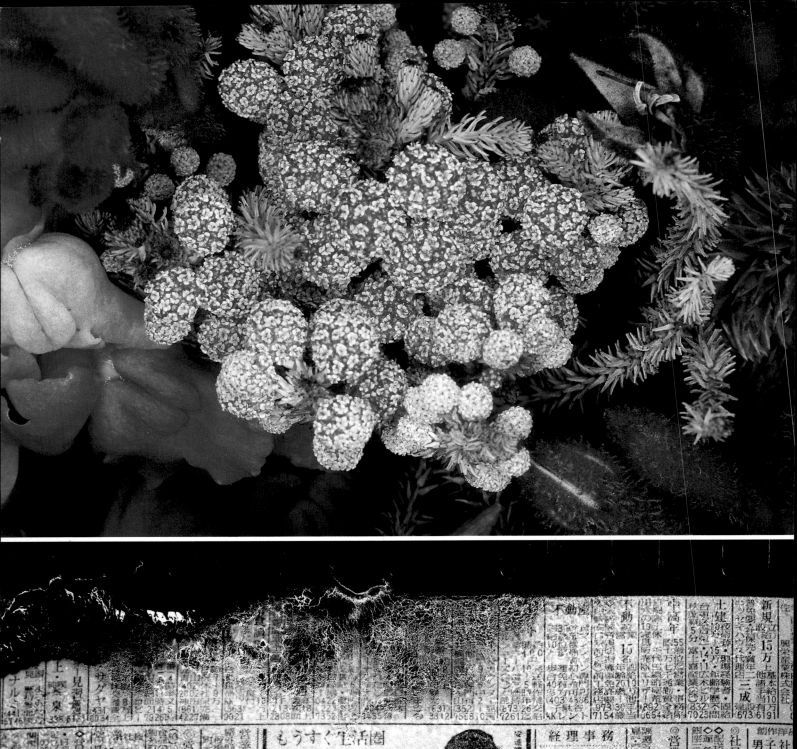

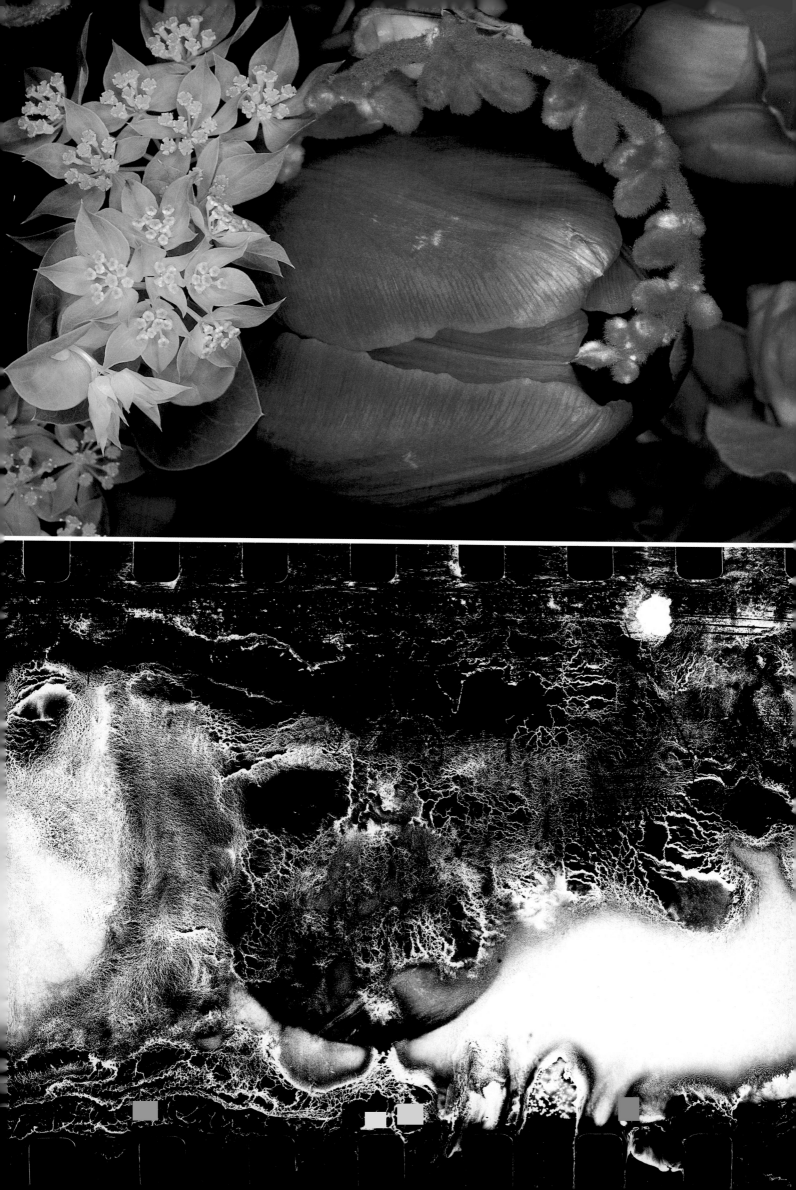

126 **NOBUYOSHI ARAKI**

Nobuyoshi Araki

Biography

1940 Nobuyoshi Araki is born in Tokyo.

1963 Araki completes his studies in photography and cinematography at Chiba University and is awarded a BA degree.

He begins work on a 16-mm film about a Tokyo child and combines this project with a series of photographs on the same theme. Even at this early date, his form of presentation is characterized by large-scale installations that seek in a certain sense to forge a link between film and photography.

1964 Araki receives the Taiyo Prize, an award devoted to the support and promotion of young Japanese photographers.

1965 His first exhibition is shown at the Shinjuku Station Building under the title *Satchin and His Brother Mabo.*

1971 Araki attracts public attention through his first publications, beginning in 1970. The book is of central importance to Araki as a medium for the presentation of his photographic work. He continues to publish profusely today.

His first major publication is a kind of photographic diary describing his honeymoon with Yoko, his very young bride. Focusing upon their shared erotic experiences, the book boldly presents their intimate secrets to the public. Araki titles the work *Sentimental Journey.*

1990 Yoko dies, and Araki attempts to give expression to his sorrow and pain in a number of exhibitions. He explores the theme of his beloved wife's death by relating the love story involving Yoko, Araki and their cat Chiro.

His wife's passing forces Araki to deal with the gruesome facts of death. His photographs combine the death's violent reality with fantasies bordering on the perverse, but they also call attention to the cultural background of Japanese society. At the same time, his work reflects an attempt to come to grips with the brutal realities of his home city of Tokyo.

Araki's photographs surely have their place within the Japanese tradition of personal novels, which also seek their themes in the realm of highly intimate detail, but they also belong to the age-old tradition of Japanese eroticism.

128 Selected Solo Exhibitions

1965 *Satchin and His Brother Mabo,* Shinjuku Station Building, Tokyo

1966 *Subway,* Mitsubishi Denki Gallery, Tokyo
Middled-Aged Women, Mitsubishi Denki Gallery, Tokyo

1967 *Ginza,* Mitsubishi Denki Gallery, Tokyo
Zoo, Mitsubishi Denki Gallery, Tokyo

1970 *Sur-Sentimentalist Manifesto No. 2: The Truth about Carmen Marie,* Kunugi Gallery, Tokyo
Kitchen Ramen Ero-Realism, Kitchen Ramen Restaurant, Tokyo

1972 *Mami' a truth,* Mail Photographs Exhibition, Tokyo

1973 *Unpeel me* and *Heat Me,* Mail Photographs Exhibition, Tokyo
Flowers in Ruins, Shimizu Gallery, Tokyo
Pseudo-Documentary: Chirring Cicadas in Chorus, Kinokuniya Gallery, Tokyo

1974 *Actresses,* Gallery Matto Grosso, Tokyo

1975 *From Photography to Photography,* Gallery Matto Grosso, Tokyo
Actress: Kisaki Sekimura, Minolta Photo Space, Tokyo
Towards an I-Reality (with his students), Shimizu Gallery, Tokyo

1976 *Wandering in Tokyo* (with his students), Shimizu Gallery, Tokyo
Yoko, My Love, Ginza Nikon Salon, Tokyo
Private Tokyo '76, Kinokuniya Gallery, Tokyo
Notes on Taeko, Seibu Book Center Libro, Tokyo

1977 *Tokyo Blues,* Nikon Salon, Tokyo and Osaka
Last Year's Photos, Shirakaba Gallery, Tokyo
This Year's Photos, Shirakaba Gallery, Tokyo
My Scenes: 1940 – 1977, Ginza Canon Salon, Tokyo

1978 *Eizo,* Camp Gallery, Tokyo
Actresses: A Senti-Roman, Horindo Art Space, Tokyo

1979 *First Visit to New York,* Minolta Photo Space, Tokyo; Obihiro Building Gallery, Hokkaido, Japan

1980 *Pseudo-Photos,* Room 301, Harada Building, Tokyo
Recent Photos, Room 301, Harada Building, Tokyo
Truth and Fiction: Zigeunerweisen, Kinokuniya Gallery, Tokyo
100% of Nairon, Bar Nylon, Tokyo
Wet Dreams on a Summer Night and the End of the War, Kinokuniya Gallery, Tokyo
Arakism Declaration, New York Theater, Tokyo

1981 *Second Arakism Declaration,* Yamaha Hall, Tokyo
Rika: Pseudo High-School Girl, Shinjuku Yamiichi Shop, Tokyo

1982 *I am Photography,* Doi Photo Plaza, Tokyo
Storm of Love, Doi Photo Plaza, Tokyo
Third Arakism Declaration, Asahi Seimei Hall, Tokyo

1984 *A World of Girls,* Zeit-Foto Salon, Tokyo
A Balthus Summer, Photo Space, Osaka

1985 *Snatching Love,* Kitchen Ramen Restaurant, Tokyo
An Immoral Woman, K's Bar, Tokyo
A Pseudo-Story About Girls, Bar New Dug, Tokyo

Cinephotographic Woman, Bar Refrain, Tokyo
1986 *Araki's Tokyo Erotomania Diary,* Zeit-Foto Salon, Tokyo
Araki Shoots Shibuya Like Atget, K's Bar, Tokyo
Shibuya Streets, Doi Photo Plaza, Tokyo; Inax Showroom, Fukuoka, Japan
Tokyo Theater, Sapporo Beer Factory, Tokyo
Arakinema: Tokyo-monogatari, Cinema Rise, Tokyo
1987 *Arakinema 2,* Studio Mag, Tokyo
Arakism: 1967–1987, Zeit-Foto Salon, Tokyo
A Part of Love, Art Space Mirage, Tokyo
Puppet Prince, Spiral Hall, Tokyo
1989 *Nobuyoshi Araki '89: Selected Photographs,* Gallery Kosai, Tokyo
1990 *Skyscapes,* Gallery Verita, Tokyo
Arakinema: Skyscapes, Shuppan Club, Tokyo
Foto Tanz, Konica Plaza, Tokyo
Tokyo Lucky Hole, Apt Gallery, Tokyo
Chiro My Love, Ikebukuro Book Center Libro, Tokyo
Towards Winter: Tokyo, A City Heading for Death, Egg Gallery, Tokyo
1991 *Winter Journey,* Egg Gallery, Tokyo
A's Nude Exhibition: Lovers, Apt Gallery, Tokyo
On the Move, Egg Gallery, Tokyo
Arakinema: Springscapes, Cinema Rise, Tokyo
From Close-Range, Hosomi Gallery, Tokyo
Jeanne, Shinchosha Art Space, Tokyo; Heartland, Hamamatsu, Shizuoka, Japan
From Close-Range II, Asense Gallery, Osaka
Colorscapes, Magazine House; The Seed Hall, Tokyo
1992 *Photomania Diary,* Egg Gallery, Tokyo
Kuruma(voiture) de Tokyo, Egg Gallery, Tokyo
Akt-Tokyo 1971–1991, Forum Stadtpark, Graz, Austria; Galerie Fotohof, Salzburg, Austria; Galerie Perspektief, Rotterdam, The Netherlands; Museum Folkwang, Essen, Germany (–1993); Fotomuseum im Münchener Stadtmuseum, Munich, Germany; Bregenzer Kunstverein, Bregenz, Austria; Museet for Fotokunst, Odense, Denmark; Nordliga Fotocentret, Oulu, Finland; Zone Gallery, Newcastle, U.K.; Galerie Bob van Orsouw, Zurich, Switzerland (–1995); Galerie Museum, Bozen, Italy
The Banquet/Monochrome, Gallery Imagine, Tokyo
Car Photographs, Tokyo, Egg Gallery, Tokyo
Colorscapes, Seikatsu-Soko, Nagoya, Japan
Nobuyoshi Araki: Festival of the Angels, Parco Gallery, Tokyo
State of Things: A Thousand Photographs Exhibited Day by Day, P3 Art and Environment, Tokyo
Love Interrogations: Tokyo Fucks, Apt Gallery, Tokyo
1993 *Tokyo Weather,* Gallery Verita, Tokyo
World of Love, La Camera, Tokyo
Erotos, Parco Gallery, Tokyo
1994 *Private Photography,* Yurakucho Asahi Gallery, Tokyo; Jablonka Galerie, Cologne, Germany
Arakinema: Private Photography, Yurakucho Asahi Hall, Tokyo
Sky, Gallery Eve, Tokyo
Tokyo Nude: Private Diary, Luhring Augustine, New York
Tokyo Cube – Unconscious Tokyo, White Cube, London
Erotic Photography Exhibition, Taka Ishii Gallery, Tokyo
1995 *Nobuyoshi Araki, Journal Intime,* Fondation Cartier pour l'Art Contemporain, Paris
A-Diary/Satchin and His Brother Mabo, Galerie Chantal Crousel, Paris
Tokyo Novelle, Kunstmuseum Wolfsburg, Wolfsburg, Germany
Erotos, Gallery Index, Stockholm, Sweden; Galleri Wang, Oslo, Norway; Forum Stadtpark, Graz, Austria (–1996)
Nobuyoshi Araki, Torch, Amsterdam, The Netherlands
The First Year of Heisei, La Garage, Reims, France
Naked Novel, Egg Gallery, Tokyo
Satchin in Summer, Laforet Museum Harajuku, Tokyo
Nobuyoshi Araki: Encontros de Fotografia, Coimbra, Portugal
Dactcho-kun, A Virgin Boy, Space Link, Tokyo
1996 *Face vs Nude,* Aoyama Spiral, Tokyo
Death Reality, Taka Ishii Gallery, Tokyo
The Past 1972–1973, Stadtsparkasse Münster, Münster, Germany
Flowers: Life and Death, Nishimura Gallery, Tokyo
Tokyo Novel, Egg Gallery, Tokyo
Sensual Flowers, Gallery Eve, Tokyo
Bokujukitan, Jablonka Gallery, Cologne, Germany
Fake Love, Ginza Komatsu, Tokyo
Nobuyoshi Araki: The Face/The Death, Pace Wildenstein MacGill, Los Angeles, California
A Moment in Time, Espace Tag Heyer, Tokyo
From Close-Range, Blum & Poe, Los Angeles, California
1997 *Nobuyoshi Araki,* Galerie Bob van Orsouw, Zurich, Switzerland
A's Life, Laforet Museum Harajuku, Tokyo
Flower Rondo, JM Gallery, Tokyo
Araki Retrographs, Hara Museum, Tokyo
A World of Girls, Il Temp, Tokyo
Nobuyoshi Araki, Wiener Secession, Vienna, Austria

Selected Group Exhibitions

1971 *The 10th Contemporary Art Exhibition of Japan,* Tokyo Metropolitan Art Museum, Tokyo
Fukushagahan, Kinokuniya Gallery, Tokyo
Shoshashin Ensokai, Aoyama Tower Hall, Tokyo

1972 *The 11th Contemporary Art Exhibition of Japan,* Tokyo Metropolitan Art Museum, Tokyo
Fin de Siècle: Regeniteration (with Shiro Tatsumi), Ginza Sony Building, Tokyo

1974 *Photo Photos,* Shimizu Gallery, Tokyo
From Photo to Photo: Miniature Gardens, Gallery Matto Grosso, Tokyo
15 Photographers, The National Museum of Modern Art, Tokyo

1975 *Towards an I-Reality,* Shimizu Gallery, Tokyo

1976 *Self Selected Works by Twelve Photographers,* Shiseido The Ginza Art Gallery, Tokyo
Neue Fotografie aus Japan, Stadtmuseum Graz mit Museumsapotheke, Graz, Austria
Walking in Tokyo, at the telephone booth, on the platform, etc., Tokyo

1978 *A Hot Wind in July,* Camp Gallery, Tokyo

1979 *Japan: A Self Portrait,* International Center of Photography, New York; Venezia Fotografia '79, Venice, Italy

1980 *Joint Concert with Ryudo Uzaki,* Sabo Kaikan, Tokyo

1983 *A Woman on 6 x 7 Films* (with Bill Brandt), Zeit-Foto Salon, Tokyo
A Scene of Contemporary Japanese Art: An Encounter with the Sights Around Us, Miyagi Museum of Art, Miyagi, Japan

1985 *Paris – New York – Tokyo,* Tsukuba Museum of Photography, Ibaraki, Japan; Miyagi Museum of Art, Miyagi, Japan
Document Foto 5: Die Japanische Photographie, Museum für Kunst und Gewerbe, Hamburg, Germany

1986 *Fotografia Japonesa Contemporanea,* Casa Elizalde, Barcelona, Spain

1989 *Eleven Photographers in Japan: 1965 – 1975,* Yamaguchi Prefectural Museum of Art, Yamaguchi, Japan

1990 *Tokyo: A City Perspective,* Tokyo Metropolitan Museum of Photography, Tokyo
Op: Positions, Fotografie Biennale Rotterdam II, The Netherlands
Photos de Famille, Mois de la Photo, Grand Halle, La Villette, Paris

1991 *Japanese Photography in the 1970s,* Tokyo Metropolitan Museum of Photography, Tokyo

1993 *Love You Tokyo* (with Kineo Kuwabara), Setagaya Art Museum, Tokyo
Nude Photographs (organized by *Brutus* magazine), Laforet Harajuku Espace, Tokyo
Nobuyoshi Araki, Sophie Calle, Larry Clark and Jack Pierson, Luhring Augustine, New York
Contemporary Japanese Photographers, Kunsthaus Zürich, Zurich, Switzerland
Das Bild des Körpers, Frankfurter Kunstverein, Frankfurt (Main), Germany

1994 *Nobuyoshi Araki and Larry Clark,* Sala Parpallo – Palau Scala, Valencia, Spain
When the Body Becomes Art: The Organs and Body as Object, Iatabahi Art Museum, Tokyo
Of the Human Condition: Hope and Despair at the End of the Century, Spiral/Wacoal Art Center, Tokyo; Ashiya City Museum of Art and History, Hyogo, Japan
Liquid Crystal Futures, The Fruitmarket Gallery, Edinburgh, U.K.
Nobuyoshi Araki: World Photography Exhibition 1994, Spiral Garden, Tokyo
Tokyo Love (with Nan Goldin), Shiseido The Ginza Art Gallery, Tokyo
Portraits, Galerie Samia Saouma, Paris
Photography and Beyond in Japan: Time space Memory, Hara Museum, Tokyo; Museo de Arte Contemporaneo International, Rufino Tamayo, Mexico City; Vancouver Art Gallery, Vancouver, Canada; Los Angeles County Museum, Los Angeles, California; Corcoran Gallery of Art, Washington, D.C.; Denver Art Museum, Denver, Colorado; The Contemporary Museum, Honolulu, Hawaii (–1995)

1995 *Sites of Being,* ICA Boston, Boston, Massachusetts
Vision of Hope and Despair, Museum of Contemporary Art Chicago, Chicago, Illinois
VI Biennale Internazionale di Fotografia, Palazzo delle Arti, Todi, Italy
Trame Inquiette (Agli Ordini del Cibo), Promotrice delle Belle Arti, Torino, Italy
The Act of Seeing (Urban Space) – Taking a Distance, Fondation pour l'Architecture, Brusselles, Belgium
The Dead, National Museum of Photography, Film & Television, Bradford, U.K.
Texture and Touch: Contemporary Japanese Photography, The Art Gallery of New South Wales, Sydney, Australia
Carnegie International 1995, The Carnegie Museum of Art, Pittsburgh, Pensylvania
My Kind of Town (with Yutaka Takanashi and Tetsu Iida), Ginza Gardian Garden, Tokyo
The Flowers from the Other World (with Painter Erik Andriesse), Galerie Paul Andriesse, Amsterdam, The Netherlands
Art in Japan Today 1985 – 1995, Museum of Contemporary Art Tokyo, Tokyo
Ginzabout, Shiseido The Ginza Art Space, Tokyo
Morphe '95: Tokyo Novel/Kiss of Flower, Aoyama district, Tokyo

1996 *Kingdom of Flora,* Shoshana Wayne Gallery, Santa Monica, California
Prospect 96, Frankfurter Kunstverein, Frankfurt (Main), Germany
Szenenwechsel X, Museum für Moderne Kunst, Frankfurt (Main), Germany
Sex and Crime, Sprengel Museum, Hanover, Germany
Nobuyoshi Araki, Thomas Struth, Christopher Williams, Larry Clark, Kunsthalle, Basel, Switzerland
Nobuyoshi Araki & Michiko Kon, Center for Photography, Carmel
Images of Women in Japanese Contemporary Art 1930 – 1990, Shoto Museum, Tokyo

1997 *Sensual Flowers* (with Yukio Nakagawa), Gallery Koyanagi, Tokyo
Nobuyoshi Araki, Diane Arbus, Nan Goldin, Sammlung Goetz, Munich, Germany
The Desire & The Void, Kunsthalle Wien, Vienna, Austria

The 10th International Biennial of the Image, Nancy Center Culturel André Malraux Vandceuvre,
Nancy, France
Amours, Fondation Cartier pour l'Art Contemporain, Paris
Du Construit, du Paysage, Centre Régional d'Art, Sète, France
Nobuyoshi Araki and Larry Clark, Taka Ishii Gallery, Tokyo
Photos (with Yasumasa Morimura, Yurie Nagashima, Kishin Shinoyama, Keiichi Tahara, Shoji Ueda),
Kobe Fashion Museum, Hyogo, Japan; Shinjuku Mitsukoshi Museum, Tokyo; Prefectural Museum
of Art, Fukuoka, Japan
*Floating Images of Women in Art History: From the Birth of the Feminism towards the Reconstruction
of Gender,* Tochigi Prefectural Museum of Fine Arts, Tochigi, Japan

Award

1964 The 1st Taiyo Prize

Publications

1970 *Xerox Assemblage,* Privately Published (25 volumes/edition: 70 each)
1971 *Bathing Beauties,* Fukusha-shudan, Geribara 5
 Oh Japan, Miki Shuppan
 Sentimental Journey, Privately Published (limited edition: 1000)
 Sentimental Journey-Okinawa Sequel, Privately Published (limited edition: 1000)
1973 *Tokyo,* Fukusha-shudan, Geribara 5
1976 *Journey to Photograph,* Asahi Sonorama
 Woman, Photo Workshop Edition
1978 *The Camera between Men and Women,* Byakuya-shobo
 Yoko My Love, Asahi Sonorama
 Dramatic Shooting: Actresses, Byakuya-shobo
1980 *Nobuyoshi Araki's Pseudo-Diary,* Byakuya-shobo
 Nobuyoshi Araki's Pseudo-Reportage, Byakuya-shobo
1981 *Theory of Photography,* Tojusha
 Photo-Novel: A Senti-Roman, Shueisha
 Arakin-Z, Mirion Shuppan; Taiyo Tosho
 Ikonta Story, Byakuya-shobo
 Romantic Images: Araki's Alices, Seirindo
 A Sentimental Journey in Pursuit of Women, Hokueisha
 Nobuyoshi Araki: Photo-Life (Asahi Camera magazine, special issue), Asahi Shimbun
 Photo-Theater: Tokyo Elegy, Tojusha
 Pseudo-Diary: High-School Girls, Hachiyosha
 The Joy of Taking Photos in Love Hotels, Byakuya-shobo
1982 *Arakkiss Love Call,* Parco Shuppan
 I am Photography: Araki Nobuyoshi's Photo-Album, Mure Shuppan
 Midori, Tankisha; Seiunsha
 My Love Life, My Sex Life (with Seiko Tanabe), Sojusha
 Lovers: A Sentimental Ero-Roman, Byakuya-shobo
 A Ten-Year Sentimental Journey (with Yoko Araki), Tojusha
 The Truth about Nobuyoshi Araki (Uwasa no Shinso magazine, special issue), Uwasa no Shinso
 The World of Nobuyoshi Araki (Shinpyo magazine, special issue), Shinpyosha
 Love Scenes, Keibunsha
 Dadaish Araki! (video), Pony Video
1983 *Araki's Storm of Love,* Byakuya-shobo
 Travels in the Woman Scape: Nobuyoshi Araki's Joy of Erotic Photography, Kodansha
 Araki Live! (*Photo Age* magazine, special issue), Byakuya-shobo
1984 *Oh, Shiniuku* (with Yasunori Okadome), Seihosha; Seiunsha
 Seoul Story (with Kenji Nakagami), Parco Shuppan
 A World of Girls, Byakuya-shobo
 Nostalgic Night, Byakuya-shobo
 Tokyo Autumn, Sanseido
 Tokyo: Private Opinions on a Flourishing Document (with Nobuhiko Kobayashi), Chuokoronsha
 Photomania Murder, Sakuhinsha
1985 *Landscapes: 1981–1984 (Photo Age* magazine, special issue), Byakuya-shobo
 Tokyo Photos (Photo Age magazine, special issue), Byakuya-shobo
1986 *Araki's Tokyo Erotomania Diary (Photo Age* magazine, special issue), Byakuya-shobo
 I-Novel (with Izumi Suzuki), Byakuya-shobo
1987 *Tokyo Diary: 1981–1995 (Photo Age* magazine, special issue), Byakuya-shobo
 On Territory 1 (with Hiromi Ito), Shinchosha
 In Raptures (with Yoko Araki), Byakuya-shobo
1988 *Girls's Story,* Ohta Shuppan
 Our Journeys of Love (with Yoko Araki), Magazine House
 Theory of Photography, Kawade Shobo Shinsha
 Pure Heart, Photo Novels, Million Shuppan
 Blue Meteorite (with Saburo Teshigawara), Kyuryudo

1989 *Tokyo Story*, Heibonsha
 Tokyo Diary: 1981–1989, Fiction Inc; Kawade Shobo Shinsha
 Tokyo Nude, Mother Brain; Ohta Shuppan
1990 *Chiro My Love*, Heibonsha
 The First Year of Heisei, Inter Press Corporation
 Foto Tanz, Inter Press Corporation
 Towards Winter: Tokyo, A City Heading for Death, Magazine House
 Catopia Catmania (with Akira Tamura), Ohta Shuppan
 Girls's Story, Ohta Shuppan (revised edition)
1991 *Tokyo Lucky Hole*, Ohta Shuppan
 Sentimental Journey/Winter Journey, Shinchosha
 Lament: Skyscapes/From Close-range, Shinchosha
 Colorscapes, Magazine House
 Plum Garden, Mother Brain; Ohta Shuppan
 Jeanne, Shinchosha
 The Camera between Men and Women, Ohta Shuppan (revised edition)
 Arakinema: Springscapes (video), Quest
 Love, Fusosha
 On the Move, Switch Corporation/Fusosha
 Yumeji, Yobisha
1992 *Photo-Maniac Diary*, Switch Corporation/Fusosha
 Akt-Tokyo 1971–1991, Camera Austria
 City in Primary Colors, Shinchosha
 Flowers Shop Behind the Cemetery (with Ryuei Semba), Magazine House
 Tokyo: Private Opinions on a Flourishing Document (with Nobuhiko Kobayashi), Chikuma Shobo
 (revised edition)
 Tokyo Autumn, Chikuma Shobo (revised edition)
 A Ten-Year Sentimental Journey (with Yoko Araki), Chikuma Shobo (revised edition)
 Angel's Festival, Taiyo Shuppan
 Car Photographs (dedicated to Robert Frank), Switch Corporation (limited edition: 1)
 State of Things, Privately Published (limited edition: 1)
1993 *Erotos*, Libro Port
 The Banquet, Magazine House
 Tokyo Fine Day, Chikuma Shobo
 Old People in Love (compiled by Nobuyoshi Araki with his commentaries), Chikuma Shobo
 Photo-Maniac Diary in Color, Switch Corporation/Fusosha
 Anti/Secret-Virgins in School Uniform, Byakuya-shobo
 Love Affair, KK Bestsellers
 Happiness of the City, Magazine House
 Living Cats in Tokyo, Heibonsha
 Post-War Japan, Aat room (limited edition: 1000)
 New World of Love (with Kei Shimamoto), Tokyo Sanseisha
 The Past, Byakuya-shobo
 Japanische Fotografie der 60er Jahre, Edition Braus
1994 *Private Diary*, Aat room (limited edition: 1000)
 Sawa, KK Bestsellers
 Fake Love, KK Bestsellers
 Private Photographs, Asahi Shimbun
 Tokyo Love (with Nan Goldin), Ohta Shuppan
 Arakitronics, Fuga Shobo
 Junco, KK Bestsellers
 The Nude and the Contemporary Photography, Kinema Junpo
 Obscenities (*déjà-vu* magazine, special issue), Photo-planète
 Arakism (with Toshiharu Ito), Sakuhinsha
 Hokeitei Diary, East Press
 Theory of Photo-Divine (dialogues with Eimi Yamada, Toshiharu Ito, Masatoshi Nagase, Keiji Ueshima),
 Libro Port
 Eros of the East Side of the Sumida River, Kobunsha
 Bokujukitan, Aat room (limited edition: 1000)
 Tokyo Air, Byakuya-shobo
 Satchin, Shinchosha
 Femme de Mouche, Mizuki Shuppan
 Arakitronics (CD-ROM), Digitalogue
1995 *Love Labyrinth*, Shinchosha
 Satchin and Mabo, Shinchosha
 A-Diary, Libro Port
 Nobuyoshi Araki à la Fondation Cartier pour l'art contemporain, hors-série 1, contrejour
 Nobuyoshi Araki, Tokyo Novelle, Kunstmuseum Wolfsburg
 A Woman without a Present, KK Bestsellers
 A's Diary (photo-CD), Inner Brain; Kodak Japan
 From the Edge of Nirvana (with Marilia, Gozo Yoshimasu, Kazuo Ohno), Quest (video)
 Datcho-kun, A Virgin Boy (drawings by Nobuyoshi Araki), Libro Port
 Araki's Naked Shooting, Take Shobo
 Children's Day: Their Dads, The Committee of the Exhibition *Satchin in Summer* (limited edition: 1000)
 Endscapes, Aat room (limited edition: 1000)
 Love Labyrinth: Passion in Okinawa, Shinchosha

133

Sentimental Journey/Winter Journey (photo-CD), Inner Brain; Kodak Japan
Arakinema: Satchin in Summer (video), Quest
Phoenix Joe, KK Bestmagazine
Tokyo Nature, Core Magazine

1996 *The Works of Nobuyoshi Araki 1: Naked Faces*, Heibonsha
The Works of Nobuyoshi Araki 2: Bodyscapes, Heibonsha
Pseudo-Love, Take shobo
Flower Town (with Ryuichi Tamura), Kawade Shobo Shinsha
The Works of Nobuyoshi Araki 3: Yoko, Heibonsha
Tono Story, Fuga Shobo
The Works of Nobuyoshi Araki 4: New York, Heibonsha
The Works of Nobuyoshi Araki 5: Chrysalis, Heibonsha
The Works of Nobuyoshi Araki 6: Tokyo Novel, Heibonsha
Yoko, Fuga Shobo
Sensual Flowers, Jatec Shuppan
The Works of Nobuyoshi Araki 7: Travelogue, Heibonsha
Love Labyrinth: Kyoto White Sentiment, Shinchosha
Novel Photography, Recruit Shuppan
There is a Distance between Niceness and Love (with Shuntaro Tanikawa), Gentosha
The Works of Nobuyoshi Araki 8: Private Diary 1980–1995, Heibonsha
Our Journeys of Love, Magazine House (revised edition)
The Works of Nobuyoshi Araki 9: Private Diary 1999, Heibonsha
Arakinema: Flower Rondo (video), Quest
The Works of Nobuyoshi Araki 10: Chiro, Araki and Two Lovers, Heibonsha
Shikijyo – Sexual Desire, Edition Stemmle
The Works of Nobuyoshi Araki 11: In Ruins, Heibonsha
Arakinema: Flower Rondo 2 (video), Quest
The Works of Nobuyoshi Araki 12: Dramatic Shooting and Fake Reportage, Heibonsha
The Journey to Photography, Magazine House (revised edition)
The Works of Nobuyoshi Araki 13: Xeroxed Photo Albums, Heibonsha

1997 *The Works of Nobuyoshi Araki 14: Obscenities and Bokujukitan*, Heibonsha
The Works of Nobuyoshi Araki 15: Death/Elegy, Heibonsha
134 *The Works of Nobuyoshi Araki 16: Erotos*, Heibonsha
Arakinema: A Girl Floating Alone in the Cosmos (video), Quest
Girl's Journey (CD-ROM), Digitalogue
Photo-Love-Suicide (CD-ROM), Kobunsha
The Works of Nobuyoshi Araki 17: Sensual Flowers, Heibonsha
Tokyo Lucky Hole, Benedikt Taschen Verlag
The Works of Nobuyoshi Araki 18: Bondage, Heibonsha
The Works of Nobuyoshi Araki 19: A's Lovers, Heibonsha
Flower Rondo, Shinchosha
Hong Kong Kiss (CD-ROM), Just System
The Works of Nobuyoshi Araki 20: Sentimental May, Heibonsha

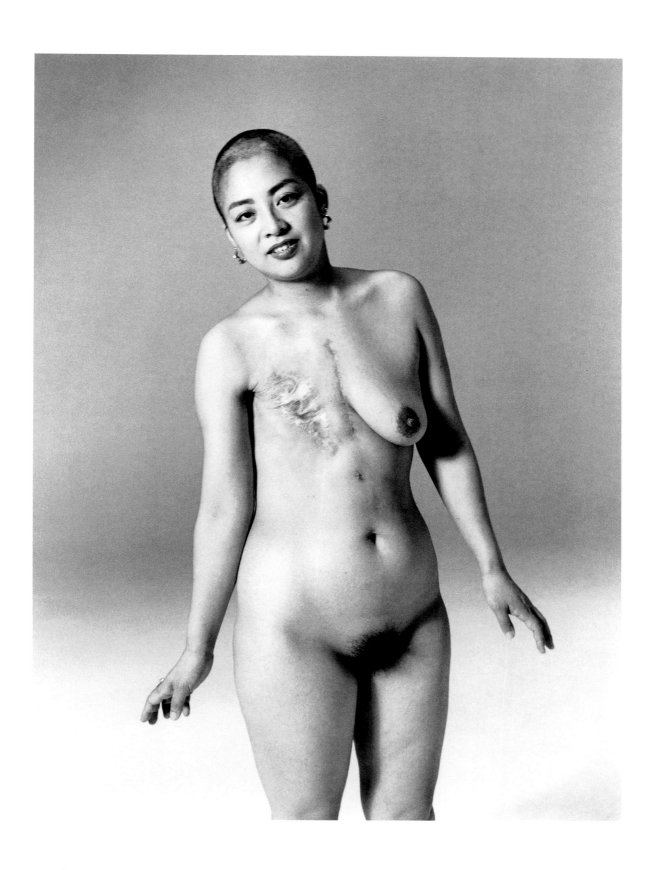

Translation from the German by John S. Southard
Editorial direction by Sara Schindler
Art direction by renntypo, Visuelle Kommunikation, Teufen, Switzerland
Printed and bound by Kündig Druck AG, Baar, Switzerland

ISBN 3-908161-21-5